CELEBRITY SKIN

THUNDER'S MOUTH PRESS NEW YORK

TY SKIN

TATTOOS,
BRANDS, AND
BODY
ADORNMENTS
OF THE STARS

JIM GERARD

First published in 2001 in the
United States of America and Canada by

Thunder's Mouth Press
an imprint of Avalon Publishing Group Inc.
161 William Street, 16th Floor
New York, NY 10038

Printed in Hong Kong.

10 9 8 7 6 5 4 3 2 1

Library of Congress
Control Number:
2001091503

ISBN 1-56025-323-1

PHOTOGRAPHY
Cover: K. / Visages
Inside pages: Albert L. Ortega
Photography, AllSport, Camerawork USA,
Inc., Corbis, Corbis-Outline, Corbis-Sygma,
Dennis Hensley, E. William Blochinger
Photography, Getty Images, Globe Photos,
Mavrix, NewsCom, Retna Ltd., Shooting Star,
Visages.

DISCARDED

contents

INTRODUCTION

A book devoted to celebrity body art is, in a way, redundant. Why? Well, because celebrities are our tattoos—emblems of our culture. As archeologists uncover the hierarchies of ancient societies from their graven images, so their descendents someday will uncover the ruins of our present global village and discover that we were enthralled with someone named Lorenzo Lamas.

Tattoos originally designated Tahitian tribal leaders; in the same way, celebrity connotes a kind of royalty. Most celebs (except maybe reality-TV survivors) have conspicuously majestic lifestyles. Their imperious demands can be downright Caesarean. (Take, for example, Christina Aguilera's contractual insistence on a special gridlock-busting motorcade escort to performing venues.)

And as the crowned heads of Europe did for centuries, celebs mate with and marry their own kind. Public appearances reinforce their image and satisfy their subjects' insatiable hunger. (Case in point: Entertainment Web sites feature channels that encourage fans to report any celebrity "sightings.") The famous are photographed by swarming paparazzi and live in a swirl of gossip, rumor, and innuendo.

Yet the kingdom of celebrity is built on the quicksand of fickle public taste. That's why, ultimately, celebrities are an advertising medium, used to hawk movies, records, and sneakers—in the same way their "art" sells them, in the same way tattoos sell their bearer's inner life.

Like last season's fashions or the computer you bought two minutes ago, celebrities also are products for mass consumption, and as such, are victims of planned obsolescence. After all, the average American consumer demands a constant turnover of new-but-not-too-different. Metalheads have big hair; boy bands require saccharine ballads and slick choreography; overpaid NBA big-shots sneer at questionable calls with "Who-you-dissin?'" attitude.

That's why, in the end, most celebs' tattoos will far outlast their fame. But that's OK, because a new batch will have emerged, eager to help us fill our spiritual void. Who else, in the absence of family, community, and political leadership, can we turn to for guidance but Pamela Anderson, The Undertaker, Flea, and their successors? Face it, if celebrities didn't exist, we would have to invent them.

In fact, in our all-American resourcefulness, we've constructed an entire celebrity industry—comprised of managers, publicists, shoppers, stylists, personal assistants and trainers, bodyguards, TV shows, Web sites (many run by fans)—complete with its own subgenre of muckraker media. Alas, with this book, I have joined the fray. While researching *Celebrity Skin,* I was alternately fascinated, amused, and frightened (mostly at the thought of injecting the image of Elvis. In ink. On my arm.) Which brings us to the phenomenon of the body as museum.

The word *tattoo*—and, it is said, the tattoo itself—comes from Polynesia, with its first reference traced to 1777. Perhaps Captain Cook hauled the word back to the English-speaking world, and until the 1990s the tattoo mostly was associated with sailors (and bikers). This may explain why Popeye, the first tattooed celebrity and spinach industry spokesman, displayed an anchor on his hypertrophied forearm.

Sailor's tattoos were a declaration of machismo or a reminder of a hazy shore-leave bender. One gets the feeling that celebs that go under the needle are a bit more calculating. Because tattoos, even those hidden from plain view, are a form of rhetoric; they're skin signage, the 90s version of "Kiss Me, I'm Irish" T-shirts, and yet one more vehicle for grabbing publicity.

The most common celeb tattoo design elements involve crosses, hearts, flowers, the macabre, and the name or initials of one's beloved (the last of which are soon enough changed—see Johnny Depp).

They're either excised (tattoo removal is a growth industry), given a new spin that substitutes a pathetic stab at self-esteem for the homage to the ex—"A.G. now stands for 'Amazing Girllll'"—or tattooed over like flyers on a lamppost.

But the overriding message of all body art is "I, too, am hip and unique," the mantra of those who practice mass individualism, and a ridiculous sentiment when conveyed by millions trying to live la vida loca vicariously at suburban tattoo parlors. To be fair, I suppose body art has its functions. It's a fashion accessory that provides a cache of cool in place of the real thing, and can serve as a conversation piece for the socially challenged.

I'm left with the conviction that tattoos soon will be replaced by some other form of mass media-induced post-hypnotic suggestion, and will fade like the memory of the Blink-182's career. Let this volume serve as a testament to both.

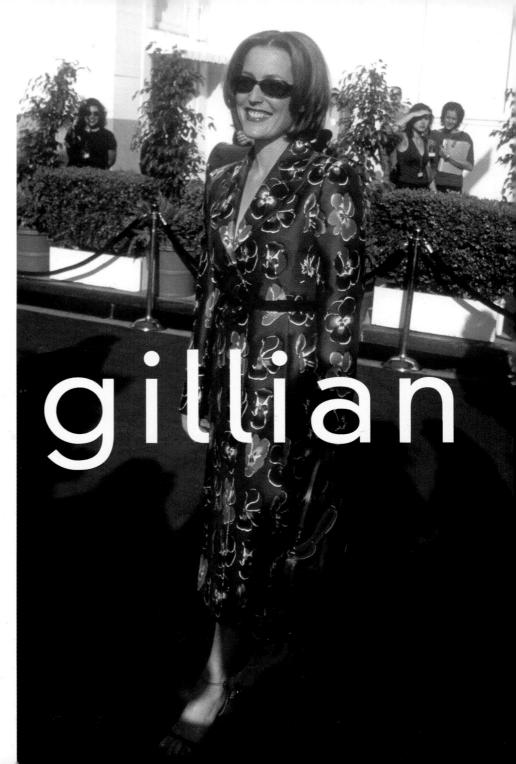

RAW DATA

DATE AND PLACE OF BIRTH August 9, 1968, in Chicago.
CURRENT RESIDENCE Los Angeles.
TV "The X-Files" (1993–present); "Class of '96" (1993).
FILMOGRAPHY *The House of Mirth* (2000); *Playing by Heart*
(1999); *The X-Files, The Mighty, Chicago Cab* (1998); *The
Turning* (1991).
WRITER/DIRECTOR "The X-Files," All Things episode (2000).
AWARDS Golden Globe, Best Actress in a TV Series,
"The X- Files," (1997); Emmy, Best Actress in a Drama Series,
"The X- Files" (1997).

STRANGE BUT TRUE

- Anderson and Klotz were married on the 17th hole of a
 Hawaiian golf course by a Buddhist priest (who was
 caddying for Richard Gere).
- Gillian puts "skin tape" over her tattoos during filming.
- There's a Web site known as The Church of the
 Immaculate Gillian. Visitors to it have been miraculously
 cured of carpal tunnel syndrome.
- She's been in therapy since she was 14–so long her
 sessions are in syndication.
- Anderson rose eyebrows when she was snapped while
 kissing Ellen de Generes in an L.A. restaurant while Ellen's
 girlfriend looked on in dismay (an incident that later trig-
 gered the famous X-Files episode, Lesbian Bed Death).
- She was voted "Most Likely to Be Arrested" by her high
 school classmates, and was in fact booked on graduation
 night for trying to glue the school locks shut.
- She starred as the voice of E.V.E. in Microsoft Hellbender, a
 game in which intergalactic warriors try to contain Bill
 Gates's ego.

> The Divided Self: "If I met SCULLY at a party, I'm not sure how much we'd have to talk about." <

THE INSIDE SCOOP

Gillian Leigh Anderson, pinup girl to the crop-circle crowd, was born to "hippie" parents and had a peripatetic childhood in Puerto Rico, London, and Grand Rapids, MI. As a child, Anderson was unusually short and adopted an English accent, both of which caused her school chums to tease her mercilessly, which led, in turn, to her becoming a Mohawk-sporting punkette and, then, an actor. She attended Goodman Theater School at DePaul University, then moved to New York, where she first gained recognition for her performance in Alan Ayckbourn's *Absent Friends* at the Manhattan Theater Club. After moving to Los Angeles in 1991, she struggled, and was cast as FBI agent Dana Scully in "The X-Files" the day after her last unemployment check arrived. She relocated to Vancouver with her husband, "X-Files" art director Clyde Klotz, and soon afterward their daughter, Piper, was born. As Anderson's X-posure made her an intergalactic goddess, she and Klotz grew apart and subsequently divorced. Anderson's strait-jacketed sensuality has inspired a cult following, and there are more than 200 Web sites devoted to her. As if to distance herself from Scully, recently she's ranged far afield in films such as *Playing by Heart; The Mighty,* and *The House of Mirth.*

ANDERSON

SKIN DEEP

> She sports two back-to-back tortoises on her ankle, as well as a pierced navel. Initially, she claimed to have no recollection of getting them and said she was the victim of alien experimentation. Eventually, though, she fessed up this tale of the South Pacific: "The tattoo was done in Tahiti," she said. "There was a local guy named George who had tattoos over half of his entire body, and he did most of them himself. I asked him what would be a Tahitian symbol for 'peace of mind,' and he told me tortoises represent peacefulness and longevity." So she went under George's Rube Goldberg-like apparatus: "His equipment was a sewing needle attached to an old electric razor with a ballpoint pen casing with a shish kebab stick through it. And he plugged it into this battery pack. It was painful. It felt like I was at the dentist and they were drilling into my bone. When I was having it done, I was thinking, 'Why the fuck am I doing this?' But when it was done, I wanted another one done immediately—it's so addictive." Gaugin couldn't have said it better.

THE INSIDE SCOOP

Contrary to rumor, Pamela Denise Anderson was not created in a Hollywood laboratory by a mad casting scientist grafting 34D breast implants onto spare parts of Farrah Fawcett and Suzanne Somers. In reality, Pam was just an average Canadian girl—perky, undistinguished, and unambitious (in her high school yearbook, she wrote that her life's objective was to be a "California beach bum"). Fate beckoned one day while she attended a pro football game. A stray cameraman displayed her image, encased in a Labatt's beer T-shirt, on a Jumbotron screen. The resultant uproar broke up tailgate parties and inspired Labatt's to hire her as a TV suds pusher. Five *Playboy* layouts, a stint as the Tool Time Girl on "Home Improvement," and her "Baywatch" star turn later, she was Pambo, Hollywood goddess. After four years of saving lives in the studio tank, Pam became a live-action hero in the flop film *Barb Wire,* the futuristic tale of an uber-babe who can shoot two Desert Eagles in a 17-inch corset and stilettos. Then Pam's tragic flaw—meatheaded heavy metal musicians—sabotaged her. After a deep friendship of 96 hours, she married Motley Crüe drummer Tommy Lee on the beach, wearing a white thong bikini. That was the highlight of a WWF marriage comprising domestic violence, angry breakups, and lawsuits over a private sex video that surfaced on the Web. After less than two years and two children, Brandon and Dylan, Pamela sued Tommy for divorce. After Tommy went to the slammer, she divorced him again—to make sure it would stick. In what was clearly a metaphor for her career, Pamela's implants sprung a leak, and she had them hauled off by Teamsters. She was last seen starring in the syndicated action show "V.I.P.," in which she plays a bodyguard.

>She IMAGINES the day "when my sons' first girlfriends come over and I'm all wrinkled up in a chair with TATTOOS all sagging down to my ankles."<

pamela

SKIN DEEP

> Pam says, "Tattoos are symbolic of the important moments in your life. Talking about where you got each tattoo and what it symbolizes is really beautiful. They're like stories." Story No. 1: Pam had the word "Tommy" stenciled on her ring finger, but retouched it to "Mommy" after "Tommy" used "Mommy" as an anger-management substitute. Pam also has a self-explanatory barbed-wire armband.

RAW DATA

DATE AND PLACE OF BIRTH July 1, 1967, in Ladysmith, British Columbia.

CURRENT RESIDENCE Los Angeles.

TV "V.I.P." (1998–present); "Baywatch" (1992–97); "The Evolution of Mr. E" (1995); "Come Die With Me: A Mickey Spillane's Mike Hammer Mystery" (1994); "Home Improvement" (1991–93); "Married...With Children" (1991).

FILMOGRAPHY *Barb Wire* (1996); *Naked Souls, Baywatch: Forbidden Paradise* (1995); *Raw Justice, Snapdragon* (1994); *The Taking of Beverly Hills, Baywatch: River of No Return* (1992).

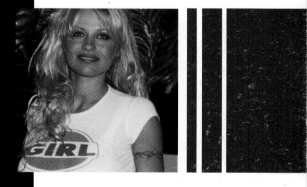

STRANGE BUT TRUE

- Island of Dr. Moreau Dept.: To stunt double for Anderson on "V.I.P.," Julie Michaels became a Pammy clone; she got identical breast implants, bleached her hair platinum, and had an artist paint her body with replicas of Anderson's tattoos. She later married an unwitting Tommy Lee.
- Double Feature Dept.: Before the XXX video with Tommy, the blonde bombshell taped herself copulating with another rocker, Brett Michaels of Poison.
- Just in Case Company Drops By: Pam keeps the placenta from her last childbirth in her freezer.
- Down, Boy Dept.: She told one reporter that Tommy had been "neutered or spayed."
- One Small Step for Man: At one of their marriages, Pam and Tommy got married in spacesuits.

ANDERSON

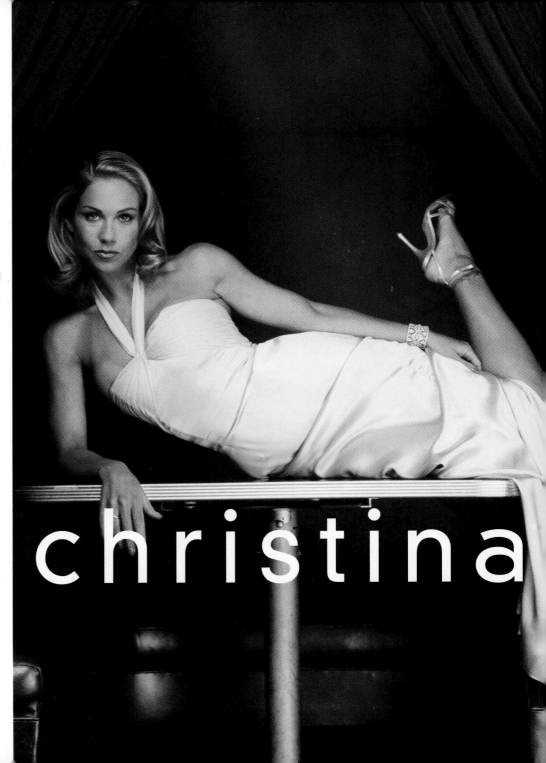

RAW DATA

DATE AND PLACE OF BIRTH November 25, 1971 in Los Angeles to actress Nancy Priddy and record executive Robert Applegate.

CURRENT RESIDENCE Los Angeles.

FILMOGRAPHY *The Big Hit, Jane Austen's Mafia!* (1998); *Nowhere* (1997); *Mars Attacks!* (1996); *Wild Bill* (1995); *Across the Moon, Vibrations* (1994); *Married With Children—It's a Bundyful Life* (1992); *Don't Tell Mom the Babysitter's Dead* (1991); *Streets* (1990); *Beatlemania* (1981); *Jaws of Satan* (1981).

TV "Married...With Children" (1987–97); "Dance 'til Dawn" (1988); "Heart of the City" (1986); "Grace Kelly" (1983).

AWARDS People's Choice, Favorite Female Performer in a New TV Series, "Jesse" (1999).

STRANGE BUT TRUE

- She has two black cats, Natasha and Jesse; and a German shepherd, Sybill, all of whom are represented by ICM.
- During the Gulf War, it was reported that U.S. soldiers in Iraq voted her the most beautiful woman on TV. (In a related story, CIA archives now reveal that "Married...With Children" was developed by Saddam Hussein as a weapon of mass destruction.)
- Although she's been linked to insta-hunks (just add goatee and stir) Christian Slater and Johnathan Schaech, she claimed to a reporter that "I've always dated guys who didn't have jobs."
- For Halloween one year, she dressed up as a pimp, and her sister was "my bitch." ("It's Superfly, Charlie Brown!")
- She belongs to a metaphysical church called Heape—unconditional love. Heape believes in eternal life, unconditional love, and points.
- She was barred from her own official Web site. (You know your 15 minutes of fame are up when...)
- Christina is yet another victim of the epidemic of post-moronic-sitcom-amnesia (they ought to have their own telethon), claiming about "Married," which ended in 1997, "It was years ago and I don't recall anything about it, really."

christina

>Of her TV FAMILY, the Bundys, she said, "We came along and set the path that it's OK to be disgusting on TELEVISION."<

THE INSIDE SCOOP

The animating spirit behind trash icon Kelly Bundy, Christina Applegate claims she "popped out" of the womb performing. (Before that, she appeared on sonograms.) Apparently shocked by the showbiz precocity of their newborn, her parents split up shortly after her birth. Christina's mother, Nancy Priddy, encouraged Christina's thespian ambition by piggybacking her to her auditions and acting gigs. In fact, a three-month-old Christina made her first TV appearance mugging in her mother's arms on the soap "Days of Our Lives," and was doing commercials for Playtex nurses at age five months, thus earning the enmity of most of SAG. At 7, she filmed several national spots for Kmart and enrolled in a high school for child performers. (Now there's a hell not even Dante could imagine.) In 1986, she won a regular role in "Heart of the City," and did several other series before landing her breakout role as the vapor-locked, hormonally imbalanced Kelly in "Married..." in 1987. Despite her gratitude for the fame the show brought her, like many stars, she sees herself as a prisoner of her persona. To distance herself from her downmarket Lolita character, real-life Christina bought a restaurant and freely donates her time to AIDS charities and animal-rights causes. She also played the eponymous barmaid in "Jesse," a sitcom canceled after its second year.

APPLEGATE

SKIN DEEP

> Applegate has seven tats: the word "OM," the name of her church (just in case), her mom's name, a vine on her left ankle, a ti-leaf lei on her right ankle, an apple just below her bikini line, and "a secret one that I don't talk about." She claims that, "They all represent something very dear to me.

The ti-leaf lei is a symbol of power in Hawaii. A girlfriend and I had the vine done to signify our friendship. And the apple isn't for Applegate—it symbolizes the forbidden fruit, from the story of Adam and Eve."

THE INSIDE SCOOP

Once upon a time, little Roseanne Barr was hit by a car. She spent time in a mental institution, then ran away to a commune, where she had a daughter whom she gave up to adoption. To survive, she turned tricks, while by night she told jokes in a biker bar in Denver. A few years later, she made many important people laugh, and they rewarded her with her own sitcom. The show, which made sport of her white-trash roots, was beloved by the villagers. At the height of her fame, who should show up but Brandi, the daughter she'd abandoned years earlier! This didn't deter her from marrying her frog-prince, a wandering player named Tom Arnold. The union was cursed from the start, and everybody in the kingdom knew it. What they didn't know was that the boorish, megalomaniacal tyrant they read about in the tabloids wasn't the real Roseanne. In fact, nobody knew who the real Roseanne was, least of all Roseanne, who declared that she had many personalities. (But it wasn't her fault; she'd just discovered that she was abused as a child.) One of her personalities—the Exhibitionist—performed an appalling, crotch-grabbing rendition of "The Star Spangled Banner" at a San Diego Padres game. Her debut film, *She-Devil,* did not reach many screens, and Roseanne consoled herselves with more surgical procedures than Frankenstein. Nonetheless, all the king's cosmetic surgeons couldn't revive her sagging Nielsens. But Rosie plodded on; she wrote two books, married her bodyguard, and had an in vitro pregnancy at age 43. Her reign of terror finally ended after 10 years, but she resurrected herself in a talk show format. However, after less than two years, the kingdom had seen about as much of Roseanne as it could stand. Her talk show was moved first from morning to late night, then to after the infomercials, and finally to the tele-morgue.

SKIN DEEP

> As if syndicating nature, Roseanne has veritable rose bushes blooming on her back. About the only remnant of her marriage to Arnold is the name "Tom," which survives on her thigh. It once read, "Property of Tom Arnold," but someone seems to have defaced it. A breast reduction clipped half a rose tattoo. And she has a garter belt and stocking "about four inches long" on her leg. "It looks really cool," she gushed, while admitting she may have a tattoo impulse-control problem. "I'm slowly losing my total mind at the tattoo parlor. I go all the time now—once every four months. It's very addictive." Calling TA (Tattoos Anonymous).

roseanne

>"Fame has made me PSYCHOTIC."<

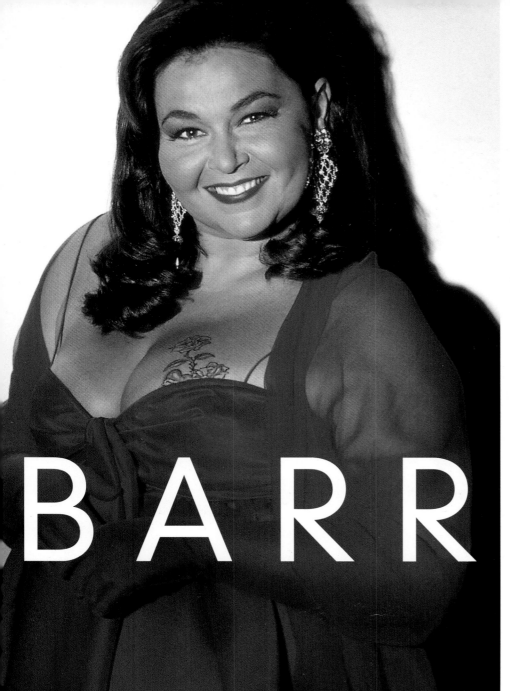

BARR

RAW DATA
DATE AND PLACE OF BIRTH November 3, 1952, in Salt Lake City.
CURRENT RESIDENCE Los Angeles.
TV "The Roseanne Show" (1998–2000); "Roseanne" (1988–1997); "The Woman Who Loved Elvis" (1993); "Backfield in Motion" (1991).
FILMOGRAPHY *Get Bruce* (1999); *Meet Wally Sparks* (1997); *Unzipped, Blue in the Face* (1995); *Even Cowgirls Get the Blues* (1994); *Freddy's Dead: The Final Nightmare* (1991); *Look Who's Talking Too* (1990); *She-Devil* (1989).
BOOKS *My Lives* (1994); *Roseanne: My Life as a Woman* (1989)
AWARDS Golden Globe, Best Actress in a Comedy Series, "Roseanne" (1993); Emmy, Outstanding Lead Actress in a Comedy Series, for the same (1993).

STRANGE BUT TRUE
- (Warning: Please do not read without comfort distress bag.) In 1996, Tina Brown had her guest-edit an issue of the *New Yorker*. "I didn't learn anything," boasted Rosie, "because I already know everything there is to know. But other people found out things. I enlightened them."
- She once said of her hometown, "I would never have dared share my humor in Salt Lake City," where bigamy is easy but comedy is hard.
- "People a hundred years from now will still be watching me. I'll be a cult figure or the cornerstone of a whole new religion." And you thought Heaven's Gate was bad…
- Raw Is War: On Oprah's show, the host challenged Roseanne to an arm wrestling match, and beat her two of three falls.
- The Horror, the Horror!: Roseanne once dared James McDaniel ("NYPD Blue") into dropping his drawers on her talk show by showing him how. After he flashed his navy-blue briefs, a mortified McDaniel exclaimed, "Oh, my God, what have I done?"

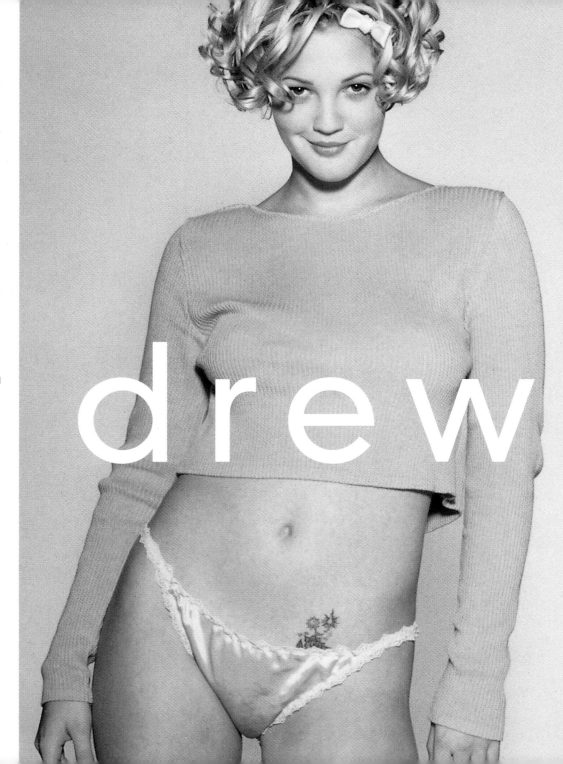

RAW DATA
DATE AND PLACE OF BIRTH February 22, 1975, in Los Angeles.
CURRENT RESIDENCE Los Angeles.
FILMOGRAPHY *Titan A.E., Charlie's Angels* (2000); *Never Been Kissed, Wishful Thinking* (1999); *Ever After: A Cinderella Story, Home Fries* (1998); *Everyone Says I Love You, Scream* (1996); *Boys on the Side, Mad Love, Batman Forever* (1995); *The Evil Within, Bad Girls* (1994); *The Amy Fisher Story, No Place to Hide, Wayne's World 2* (1993); *Sketch Artist, Poison Ivy* (1992); *Motorama* (1991); *Far From Home, See You in the Morning* (1989); *A Conspiracy of Love* (1987); *Babes in Toyland* (1986); *Cat's Eye* (1985); *Firestarter, Irreconcilable Differences* (1984); *E.T.* (1982); *Altered States, Bogie* (1980).
TV "Gun Crazy" (1993); "2000 Malibu Road" (1992); "Strange Tales/Ray Bradbury Theater"(1986).
BOOKS *Little Girl Lost*, a memoir (1991).
AWARDS Golden Globe, Best Actress in a Miniseries or Telefilm, "Gun Crazy," 1993.

STRANGE BUT TRUE
- Drew almost married Tom Green on "Saturday Night Live," but at the last minute, Lorne Michaels sent the wedding back for a rewrite. (Actually, Drew backed out).
- She and "Simpsons" creator Matt Groening co-produced a Christmas special, "Olive the Other Reindeer," about a dog who wants to be a reindeer (fails, hits the sauce, and lands in the Betty Ford Pound).
- If she couldn't be an actor, Drew says she'd work in the stain-removal business. "I don't get how they do that. It's like the Bermuda Triangle." ("Next on 'Unexplained Mysteries'— The Dry Cleaners.")

drew

>Of her FONDNESS for belching, Barrymore says, "I love human functions.... It's one way WE CAN BOND."<

THE INSIDE SCOOP

At the current warp speed of contemporary life, it is now possible to have been a movie star, nightclub habitue, booze/pot/cocaine addict, suicide attemptee, 12-step graduate, *Playboy* centerfold, and divorcee—all before you're old enough to vote. Take the poster child for the perils of adolescent stardom, Andrew Blythe Barrymore, who, as the granddaughter of famed actor-lush John, seemingly can't resist the pull of her genes. Drew appeared in a Puppy Choice dog food spot at 11 months, and when she was 4, in one of those moments properly accompanied by ominous *Invasion of the Body Snatchers* music, informed her mother, "I really want to act." Her mother, Ildigo Jaid, herself an actress, acquiesced. At 2, Drew filmed the premonitorily titled *Altered States,* then *E.T.,* which made her famous and accelerated her descent, lowlighted by her getting drunk at a Rob Lowe party. She was 9. Then came the cocaine, near-nude scenes in the thriller *Far From Home* and, at manager-mother's insistence, rehab. Barrymore celebrated her sobriety with more nude layouts and a marriage to Jeremy Thomas that was over so fast physicists had to put it through a particle accelerator to make sure it actually happened. Along the way Drew won legal emancipation from her mom (who, incidentally, has posed nude for *Playboy* and been busted on a gun charge), then launched a comeback with a gaggle of films, the most successful of which were *Batman Forever, Scream* (an apropos title for her autobiography) *Everyone Says I Love You, The Wedding Singer, Ever After,* and *Charlie's Angels.* Since 1994, she has managed her own production company, Flower Films, and she served as executive producer as well as star of *Never Been Kissed.* Given her accelerated pace and the life span of the Hollywood ingenue, at 25, soon she'll be looking to revive "Golden Girls."

BARRYMORE

SKIN DEEP

> Drew has a panoply of tattoos—none of which are as interesting as Popeye's—and her body hosts more crosses than Forest Lawn. On her right ankle, there's a cross bigger than the one left at Calvary. If you turn Drew over, you'll find two more: An angel lugs one that blots out the name of ex-boyfriend "Jaimie," which had been imprinted on a banner. And on her derriere her mom's name, Jaid, is displayed on a cross surrounded by three cherubs. Other tats not expected to rile the Vatican are a blue moon on the big toe of her right foot, a sub-navel butterfly, and a bouquet on her lower left abdomen. Drew says she likes to "incorporate butterflies and daisies into my wardrobe, and I always wear some glitter in my makeup." However, she adds, "These are not my fashion crutches. They give me a kick and are an expression of how alive I feel."

>"More than anything else, I'd like to be an old man with a GOOD FACE, like Hitchcock or Picasso."<

THE INSIDE SCOOP

Thomas Sean Connery is a prototypical self-made man, transforming himself from the son of a truck driver in Depression Scotland to an international movie icon declared by *People* magazine as "The Sexiest Man Alive." An athletic young man, he dropped out of school at 13 to help support his family and took a series of menial jobs, including coffin polisher and the decidedly un-Bond-like swimsuit model—and added a stint in the British Navy—before drifting into acting.

He flitted about in small roles in British TV and film before heading to Hollywood in the late '50s. His career seemed to be deconstructing like one of Odd-Job's karate boards when in 1962 producer Harry Saltzman chose him over such megawatt stars as Cary Grant to play James Bond in *Dr. No.* (According to one story, Saltzman handed Connery the part of 007 after watching him walk down the street.) As Ian Fleming's international superspy, Connery dashed, gunned, bedded, and martinied his way through six Bond films, mixing in more serious work in films directed by Alfred Hitchcock and Sidney Lumet. His blithe wit, understated swagger, and mordant humor led audiences to identify him with Bond, a position that irked Connery.

Eventually, he became increasingly disenchanted with the cage Bond had put him in, and forged a second career as one of Hollywood's most versatile leading men. He remains, at 70, one of the great movie stars, who commands top dollar and often contributes it to Scottish causes, such as the Scottish National Theater. Yet despite his ardent nationalism, he still received British knighthood in 1999.

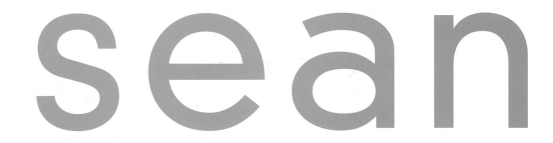

SKIN DEEP

> "Scotland Forever" on one forearm and "Mum and Dad" on the other. Connery comes from an era when tattoos were for sailors and circus freaks, not fashion statements of what you might call mass individualism. For Sean, it was a rite of macho passage—for God's sake, he got it in the Navy. And the sentiments he expresses in his body art—Scottish nationalism and devotion to his working-class folks—aren't likely to show up on your teenage son's anatomy any time soon.

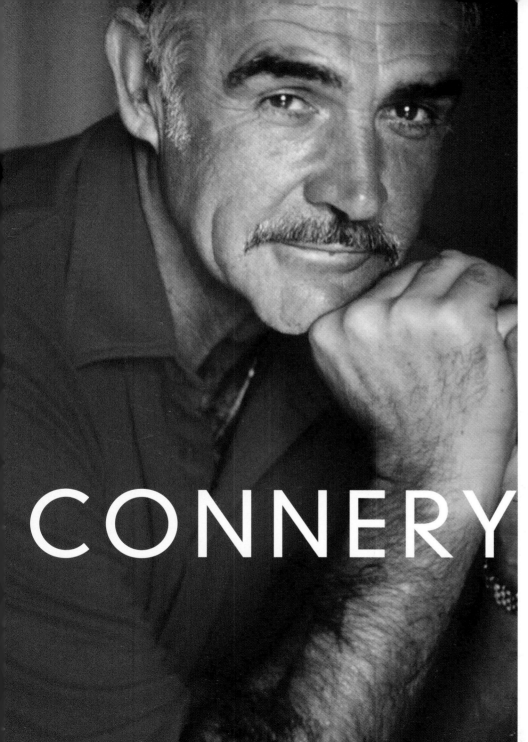

CONNERY

RAW DATA

DATE AND PLACE OF BIRTH August 25, 1930, in Edinburgh, Scotland.

CURRENT RESIDENCE Marbella, Spain.

FILMOGRAPHY (selected) *Finding Forrester* (2000); *Entrapment, Playing by Heart* (1999); *The Avengers* (1998); *The Rock* (1996); *Rising Sun, First Knight* (1995); *Medicine Man* (1992); *The Hunt for Red October, Russia House* (1990); *Indiana Jones and the Last Crusade* (1989); *The Untouchables* (1987); *The Name of the Rose* (1986); *Never Say Never Again* (1983); *Time Bandits* (1981); *A Bridge Too Far* (1977); *Robin and Marian* (1976); *The Wind and the Lion, The Man Who Would Be King* (1975); *Murder on the Orient Express, Zardoz* (1974); *The Anderson Tapes, Diamonds Are Forever* (1971); *The Molly McGuires* (1970); *A Fine Madness, You Only Live Once* (1966); *Thunderball* (1965); *Marnie* (1964); *From Russia With Love* (1963); *Dr. No* (1962).

AWARDS Cecil B. DeMille Award for Lifetime Achievement (1996); Oscar, Best Supporting Actor, *The Untouchables* (1987); Golden Globe for same (1987); Golden Globe, World Film Favorite, Male (1971).

STRANGE BUT TRUE

- Whether playing James Bond, a 1920s Chicago cop, or an avatar from the future, Connery always manages to retain his Scottish accent.
- As a teen, he was a bodybuilding afficionado, and was Scotland's representative in the Mr. Universe contest in 1953, taking third in the Tall Men's Division.
- He started losing his hair at age 16 and wore a toupee in all his Bond films.
- He took dancing lessons for 11 years.
- At 19, he was a nude model at Edinburgh Art College.
- The Mafia once put out a hit on him. In 1958, while starring with Lana Turner in *Another Time, Another Place*, Turner's jealous boyfriend (and hoodlum) Johnny Stampanato confronted Connery, who promptly knocked him out. Not long thereafter, Turner's daughter fatally stabbed Stampanato; the wiseguys thought Connery was involved.
- His younger brother, Neil Connery, is a former actor turned plasterer.

RAW DATA

DATE AND PLACE OF BIRTH June 9, 1963, in Owensboro, KY.
CURRENT RESIDENCE France.
FILMOGRAPHY *Blow* (2001); *The Man Who Cried, Chocolat, The Ninth Gate* (2000); *Sleepy Hollow, The Astronaut's Wife* (1999); *Fear and Loathing in Las Vegas* (1998); *Donnie Brasco, The Brave* (1997); *Dead Man, Don Juan DeMarco, Nick of Time* (1995); *Ed Wood* (1994); *What's Eating Gilbert Grape, Arizona Dream, Benny & Joon* (1993); *Freddy's Dead: The Final Nightmare* (1991); *Cry Baby* (1990); *Platoon* (1986); *Private Resort* (1985); *A Nightmare on Elm Street* (1984).
TV "21 Jump Street" (1987–90); "Slow Burn" (1986).

STRANGE BUT TRUE

- In German, the word "depp" means "village idiot."
- Johnny likes to collect insects and catbird seats.
- A simple X-ray would clear this up: Johnny told a French journalist: "In America, I met real mad and dangerous people ringing my doorbell who are deeply convinced they have been living in my kidneys."
- On the set of *Dead Man*, a fan begged Johnny to come home and mediate his divorce. (And now it's time for "Celebrity Judge!")
- Johnny has some truly idiosyncratic phobias: For one thing, he's afraid of clowns. Also, he says, "I used to have a nightmare that I was being chased through bushes and fronds by the skipper from "Gilligan's Island." I don't know what was on his mind, but it wasn't good. As a kid I was also afraid of [helmet-haired warbler] John Davidson."

johnny

> "I would like for someone to explain to me what 'NORMAL' means. People best accepted in society are the ones I find the most SCARY." <

DEPP

THE INSIDE SCOOP

Teen idol turned artistic maverick, John Christopher Depp III grew up in small-town Kentucky. After his family moved to Florida and his parents divorced, he became an alienated teen who turned to drugs and the electric guitar for solace. He formed a band that toured with Iggy Pop, then moved to L.A., where a brief marriage to makeup artist Lori Allison led to a meeting with Nicholas Cage and, more important, Cage's agent. The next thing Depp knew, he was being sucked through a bed into hell in Wes Craven's *Nightmare on Elm Street* and crawling through 'Nam in a small role in *Platoon*.

He reluctantly took a lead role in a new TV series, "21 Jump Street" only after his agents perversely convinced him that the series, which Depp found beneath his artistic standards, would tank after one season (thus freeing him to tackle more ambitious projects). The show—and Depp's Rushmored cheekbones—made him a cynosure of the Tiger Beat set. In the early '90s, the actor became a tabloid magnet when River Phoenix fatally O.D'd in his nightclub, the Viper Room, and Johnny trashed the presidential suite at New York's swank Marc Hotel.

However, as if he were mining his psyche for inspiration, his acting took a quantum leap in such films as *What's Eating Gilbert Grape, Dead Man, Ed Wood,* and *Donnie Brasco.* In 1996, he bought Bela Lugosi's Hollywood Hills mansion, which apparently was designed with turnstiles through which shuttled fiancées Winona Ryder, Jennifer Grey, Kate Moss, and Sherilyn Fenn. His current consort is singer Vanessa Paradis, with whom he has a daughter, Lily-Rose Melody. Depp continues to pursue quirky, artsy projects, such as Terry Gilliam's *Fear and Loathing in Las Vegas, The Astronaut's Wife,* and Roman Polanski's *The Ninth Gate.* He's due to star with Ryder and Sam Shepherd in Michelangelo Antonioni's *Just to Be Together,* as Jack the Ripper in *From Hell,* and as the 16th-century playwright in *Marlowe,* while searching for a U.S. distributor for his first feature as writer-director, *The Brave,* which premiered at Cannes in 1997.

SKIN DEEP

> Left Arm: His mother Betty Sue's name inscribed within a heart; inverted triangle, something that resembles an "E" on his left hand.
> Right Arm: One more reason to buy stock in laser companies...Depp, in the wake of his breakup with Winona Ryder, had "Winona Forever" altered, somewhat questionably, to "Wino Forever." He also has an Indian head, plus the words "The Brave" doodled on his forearm.
> Right Ankle: Skull and crossbones.

> "They all say I'm a SEX symbol. Just what the world needs, another sex symbol."<

THE INSIDE SCOOP

Proof of God's Existence Finally Revealed!

"I was a large geek," says Taye Diggs of his high school self. "I had nothing. None of the ladies would look at me for a second. I remember going home and praying to God and saying, `I want to be good-looking. I want to have a girlfriend. I want girls to like me.' "

Diggs is perhaps the most vivid example yet of that fatuous showbiz archetype as old as Aeschylus: the geek in hunk's clothing. Only in his mid-20s, he's already a major star lusted after by half the moviegoing public. A man so physically flawless that his black "brothers" accuse him of ruining their lives by being "the perfect man." A dude so irresistible that female strangers pinch his butt at the mall. A guy whose strength and magnetism cause professional actresses to brain-lock—like the unnamed emoter who had to be edited out of a scene in his film, *Go,* when her eyes kept zeroing in on Taye instead of the actor she was supposed to address.

And yet, he's a nerd, a regular guy, what's all the fuss about?

He was born Scott Diggs in New Jersey and grew up in Rochester, NY, the oldest of five children. His mother convinced him to attend the School of the Performing Arts in Rochester. From there he went to Syracuse University, majoring in musical theater. According to the source, he was discovered: (a) performing in a university talent showcase during his senior year; or (b) while singing at Tokyo Disney's Caribbeanland. Whatever.

He then moved to Manhattanland and landed an understudy role in an Off-Broadway production of *Carousel,* then was cast as Benny, the evil landlord, in *Rent.* During this time, he segued into TV, with appearances on "The Guiding Light" and "New York Undercover," among other shows. He was still evicting stage tenants when he received the news that he'd been cast as Winston, Angela Bassett's boy toy in *How Stella Got Her Groove Back.* This featured Taye in perhaps the most notorious shower scene since *Psycho,* which sent America ga-ga over Diggs' sculpted corpus (like they'd never been to a gay gym!). Diggs cemented his fame with back-to-back No. 1 smashes: *The Best Man,* a lame black ensemble film in which he played a novelist, and *House on Haunted Hill.* Industry observers are proclaiming Diggs "the next Sidney Poitier," but despite his lightning-like eminence, he says he's concerned about the lack of opportunity for black actors in Hollywood.

RAW DATA

DATE AND PLACE OF BIRTH 1972 in New Jersey, raised in Rochester, NY.
CURRENT RESIDENCE New York City.
FILMOGRAPHY *The Way of the Gun* (2000); *Go, House on Haunted Hill, The Best Man, The Wood, Mary Jane's Last Dance* (1999); *How Stella Got Her Groove Back* (1998).
TV "Ally McBeal" (2001); "The Guiding Light" (1997-99); "Law & Order," "New York Undercover" (1996).
THEATER *The Wild Party* (2000); *Rent* (1996); *Carousel* (1995).

STRANGE BUT TRUE

- A beleaguered Taye told an interviewer, "I wish there was a school for dealing with becoming famous." (Readers are encouraged to make donations to the Institute for the Recovery of People With Fame, c/o *Celebrity Skin*.)
- "First I wanted to be an inventor, then I wanted to be a pediatrician, then I wanted to be a psychologist, then I wanted to be an actor." With a name like Taye Diggs, it was a wise choice.
- When he got the word that he had landed the role of Winston in *Stella,* he "streaked" around the theater proclaiming it.
- Substance Abuse: He's admitted that, when in high school, he did Jheri Curl.

taye

SKIN DEEP

> Perhaps in an effort to draw even more attention to his perfectly sculpted deltoid (and consequently his body), Taye had what appears to be a Chinese Dao symbol inked on his shoulder. (Sure-fire audition trick: Taye flexes and it dances.)

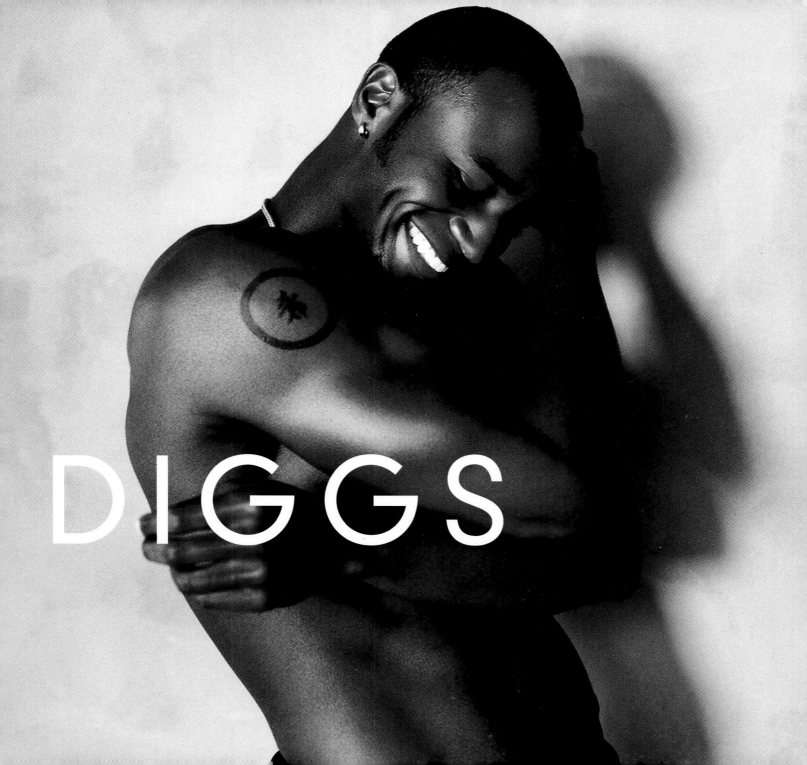

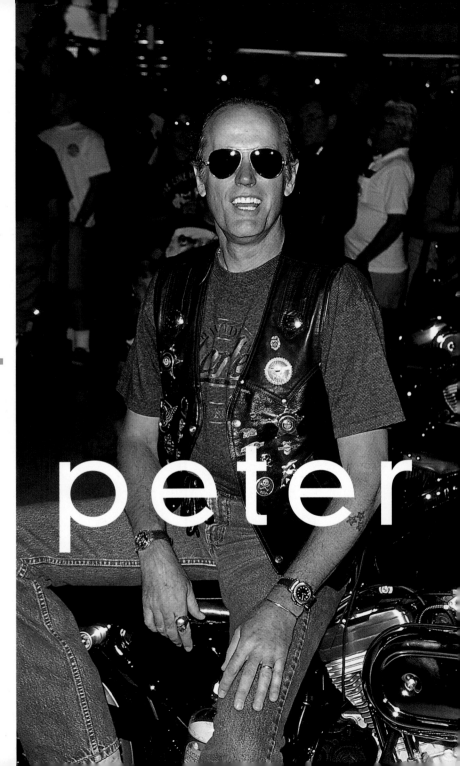

peter

RAW DATA

DATE AND PLACE OF BIRTH February 23, 1939 in New York City. Son of Henry, brother of Jane, father of Bridget.

CURRENT RESIDENCE Paradise Valley, WY.

FILMOGRAPHY *Thomas and the Magic Railroad* (2000); *The Limey* (1999); *Ulee's Gold* (1997); *Escape from L.A.* (1996); *Molly and Gina, Love and a .45, Nadia* (1994); *Deadfall* (1993); *South Beach* (1992); *The Rose Garden, Fatal Mission* (1989); *Mercenary Fighters, A Time of Indifference* (1988); *Hawken's Breed, Signatures of the Soul* (1987); *Certain Fury* (1985); *Jungle Heat* (1984); *Dance of the Dwarfs* (1983); *Spasms, Split Image* (1982); *The Hostage Tower* (1980); *Wanda Nevada* (1979); *High-Ballin', Little Moon and Jud McGraw* (1978); *Outlaw Blues* (1977); *92 in the Shade, Futureworld, Fighting Mad* (1976); *Gone with the West, Killer Force, Race with the Devil* (1975); *Dirty Mary, Crazy Larry* (1974); *Two People* (1973); *The Hired Hand, Idaho Transfer, The Last Movie* (1971); *Easy Rider* (1969); *Spirits of the Dead* (1968); *The Trip* (1967); *The Wild Angels* (1966); *Lilith, The Young Lovers* (1964); *Tammy and the Doctor* (1963).

TV MOVIES "The Passion of Ayn Rand" (1999); "The Tempest" (1998).

DIRECTOR *Wanda Nevada* (1979), *Idaho Transfer* (1973), *The Hired Hand* (1971).

BOOKS *Don't Tell Dad: A Memoir* (1998).

AWARDS Golden Globe, Best Supporting Actor (Series, Miniseries, TV Movie), "The Passion of Ayn Rand" (1999); Golden Globe, Best Actor in a Motion Picture, *Ulee's Gold,* (1997).

STRANGE BUT TRUE

- John Lennon wrote "She Said, She Said" about an acid trip he shared with Peter, during which Fonda kept telling him, "I know what it's like to be dead, man."
- Fonda, a fanatical Harley rider to this day, waffles over doing another biker pic. Quote #1: "The last thing I'm going to make is another biker movie." Quote #2: "I'm the head of a biker club, and this wonderful script has come across my desk and there's bikes in it."
- Possible Title: "Hell's Geriatrics." Their slogan: "Ride Free or Get a Senior Discount."
- Once a symbol of drug-taking rebellion, the elder Fonda recently admitted, "I don't even do decaf." Yet he later gave an interview to *Hemp Times*.
- Too Close for Comfort: In his memoir, Peter speaks of a reconciliation with Henry: "I hugged him so hard I could feel the pacemaker in his chest."
- On his Web site, fondawhite.com, Peter sells memorabilia such as Captain America notecards, a Stars and Stripes helmet, and the original roach clip from *Easy Rider*.

> "Acting is an INNER DRUG. I don't care how bad the movie is, if it's the only one I'm getting that year, I'LL TAKE IT." <

THE INSIDE SCOOP

The sad-sack jester of the Fonda clan, Peter's career seems to have been a valiant but pathetic attempt to disprove the fact that some genes skip a generation. While trying to forge a penumbra outside Henry's mammoth shadow, Peter also had to cope with his stoic neglect at home. Unlike his celebrated sister, Jane, Peter's resume consists of two pillars bookending a long stretch in B-movie purgatory.

Young Peter took some knocks early on: His mother, Frances Seymour Brokaw, committed suicide (although Peter and Jane didn't learn the reason for her death for many years), while Henry went onstage hours afterward. In the aftermath of his mother's death, 10-year-old Peter accidentally shot himself in the stomach.

These traumas didn't deter him from making his Broadway debut in 1961, but it would be eight years later when Fonda and Dennis Hopper, both disillusioned by the homogenous pap Hollywood was dishing up, devised the concept for *Easy Rider* (the story of which could be summarized as Timothy Leary's version of the Tour de France). This low-budget road movie about two motorcyclists who sell a stash of coke and are blown away by rednecks, which Fonda produced and Hopper lensed, seemed to echo the era's turbulent zeitgeist. It was a huge financial success and inspired a wave of even cheaper ripoffs. It should've launched Fonda and Hopper into the cinematic stratosphere, but they squandered their big break—Hopper by making the flatulent, appropriately titled *The Last Movie*, and Fonda by directing and starring in the floppola western *The Hired Hand*.

Fast forward past land minds like *Killer Force, Futureworld,* and *Mercenary Fighters* (and Fonda's variations on his Captain America character from *Rider*) to his '90s comeback when, with performances in *Nadia, The Limey,* and especially *Ulee's Gold,* he convinced the industry that he had Fonda blood after all.

FONDA

SKIN DEEP

> Peter has three stars on his forearm and dolphins on his shoulder, which led to a near-calamity when, while swimming, he became enmeshed in a net cast by Japanese tuna fishermen. He also has a yacht, *Tatoosh,* on which his friends can get contraband tattoos outside of the U.S. territorial limits. It's said that Jane has a tattoo depicting the merger of Time Warner and Turner Broadcasting.

RAW DATA

DATE AND PLACE OF BIRTH September 28, 1964, in Newton, NJ, to Carmine and Joan Garofolo.
CURRENT RESIDENCE Los Angeles.
TV "Indie Outing" (1997); "Comedy Product," "TV Nation" (1995–96); "Saturday Night Live" (1994); "The Larry Sanders Show" (1992–96); "The Ben Stiller Show" (1992–93).
FILMOGRAPHY *Big Trouble* (2001); *The Search for John Gissing, Nobody Knows Anything, Wet Hot American Summer, The Adventures of Rocky & Bullwinkle, The Independent, The Bumblebee Flies Anyway, Dog Park, Steal This Movie* (2000); *Mystery Man, Permanent Midnight, Clay Pigeons, The Minus Man, Dogma* (1998); *Touch, Copland, The Matchmaker, Romy & Michele's High School Reunion* (1997); *Sweethearts, The Cable Guy, Brain Candy, Larger than Life, The Truth About Cats and Dogs* (1996); *Now and Then, Coldblooded, Bye Bye Love, I Shot a Man in Vegas* (1995); *Suspicious, Reality Bites* (1994); *Late for Dinner* (1991).
MUSIC VIDEOS "Shangri-La" (The Rutles, 1996); "Watery Hands" (Superchunk, 1997).
BOOKS (with Ben Stiller) *Feel This Book* (1999).

STRANGE BUT TRUE

- "I get so angry watching television or watching films—just pop culture in general makes me really angry." (So steamed that she feels compelled to make hundreds of TV appearances on, among other shows, "Talk Soup" and "Regis & Kathie Lee.")
- She sometimes performs as her alter ego, Lisa Loeb.
- She once confessed: "I am a sellout, I admit it. I will not pretend. I joined the other side, the wrong team. I am not proud of it. It was a calculated career move." (Later she recanted, claiming she was brainwashed by North Koreans.)
- While filming *Mystery Man*, she started improving by talking to her character's dead father's head, which was inside a bowling ball. (The head later bowled a perfect game, then joined SAG.)
- She feels her current fame is "the precursor to the Janeane Garofalo backlash, which is inevitable."

THE INSIDE SCOOP

What do you do if you're a highly intelligent, acutely perceptive artist who nonetheless craves Hollywood fame? Janeane Garofolo has contrived a canny M.O.: She decries pop culture, yet plasters herself all over the mass media. She purports to deplore the meretriciousness of Hollywood films, while being linked to more bombs than Osama bin Laden. She derides herself for selling out, which, in Hollywood, passes for integrity.

Despite her mother's insistence that she enter Bloomingdale's management-training program, and a series of day jobs that included shoe salesperson, bike messenger, movie-theatre usher, and chat-line moderator, Garofolo has remained true to her comic muse. Out of the no-man's-land of open-mike nights, she forged a brand of humor that fans call "sardonic" and others label "whiny." In 1989, she became a regular on "The Dennis Miller Show" and MTV's "Half-Hour Comedy Hour." A few years later, a chance late-night meeting with Ben Stiller at an L.A. deli led to a part on his new Fox show, and subsequently to featured roles on "The Larry Sanders Show" and in Stiller's 1994 feature, *Reality Bites*. She became a regular on "Saturday Night Live" that year, but her tenure was one big bitch-a-rama, and she left before season's end. Despite this, Garofolo has solidified a busy second-tier career while enduring diet yo-yo's—induced, she claims, by Hollywood execs' anorectic obsession. She also performs at alternative comedy clubs and runs I Hate Myself Productions.

janeane

SKIN DEEP

> In public, Garofolo often adopts her anti-celebrity persona, who dresses in a kind of feminist drag— baggy cords, clunky work boots and, of course, a gallery of tattoos. Celebrity Skin learned that Janeane had four green stars, representing the points of the compass, imprinted around her navel. This operation was performed at the San Francisco Dickens Festival, which would appear to be a cross between Lilith Fair and a Renaissance theme park. She once wore the word "THINK" on her right forearm, but had it renovated because she didn't want to be reminded. The running man on her left forearm was an impulse buy, she says. The rest of her tats are a grab bag of contemporary clichés: a star, Egyptian characters, and a peace sign. Of her tats, Garofolo says, "They're just tattoos I've been accumulating over the years." She keeps them small, because "it's too painful."

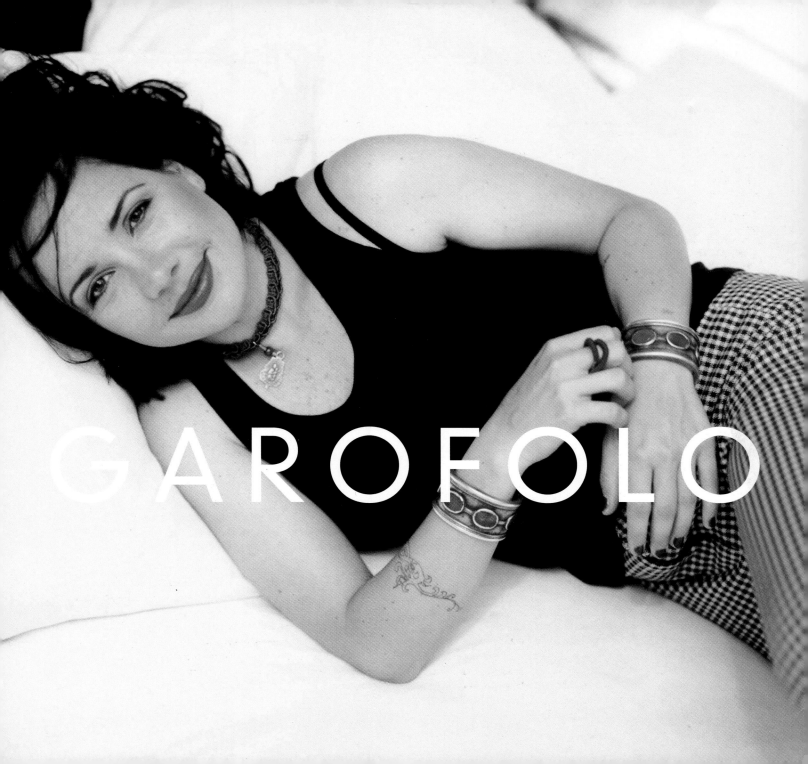

> She's EVERYBODY'S BABY DOLL, a luscious, pansexual WILD CHILD whose rapid ascent to Hollywood icon is matched only by her compulsive, SHOOT-FROM-THE-HIP iconoclasm.<

THE INSIDE SCOOP

The 25-year-old daughter of Jon Voight and Marcheline Bertrand, Jolie has secured her spot in Hollywood's Olympus, a precarious position for a woman who's either admitted to or been accused of self-mutilation, bisexuality, obsessive love, incest, an obsession with death, and suicidal tendencies—and whose most notorious quote is "You're young, you're crazy, you're in bed, and you've got knives, so shit happens."

Indeed, Jolie's personal life is like a John Waters version of *A Star Is Born*. She concluded her first wedding, to Jonny Lee Miller, by writing his name on her blouse—in blood. Her Oscar acceptance speech included the declaration, "I'm so in love with my brother," James Haven—a fact she demonstrated afterward by French-kissing him. (Haven's prior claim to fame was assistant-directing an episode of TV's "Space Cadets.")

Then there's the impulsive Vegas wedding to Billy Bob, which came as a shock to Thornton's live-in girlfriend of three years, Laura Dern. (We know she and Billy Bob have one thing in common: Besides Jolie's many tattoos, Thornton has five of his own.)

Thornton, who's been married four times before and was accused by one ex of physical abuse, expresses such chivalric sentiments toward his new bride as, "I was looking at her sleep, and I had to restrain myself from literally squeezing her to death."

Jolie and Thornton could be a conjugal Krakatoa, and one can only wonder: In the aftermath of a smash-up, who gets custody of the tattoos?

SKIN DEEP

> A dragon, on her left arm. While this mythological creature is a symbol of strength and power, the design is a tad conventional for this uber-sexpot rebel. On the other hand, the dragon is said to possess magical powers, capable of soaring to the heavenly heights, diving to the depths of the sea, and evading hordes of flash-bulbing paparazzi.

> The letter "H" on the inside of her wrist. Jolie has told some interviewers that this tattoo is an homage to her brother, James Haven, but also admitted that it's a tribute to two people close to her that have an "H" in their name.

> A Tennessee Williams quote: "A prayer for the wild at heart, kept in cages," on her left forearm. She says she took her mom to the parlor for this one (perhaps to proofread for typos). Let's just be thankful she didn't decide to inscribe, say, all of *Glass Menagerie*.

> A cross, on her hip.

> A Latin motto, "Quod me nutrit me destruit" ("What nourishes me destroys me"), that curves across her lower abdomen. Jolie has conjectured that

angelina

these ominous words might freeze a seducer in the act of unpeeling her drawers (no doubt forcing him to immediately consult his Virgil).

> A small, blue rectangle on the small of her back. Jolie says that it's a window, and that she plans to recolor it in black, to match the rest of her tattoos. "It's because wherever I am, I always find myself looking out the window, wanting to be somewhere else."

> The words "Billy Bob," etched on her arm and on another, more private, part. The latest additions to the Jolie Body Art Collection, these were commissioned in the heady afterbloom of romance, which started on the set of *Pushing Tin* (she played the wanton hussy wife of Thornton's air-traffic controller).

> She once had a tattoo that read "courage," but had it removed.

> In summation, Jolie declares, "Tattoos and these things that you wear? It's who you are. It's a statement of what stands behind you, what represents you, and where your heart and life are at." (Not to mention a reminder of who you're married to at the time.)

JOLIE

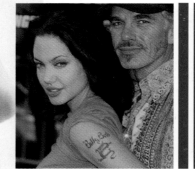

RAW DATA

DATE AND PLACE OF BIRTH June 4, 1975, in Los Angeles.
CURRENT RESIDENCE Los Angeles.
TV "Gia" (1998); "True Women," "George Wallace" (1997).
FILMOGRAPHY *Tomb Raider* (2001); *Gone in 60 Seconds, Dancing in the Dark* (2000); *Girl, Interrupted, Playing by Heart, Pushing Tin, The Bone Collector* (1999); *Playing God, Hell's Kitchen* (1998); *Love Is All There Is, Mojave Moon, Foxfire* (1996); *Hackers, Foxfire* (1995); *Cyborg II: Glass Shadows* (1993).
AWARDS Oscar, Best Supporting Actress, *Girl, Interrupted* (1999); Golden Globe, Best Actress in a Made-for-Television Film, "Gia" (1998); Golden Globe, Best Supporting Actress in a Made-for-Television Film, "George Wallace" (1997).

STRANGE BUT TRUE

- Her first film role as an adult—she did one film as a child with her father—was a supporting role as a human-machine hybrid in the 1993 directly-dumped-to-desperate-Third-World markets sci-fi film, "Cyborg II: Glass Shadows."
- If she couldn't be an actress, she'd run a funeral home or a motel.
- Owns a plaque that reads: "Some days it's not worth chewing through the leather straps in the morning." (Hallmark, where are you?)
- Jolie has sworn that "scars are sexy because it means you made a mistake that led to a mess." To demonstrate, she sports an "X" on her arm, a slice on her stomach, and a faint nick below her jawline.

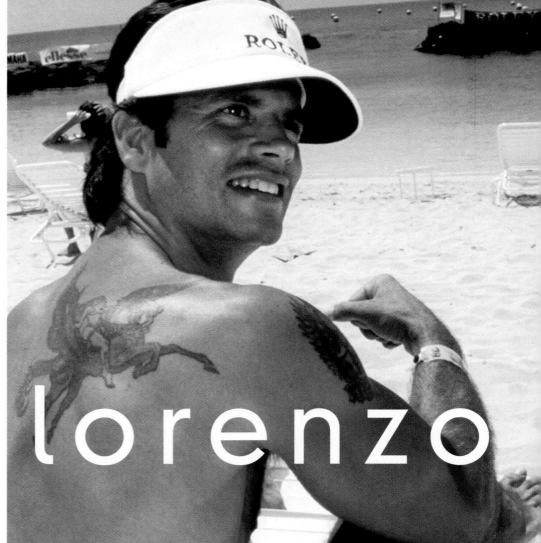

RAW DATA

DATE AND PLACE OF BIRTH January 20, 1958, in Santa Monica, CA.
CURRENT RESIDENCE Los Angeles.
FILMOGRAPHY *Good Cop Bad Cop, Back to Even, Undercurrent* (1998); *Terminal Justice, Blood for Blood, Rage, Midnight Man, Mask of Death, Cybertech P.D.* (1995); *Bad Blood; Gladiator Cop: The Swordsman II, CIA II: Target Alexa* (also directed), (1994); *Final Round* (1993); *Bounty Hunter, CIA Code Name Alexa, SnakeEater 3: His Law* (1992); *Final Impact; Killing Streets; Night of the Warrior, SnakeEater II: The Drug Buster* (1991); *The Swordsman* (1990); *SnakeEater* (1989); *Body Rock* (1984); *Detour to Terror* (1980); *Grease; Takedown* (1978).
TV "The Immortal" (2000); "Air America" (1998–99); "Renegade" (1992–97); "Dancin' to the Hits" (1986); "Falcon Crest," "Secrets of Midland Heights" (1980); "California Fever" (1979); "Harley Mania" (as a celebrity rider) (1998).
VIDEOS "The Lorenzo Lamas Self-Defense Workout"; "The Joy of Natural Childbirth" (a.k.a. the Lamas Class).
AWARDS Not even in L.A. . . .

STRANGE BUT TRUE

- In one Pirandellian episode of "Renegade," Lorenzo and his real-life ex-wife, Kathleen Kinmont, who play bounty hunters posing as husband and wife, agreed to a plot twist in which they get romantically involved.
- The Next Unabomber: One fan holds a "Lorenzo Lamas Birthday Countdown" on his tribute site.
- Renaissance Man: A Web search for Lamas also brings up Lorenzo de Medici.
- Quiz: The Lorenzo Lamas Ride For Life bike race:
 a. Raises money to send tattoos to needy Third World Hell's Angels;
 b. Will soon become an Olympic event;
 c. Aids the World Children's Transplant Fund, which provides organs to needy Third World children.
- A "life-size" cardboard cutout of Lorenzo is now available for $29.95. Producers of his TV show immediately went out and bought a dozen.

lorenzo

>Dalai Lama SEZ meditate!: "My interpretation of EASTERN PHILOSOPHY is: You count to three and look before you leap."<

THE INSIDE SCOOP

One of the unintended benefits of the Genome Project will be the discovery of a B movie acting gene. This will scientifically establish the transmission of a specialized kind of ineptitude exemplified by Fernando Lamas and his son, Lorenzo.

The son of Fernando Lamas and Arlene Dahl, Lorenzo was born in Pacific Palisades but raised mostly in New York. He attended Admiral Farragut Academy (then went to the Manhattan Institute of Tanning Arts), after which he moved back to California. Encouraged by his pop, he entered Tony Barr's Film Actors Workshop. Although his career began inauspiciously in 1976, Hollywood execs and investors looking for tax shelters couldn't long resist his burnished pecs, flowing locks, and vacant stare.

Soon Lamas was playing Lance Cumson on "Falcon Crest" and starring in B action flicks, usually playing a disaffected CIA agent who rides a Harley (or some variation thereof). In the 1990s, he starred in "Renegade," portraying Reno Raines, a grammatically challenged, Harley-riding fugitive "who travels doing good for those who were done wrong."

On the personal side, Lorenzo lists "Marriage" under the "Special Skills" section of his resume, with four brides already to his credit: Victoria Hilbert; "Falcon Crest" publicist Michele Smith (with whom he had two kids); Kathleen Kinmont, daughter of his "Falcon Crest" co-star Abby Dalton (the nuptials were staged at the Elvis chapel in Vegas); and ex-Playmate Shauna Sand, with whom he has two kids, Alexandra Lynne and Victoria. "Falcon Crest" co-star Daphne Ashbrook also used the Lamas Method, and unless those geneticists can find a cure, we're sure to suffer a third generation of Lamasian camp.

LAMAS

SKIN DEEP

> Four. A winged crest high on his left arm that could be product placement for Harley Davidson, an eagle on his right arm, and Pegasus on his back "The last one I got for my [wife]...we both got the same Tahitian eternal love tattoo," Lorenzo said.

THE INSIDE SCOOP

Self-promoting starlet McGowan (celebrity bar code #00738431) is best known for arriving at the 1998 MTV Video Music Awards on the arm of now ex-fiancé Marilyn Manson, wearing a rhinestone-studded see-through dress. (One of the perks of being Manson's S.O. is you get to raid his closet.)

This self-consciously bad girl was born in Italy and raised in the local chapter of the Children of God cult (the same talent factory that produced River and Joaquin Phoenix). Then her father ran off with the nanny (with God's blessing, of course), and her mother moved the family to Seattle. She attended art school, then beauty school, then the school of hard knocks, fleeing home at 13 and sleeping on the streets or in nightclubs.

McGowan became an emancipated minor in 1991 (No More Homework!), and realizing her dysfunction needed a much bigger canvas, moved to L.A. In 1994, after bit parts in *Encino Man* and the TV show "True Colors," a casting agent spotted her on the sidewalk and transformed her into the angry young speed queen, Amy Blue, in Gregg Araki's *The Doom Generation.* Next she played blond bigmouth Tatum Riley in *Scream,* which was followed by starring roles in the remainder-binned Dean Koontz adaptation *Phantoms* and the indie release *Going All the Way.* Her best-known role is Courtney Shane, the Satanic dictatrice of Ronald Reagan High in the dark comedy *Jawbreaker.* Even so, it was her former engagement to right-wing, S&M glam rocker Marilyn that boosted her Q factor higher than, say, Dave Manson (a journeyman defenseman for the Toronto Maple Leafs).

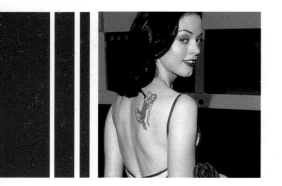

rose

SKIN DEEP

> McGowan wears her viperesque ambition on her back—in the shape of a negligee-clad siren, the kind of instinctual man-slaying force of nature Rose wants half of us to think she is. The other half thinks she's being ironic. She also sports a narrow band around her left bicep.

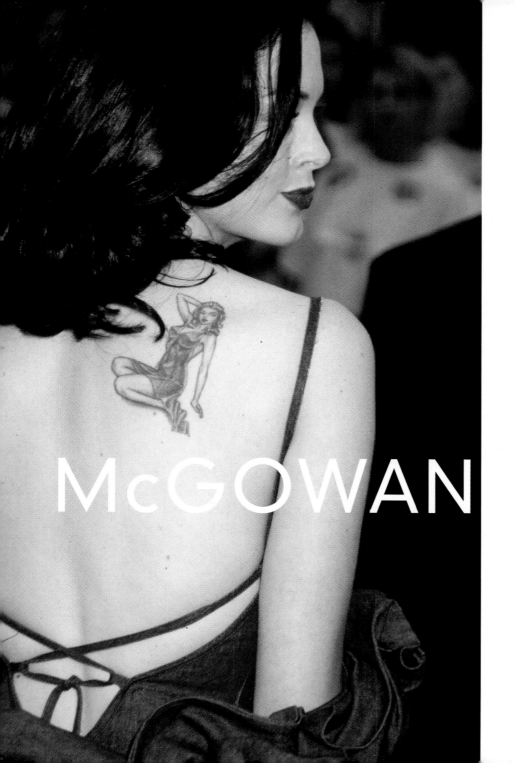

McGOWAN

RAW DATA
DATE AND PLACE OF BIRTH December 13, 1974, in Florence, Italy.
CURRENT RESIDENCE Los Angeles.
FILMOGRAPHY *Monkeybone, Ready to Rumble* (2000); *Jawbreaker* (1999); *Phanthoms, Lewis and Clark and George* (1998); *Going All the Way* (1997); *Scream* (1996); *The Doom Generation* (1995).
VIDEOS She appeared in Imperial Teen's "Yoo-Hoo."

STRANGE BUT TRUE

- Natural Born Liar: "I have killed my family so many times to get out of school and stuff. I got out of an apartment lease by saying my father had a brain tumor. I was sobbing hysterically, mind you. And my grandmother 'died' so many times…"
- Rose alarmed her parents so much they sent her to a drug rehab program, even though she never did drugs. (She was eventually discovered and told not to come back until she was hooked.)
- Quick, Somebody Call the Vatican!: McGowan says, "I have a terrible overempathy thing. I can't even go through the drive-through at Taco Bell without thinking, 'Oh my God, this woman is waiting on me, and she's got eight kids at home all living in one bedroom. My life is constant guilt, thinking, 'I should have tipped the waiter more,' or putting quarters in other people's parking meters."
- Biting the Hand Dept.: She says of the many adulatory fan Web sites, "I always look at them on a day when I'm at home with the flu and my hair is sticking up and I'm wearing old frumpy pajamas, and I'm like, 'Ha ha ha!'"
- Let the Games Begin: She was a part of the Great Guinness Toast 2000, the largest simultaneous such event ever. Alcoholics from 183 countries participated, and anyone who passed a breathalizer test was disqualified.

RAW DATA

DATE AND PLACE OF BIRTH December 19, 1972, in Brooklyn, NY. Her father, Tom Milano, is a music composer and her mother, Lin, is a former fashion designer. Younger brother, Cory, is 18.

CURRENT RESIDENCE Los Angeles.

TV "Charmed" (1998–present); "Gold Rush" (1998); "Melrose Place" (1997–1998); "To Brave Alaska" (1996); "The Surrogate" (1995); "Candles in the Dark," "The Long Island Lolita Story," "Casualties of Love," "Confessions of a Sorority Girl" (1993); "Crash Course," "Dance 'til Dawn" (1988); "Who's the Boss?" (1984–1992).

FILMOGRAPHY *Hugo Pool, Below Utopia* (1997), *Glory Daze, Fear, Jimmy Zip* (1996), *Commando, Deadly Sins, Poison Ivy II, Public Enemies* (1995); *Embrace of the Vampire* (1994), *Conflict of Interest, Double Dragon, The Webbers* (1993); *Little Sister, Where the Day Takes You* (1992); *Speed Zone!* (1989); *The Canterville Ghost* (1986); *Old Enough* (1984).

STRANGE BUT TRUE

- Even though she's a star of one of the biggest hits on TV, has appeared in movies, and has many Web sites devoted to her, she says she can't get a date. Maybe it's because...
- She prefers men's underwear: "Women's underwear goes up your butt."
- Her mom runs a company, Cyber-Trackers, whose goal is to purge nude celebrity photos—including some of her daughter—from the Internet. (If you think there are manipulated nude images of you on the Web, you can pay Mama Milano $2,000 to help remove them.)
- She claims she doesn't remember anything about "Who's the Boss?" "People always ask me what my favorite episode was, and I can't say because it's all such a blur," she says. "I don't remember the lines or anything. It's weird. It's like they're the lost years."
- According to a German fan site, her middle name is "either Lyssa or Conan" (depending on what kind of underwear she has on that day).
- Her favorite book is *Animal Farm* (second choice: *The Tao of Danza*).

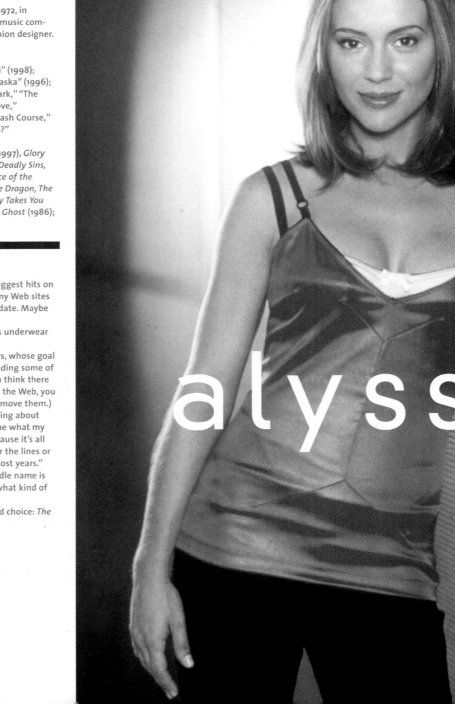

alyssa

> "It's nice to be IMPORTANT, but it's important to always be NICE." (Originally attributed to Joseph Stalin.)<

THE INSIDE SCOOP

At age 7, her parents took her to see the Broadway Annie, and Alyssa told them, "I'm going to do that." A year later, she was playing the role of July in that same play. Twenty years later, she was posing with a buck-naked man in the back of a stretch limo for Candie's Fragrances.

At age 11, she snagged the role of Samantha Micelli on "Who's the Boss?" after the producers came to Brooklyn looking for "an authentic" Italian dynamo to play Tony Danza's daughter. She played Samantha in the series from 1984 to 1992, and won three Youth in Film Awards (the Pubescent Oscars) for Best Supporting Actress.

In her teens, Alyssa recorded five albums in Japan, all of which went platinum, and once performed before 40,000 fans at a Tokyo music festival. (And you wonder why they want to restore the Emperor?)

She made her feature film debut a year earlier in Old Enough, and worked mainly in films from 1992 to 1997. That year, she was cast as Jennifer Mancini, the devious younger sister of the odious Dr. Michael Mancini, in "Melrose Place," a role she held for a year.

In 1998, she joined the cast of the show "Charmed," a "Charlie's Angels"-meets-"Bewitched"-via-"Buffy the Vampire Slayer" concoction also starring Shannen Doherty.

In 1999, she married Cinjin Tate of the L.A.-based band Remy Zero. Citing irreconcilable differences (their tattoos didn't match), they divorced that same year.

MILANO

SKIN DEEP

> She has five tattoos. Rosary beads on her back, a vine of flowers on her right ankle, an angel holding a cross with her ex-fiancé's initials, "SRW," on her left ankle (she now says it stands for Single Rad Woman), a fairy on her stomach, and a big sacred heart on her lower back. She says, "I've always gotten them at times when I was sad about something...relationship problems or the fact that it had rained every day for a month." She feels tattoos are a form of rebellion because "I mean what else are we supposed to do? We can't do drugs anymore, and we can't have careless, fun sex, right?" (When this news hit Wall Street, the Dow dropped 5,000 points.) Her mom has a tattoo on her back; maybe it's genetic.

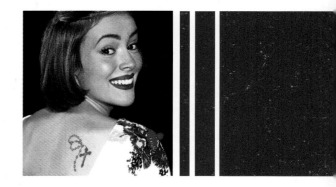

>"I have life RAGE. I'd say that, deep down, I'm very DISILLUSIONED. I've been that way for a very long time."<

THE INSIDE SCOOP

Although she's just 20, it seems as if the fleshy-hipped, saucer-eyed Christina Ricci has been with us forever. The precociously jaundiced actor's big break occurred when a local theater critic happened to catch the 8-year-old in a New Jersey grade school production of *The Twelve Days of Christmas.* Two years later she was sharing face time with Cher, playing her youngest daughter in the 1990 feature *Mermaids.* Impressed director Barry Sonnenfeld made her famous when he chose her to play Wednesday in *The Addams Family.* From that point, Ricci worked constantly, sublimating into films an adolescent rage that, her mother said later, would've landed her in Troubled Teen Land. Instead, Christina not only was serving her muse, but also was able to forego traditional education; while doing a film she engaged a tutor, and in between attended the exclusive Professional Children's School. For a while she was careering from one juvenile pic to the next, but her performance as a troubled teen experimenting with sex in *The Ice Storm* redirected her career. She's solidified her reputation for doing provocative, offbeat work with films such as *Desert Blue,* John Waters's *Pecker,* Vincent Gallo's *Buffalo 66,* and *Prozac Nation.*

christina

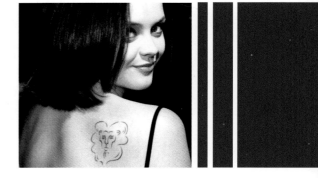

SKIN DEEP

> Wild child Ricci thrives in flora and fauna. Mr. Lion prowls on her shoulder. She has been meaning to have it done for over two years, ever since she found a piece of cardboard with a doodle of a lion on it at a cash machine. It reminded her of Aslan, a character from C.S. Lewis's *The Chronicles of Narnia.* "Ever since I was little," she says, "I've loved the Narnia Chronicles." In fact, Ricci used to carry copies of the book in her bag and give them to people impulsively. A bat hangs from her bikini line. A bouquet of sweet peas flowering on her lower back is the work of famed Vancouver tattoo artiste Thomas Lockhart. She commissioned it while filming *Prozac Nation* in British Columbia.

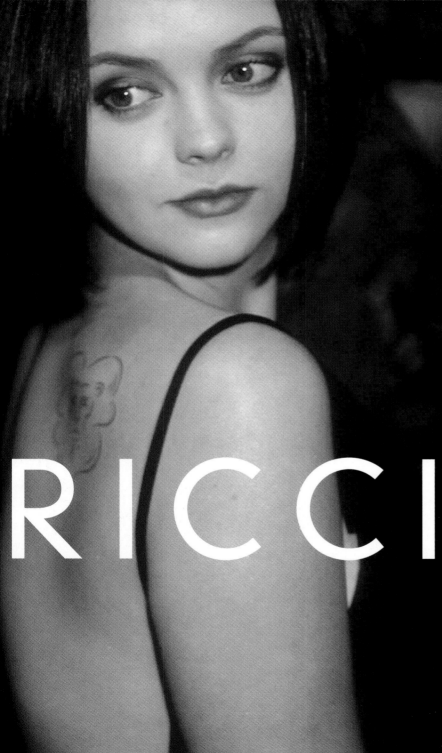

RICCI

DATE AND PLACE OF BIRTH February 12, 1980 in Santa Monica, CA.
CURRENT RESIDENCE New York City.
FILMOGRAPHY *Prozac Nation* (2001); *The Man Who Cried, Bless the Child* (2000); *Sleepy Hollow, Desert Blue, 200 Cigarettes* (1999); *Fear and Loathing in Las Vegas, The Opposite of Sex, Buffalo 66, Pecker* (1998); *Little Red Riding Hood, The Ice Storm, That Darn Cat* (1997); *Casper, Gold Diggers: The Secret of Bear Mountain, Now and Then* (1995); *The Cemetery Club, Addams Family Values* (1993); *The Addams Family, The Hard Way* (1991); *Mermaids* (1990).
TV "Bastard Out of Carolina" (TV movie, 1996).

STRANGE BUT TRUE

- Her S.O. is Matthew Frauman, an actor-waiter hyphenate (who wrote the best-selling self-help book for unemployed performers, *The Waiters' Way*).
- All About Eve Dept.: A critic's son was originally cast in Christina's Christmas pageant role, but Ricci provoked the kid into hitting her, then snitched on him. As part of his punishment, he had to forfeit the role.
- Human Rights Watch: "I get annoyed very easily, especially when I'm working. You sit in a chair, and someone puts makeup on you for, like, an hour and does your hair for, like, another half hour."
- "I have only three friends, and two of them are actors." Do the math.
- Vincent Gallo, who used Ricci in the aftermath of *Buffalo 66,* says his next project is a musical about Charlie Manson (*Helter Belter*).
- Christina's mom, Sarah Ricci, is a real estate agent and her dad, Ralph Ricci, is a primal-scream therapist. ("LOCATION, LOCATION, LOCATION!!!!")
- Cher says that she and Ricci are still close pals. "We're kind of kindred spirits," the 50-something inflatable celeb explains. (Note to Cher: Read *Passages*.)

RAW DATA

DATE AND PLACE OF BIRTH July 16, 1953 in Schenectady, NY. His father was an Irish caretaker and amateur bodybuilder and his stepfather a policeman.

CURRENT RESIDENCE Venice Beach, CA. **FILMOGRAPHY** *Animal Factory, Get Carter* (2000); *Thicker Than Blood, Buffalo '66, Point Blank* (1998); *Bullet, Double Team, Exit in Red, Another 9 1/2 Weeks, Love in Paris, The Rainmaker* (1997); *Fall Time* (1995); *The Last Ride, Francesco* (1994); *The Last Outlaw* (1993); *White Sands* (1992); *Harley Davidson and the Marlboro Man* (1991); *Wild Orchid, Desperate Hours* (1990); *Johnny Handsome, Francesco* (1989); *Homeboy* (1988; received a writing credit); *Angel Heart, Barfly, A Prayer for the Dying* (1987); *9 1/2 Weeks* (1986); *Year of the Dragon* (1985); *The Pope of Greenwich Village* (1984); *Eureka, Rumble Fish* (1983); *Diner* (1982); *Body Heat* (1981); *City in Fear, Fade to Black, Heaven's Gate, Rape and Marriage: The Rideout Case, Act of Love* (1980); *1941* (1979).

AWARDS Best Supporting Actor, National Society of Film Critics, *Diner* (1982).

STRANGE BUT TRUE

- When Pal, the canine companion of a nearly blind 84-year-old L.A. woman, was found mutilated, Rourke and other celebs held a candlelit vigil for the pooch. Then they held one for Rourke's career.
- On male bonding with Tupac Shakur: "There was just this unspoken thing that two men feel and understand. I look at him and think, 'Yeah, this motherfucker would pull the trigger on me.'"
- He has admitted: "I pray to St. Jude all the time because that's who I feel safe about—the one with the miracles." A spokesperson for the saint claimed that not even Jude could help Rourke.
- Rourke is a gay rights advocate of sorts, as he once declared, "If I was gay, I'd be the biggest homo around."
- On the set, he has been known to demand carrot juice that is no more than six minutes old. (Quick, before my latest release goes to video!)

mickey

>"People think I do DRUGS, that I punch people out. They think I have horns coming OUT OF MY HEAD."<

THE INSIDE SCOOP

The job history of Philip Andre Rourke, Jr.—attack dog trainer, linoleum layer, amateur boxer, chestnut vendor, handyman in brothels and transvestite nightclubs, and star of *Harley Davidson and the Marlboro Man*—reads like an HR nightmare.

Mickey Rourke's odyssey has taken him from the back streets of Miami to the backstabbing boardrooms of Hollywood, and halfway home again. Rourke was a break-neck street kid who at age 11 began to channel his adolescent energy into boxing. He fell into acting when a classmate tipped him to a role in a school play, and he eventually studied at the Actors Studioin New York City. Within a few years his junkyard puppy mug was appearing in films such as *Body Heat,* followed by star turns in *Diner, Rumble Fish,* and *The Pope of Greenwich Village.* Yet not long after the apex of his popularity, Rourke's belligerent reputation, underscored by a series of box office depth charges, sent his career into twilight, and the film *9 1/2 Weeks* seemed to refer to its length.

In the late 1980s, posturing as an artiste scorned by philistines, Rourke returned to Miami and resumed his pugilistic career, which culminated in the alleged knockdown of his wife and *Wild Orchids* co-star, Carre Otis (protested by Otis's manager, Kate Moss).

Not long afterward, the bad-boy-cum-basket-case checked himself into the psychiatric ward at Cedars Sinai Hospital in L. A. after either an "anxiety attack" (his version) or suicide attempt (tabloid version). Let's go with the tabloids: After he told worried friends he wanted to go to the big trailer in the sky, Rourke was placed under 24/7 surveillance and stripped of his shoelaces, belt, and all sharp instruments. (He was allowed to keep his films.)

After his house was repossessed, a financially strapped Rourke returned to movie acting, yet continued to boor his way through life, destroying a $5,000-a-night suite at the Plaza Hotel, a house rented to him by an L.A. woman, and what was left of his professional status. He was last seen attempting a comeback in *The Rainmaker* and other films.

R O U R K E

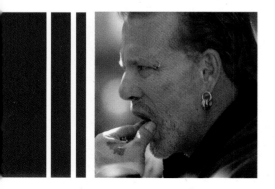

SKIN DEEP

> He has a bull's skull with four feathers on one bicep. In ancient Zapotec culture, this was branded on an over-the-hill shaman who consistently misinterpreted communal dreams. On his other arm is a standard cross. He's said to have four others, but they're fading so badly, they need to go into tattoo rehab. Rourke also sports earrings, which make him look like a suburban bartender.

> On his first of FIVE MARRIAGES: "I went BOWLING one night and ended up married. It was one of those deals."<

THE INSIDE SCOOP

He doesn't sleep. He barely eats. But a healthy diet of nicotine, coffee and champagne, combined with (presumably, if you believe the tabloids) lots of wild sex with his new wife, "Angie," keeps this Arkansas native churning out ideas. After a lethargic start, Billy Bob's career catapulted into the Hollywood history books when he took home the oh-so-coveted Oscar for his work on the 1996 character study, *Sling Blade* (he wrote, acted, and directed). His work acting in such films as *A Simple Plan* and the Cohen Brothers' upcoming *The Barber Project,* in addition to directing *All the Pretty Horses* helped him gain even more credibility and creative clout.

He's now aiming to add the "musician" moniker to his actor-writer-director status, and has been spending countless hours in the recording studio crooning alongside such established singers as Johnny Cash and Peter Frampton. The lyrics to his songs are heartfelt, moody ditties—the stuff of cry-in-your beer country—and it's altogether fitting that they come from this southern-fried auteur: *Time keeps dragging by, but she ain't coming home at all.*

Speaking of coming home, speculation about the state of Billy Bob and Angie's union has become prime tabloid fodder. With no engagement to speak of, the couple exchanged vows with little fanfare in May 2000 at the Little Church of the West in Las Vegas (it just so happens that the track record for celebs married there is pretty poor). Shortly thereafter, they splashed out in the media, detailing the intensity of their sex life. Jolie goes to London for an extended stay to film *Tomb Raider,* leaving hubby behind in their new L.A. digs. Enter rumor mill: They want to renew their vows. They are no longer together. Jolie attends the Oscars in March sans Thornton. Thorton is hospitalized for being severely run down, and Jolie rushes to be by his side. The latest and juiciest: Jolie throws a tantrum when asked at a photo shoot to take off the glass ball pendant she's wearing. Evidently, it's sentimental: "This is my husband's blood!" she snarled. Sounds like Girl, Infatuated.

billy bob

SKIN DEEP

> Billy Bob has a number of tattoos—at least six on his arms (three right, three left) and some on his lower back/hip. The name of Wife No. 4, "Pietra," appears in script on one bicep. We really want to know where "Angie" appears...

THORNTON

RAW DATA

DATE AND PLACE OF BIRTH August 4, 1955, in Hot Springs, AR.
CURRENT RESIDENCE Los Angeles.
TV "King of the Hill" (1997); "Ellen" (1994); "Evening Shade" (1990); "Matlock" (1986).
FILMOGRAPHY *Bandits, The Barber Project, Daddy and Them* (2001); *Wakin' Up in Reno, The Last Real Cowboys, South of Heaven, West of Hell* (2000); *Franky Goes to Hollywood, Pushing Tin* (1999); *A Simple Plan, Homegrown, Armageddon, Primary Colors, A Gun, a Car, and a Blonde* (1998); *The Winner, U Turn, The Apostle, Wag the Dog* (1997); *Dead Man, Out There, Sling Blade* (1996); *Ghost Brigade* (1995); *On Deadly Ground, Floundering* (1994); *Tombstone, Trouble Bound, Indecent Proposal, Bound by Honor* (1993); *One False Move* (1992); *For the Boys, Chopper Chicks in Zombietown* (1991); *Hunter's Blood* (1987).
WRITING/DIRECTING/PRODUCING *All the Pretty Horses* (director, producer), *The Gift* (writer) (2000); *A Family Thing* (writer), *Sling Blade* (writer, director) (1996); *One False Move* (writer) (1992).
AWARDS Golden Globe nominee, Best Supporting Actor, *A Simple Plan* (1999); Oscar, Best Adapted Screenplay, *Sling Blade*; Oscar nominee, Best Actor, *Sling Blade* (1996).

STRANGE BUT TRUE

- Billy Bob's mother, a psychic, predicted he would work with Burt Reynolds. (Her premonition was realized in 1990 when he did three episodes of CBS's "Evening Shade.")
- Field of Dreams: A hometown baseball hero, Billy Bob scored a Major League tryout at age 18. A wild ball took him out, and he broke his collarbone.
- At age 7 months, Billy Bob tipped the scales at 30 pounds, setting a record in Alpine County. Years later in L.A., he would be admitted to the hospital, emaciated from malnutrition.
- Been There, Done That: His odd jobs include working on a screen-door assembly line, as a farmhand, a nursing home attendant, collections agent, and drummer in a band.
- Home Sweet Snakepit: The couple's new $3 million home in Beverly Hills used to be owned by former Guns N' Roses drummer Slash, who kept snakes all over.
- Dem Carnies Sure Are on to Sumptin': Billy Bob was quoted in *Esquire* as saying he "always wanted to fuck a midget."

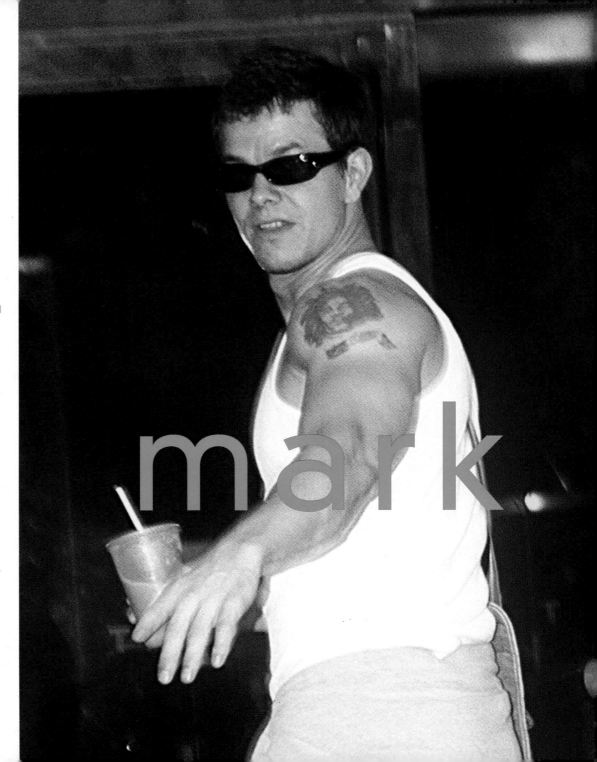

RAW DATA

DATE AND PLACE OF BIRTH June 5, 1971, in Dorchester, MA. Younger brother of New Kids on the Block's Donnie Wahlberg.

CURRENT RESIDENCE Los Angeles.

FILMOGRAPHY *The Truth About Charlie* (2001); *The Perfect Storm, The Yards* (2000); *The Corrupter, Three Kings* (1999); *The Big Hit* (1998); *Traveller, Boogie Nights* (1997); *Fear* (1996); *The Basketball Diaries* (1995); *Renaissance Man* (1994).

RECORDINGS *You Gotta Believe* (1992); *Music for the People* (1991); singles: "You Gotta Believe" (1992); "Good Vibrations" (1991).

VIDEOS "Wildside," "You Gotta Believe," "I Need Money."

STRANGE BUT TRUE

- The Eleventh Commandment: After Wahlberg was cast in the Charlton Heston role in Tim Burton's remake of *Planet of the Apes*, Moses said unto him: "He's got to have them design some fake naked feet, or he'll get killed running around on the rocks."
- Say It Ain't So!: Wahlberg now admits that he was kicked out of the New Kids "because I couldn't sing. They can't either. It's all lip-synched."
- Best Stage Direction: In *The Big Hit*, the director called him up and asked if he could jump off a building. (And they weren't even shooting that day.)
- Wahlberg's written and made three short films: *GHB* is about a Chippendale's dancer involved in a murder; *Damn Van Damme* is about a guy who tries to assassinate the action star; and *Gotta Get Off Donkey Kong* is the tragic saga of a video game addict.

> On the transience of TEEN IDOLDOM: "Everybody knows that little girls grow up. Next thing you know, they're into Marilyn Manson." <

THE INSIDE SCOOP

Mark Robert Michael Wahlberg—ex-musician, ex-model, ex-con—was nurtured by the mean streets of proletarian South Boston and by his early teens had worked his way up to juvenile delinquency. At 16, he assaulted a Vietnamese man and went to the finishing school for rappers called Da House of Detention. Luckily, Mark had for a role model older brother Donnie, who had scrabbled his way out of the low life and helped establish the group New Kids on the Block.

After decarceration, Mark briefly joined the New Kids, then formed his own band, Marky Mark and the Funky Bunch (which unfortunately sounded like a Saturday morning cartoon show). As a rapper, he released two albums—the platinum-selling *Music for the People* and the tin *You Gotta Believe*. He became an MTV favorite and even was dubbed the "thinking rapper's Madonna" (three words you'll never see in the same sentence again). For his choreographer, Mark must've hired a flasher, for his signature stage move was dropping his drawers. However, this inspired in Calvin Klein a "Eureka" moment, and soon Marky's brief-bulging bod was suggestively plastered over many a billboard.

Declining record sales and accusations of homophobia dogged Wahlberg, though, and he segued into movies in the mid-'90s. He specialized in streetwise roles—a junkie dropout in *The Basketball Diaries,* a small-time thug in *Traveller,* a hit man in *The Big Hit.* Then Paul Thomas Anderson cast him in *Boogie Nights* as Dirk Diggler, a porn star with an endowment bigger than Carnegie's (conveyed with a prosthetic penis). Wahlberg and the film so impressed critics that his musical past evaporated in the heat generated by his new career. He has since gone on to star in the ambitious *Three Kings, The Yards* (a prison pic to which he brought first-hand experience), and *The Perfect Storm.* Recently, he's floated rumors of a return to music.

WAHLBERG

SKIN DEEP

> Wahlberg's body hosts a postmodern art exhibit: On one shoulder he's inscribed his initials and surname; from the other stares Bob Marley. He wears an ink-stained rosary around his neck. Sylvester chases Tweety around his ankle. Who knows what it all means…

RAW DATA

DATE AND PLACE OF BIRTH May 2, 1975, in London.
CURRENT RESIDENCE London.
CREDITS Manchester United, English Premier League, 247 appearances, 46 goals (1992–2000).
TEAM ACCOMPLISHMENTS Champions League winner, F.A. Premier League winner, F.A. Cup winner (1999); F.A. Premier League winner (1997); F.A. Charity Shield winner, F.A. Premier League winner, F.A. Cup winner, (1996); F.A. Youth Cup runner-up (1993); F.A. Youth Cup winner (1992).

STRANGE BUT TRUE

- Manchester United turned down a record $56.7 million bid for Beckham by Italian side Fiorentina.
- On February 22, 1997, Beckham scored a tying goal against Chelsea. The shot was measured at 97.9 m.p.h.
- Too many headers have addled Beckham's noggin: After signing a million-pound endorsement deal with Brylcreem, he shaved off his famous blond locks, forcing the hair-gunk maker to void the deal.
- A school games teacher said of Beckham: "If you stuck a girl and a ball in front of David he'd pick up the ball." And tackle the girl.
- Red Card for Swinging a Prada Bag: When asked to describe his strengths, pretty-boy Beckham replied, "Shopping."

david

THE INSIDE SCOOP

You're racing downfield, your cleats tearing clumps of pitch from the field. You spot your teammate along near the penalty kick marker and, with two defenders hounding you, float across a long, arching ball that lands right at his feet. As he boots in the goal, the crowd of 100,000 roars with ecstasy, and yet you know they're all thinking just one thing: What a pass by Mr. Posh Spice!

Such is David Beckham's dilemma. Despite being considered the world's greatest crossing midfielder and one of the elite players in contemporary soccer, Beckham is better known as the marital appendage of pop warbler Victoria Adams. A footballing prodigy, he joined Manchester United's youth team at 16 and immediately showed his innate genius at passing and a chess master's ability to create set pieces. He made United's first team in 1996, scoring seven goals. The following year, Beckham became a worldwide star when he scored an implausible goal from 60 yards out against Wimbledon. He also made the English national team that year, and riveted further attention when he swept Victoria

(Posh Spice) Adams off the rack. Beckham's notoriety was cemented at World Cup '98 in France. The English coach, Glenn Hoddle, initially chose to use him as a sub, but after a remarkable free kick goal against Colombia, Beckham joined the starting squad. In a quarterfinal match against Argentina, Beckham was ejected for fouling Diego Simeone, and when England lost the match, the rabid British tabloids pilloried him as the Neville Chamberlain of football. Many thought the defamed Beckham would succumb to the pressure—indeed, rumors had him jumping to Spain's Real Madrid club—but he bravely decided to return to the Premier League and face the vituperative English fans.

By the end of the 1998–99 season, he'd become one of the biggest heroes in England, leading United to the F.A. Cup and the European championship. That same year, he married Posh, and their son, Brooklyn, was born. Yet gratitude is in short supply in English Premier League: Posh's Robin Leach-y lifestyle has strained Beckham's relations with Manchester's coach, Sir Alex Ferguson, who's accused Beckham of living an "arrogant playboy lifestyle."

BECKHAM

SKIN DEEP

> Long before Beckham named his son "Brooklyn," he was fond of the name and had it tattooed across the small of his back. You see, it's part of his embarrassing "White Nigger" fascination with hip-hop culture. First he named his rottweillers Snoop and Puffy. Then, according to one Afro-British publication, he tattooed a huge crucifix on his back—in homage to Tupac

Shakur—and liberally displayed it to paparazzi in a pose imitative of the rapper's stance on his album, *Me Against the World*. Another writer claimed that Beckham christened his son Brooklyn in deference to Tupac's rival Biggie Smalls, who was born there. "It's like the East Coast-West Coast rap rivalry is being fought out on Beckham's back," said the reporter.

> A Toronto RAPTORS official after that team traded Camby to the KNICKS: "I'll give it a month till Patrick (Ewing) PUNCHES him in the head."<

THE INSIDE SCOOP

Marcus Camby, a Hangman diagram in a jersey and shorts, is as enigmatic as the Chinese ideographs he has tattooed on his right arm. Since entering the NBA in 1996, he's been dogged by accusations of fecklessness and unrealized potential, stains familiar to black athletes assumed by whites to be universally endowed with an abundance of natural talent. It's true that the vulnerably slight Camby has been injury plagued and has major holes in his game—such as, well, offense. Yet he possesses athleticism uncommon for a player of his height (6'11"), is one of the league's preeminent shot blockers, and can ignite a team that fancies his kind of fiery, floor-charging game.

Camby, who was born and raised in inner-city Hartford, CT, has cast a shroud of secrecy over his pre-college days. So in the music video of his life, the first scene would be Camby powering his University of Massachusetts squad to a 35-2 record and the 1996 NCAA Final Four (where they were defeated by the Kentucky Wildcats). Camby was named the 1995–1996 College Basketball Player of the year, then skipped his final season of eligibility to enter the NBA draft, where he was tabbed second overall by the expansion Toronto Raptors. In his two inconsistent seasons with the fang-less Raptors, he alternated stretches of brilliance–he made the NBA All-Rookie Team—with long sessions on automatic pilot, and endured criticism for his erratic play and a brittleness that often landed him on the injured list. Faced with the prospect of Camby's impending free agency in 1998, Toronto swapped him to the New York Knicks for his polar opposite, veteran power forward Charles Oakley, a stoic veteran whose workaholism gave him cred with working-stiff beat reporters.

At first, Camby was marginalized by coach Jeff Van Gundy's Neanderthal half-court offense, but after an injury to center Patrick Ewing forced a change in team tempo, Camby's shot-rejecting, rebounding, and court-running aptitude spearheaded the Knicks' surprising run to the NBA Finals. The 2000 season saw Camby awarded a lavish contract extension, then revert back to his slack, inoffensive ways, and as of 2001, he was still hounded by his reputation as a soft-centered, high-maintenance conundrum.

marcus

SKIN DEEP

> In Camby's tattoology, his left arm is relatively prosaic—his first name inked in Gothic script set above a rose. His right, or shooting side, is lined with Chinese characters, about which he explained, "When I got my new tattoos, I wanted them to reflect the two things I try and live my life by. One of them deals with love of family and the other is about striving to be your best." (A Sinologist has provided a literal translation: "Sorry, coach, can't make it; I'm having a bad hair day.")

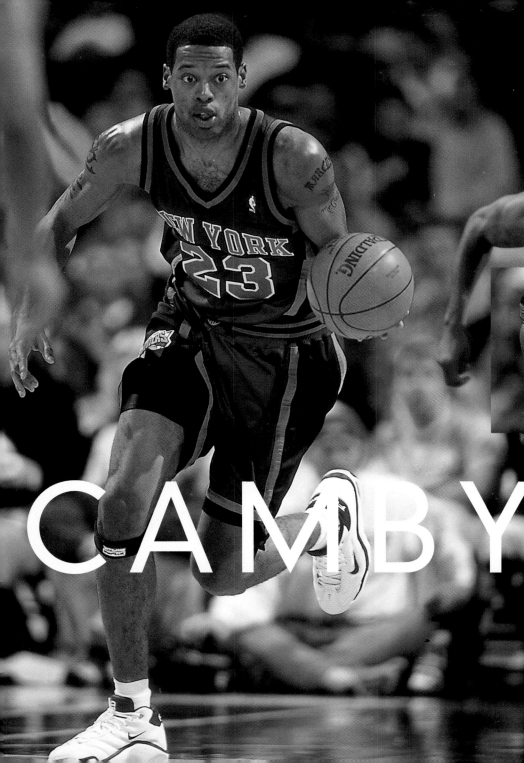

RAW DATA

DATE AND PLACE OF BIRTH March 22, 1974, in Hartford, CT.
CURRENT RESIDENCE Hartford, CT.
CREDITS Won both the James A. Naismith and John
Wooden Awards as college Player of the Year after his
junior season at Massachusetts in 1995–96. Selected
by the Toronto Raptors in the first round (second pick
overall) of the 1996 NBA Draft. Traded by the Raptors to
the New York Knicks for Charles Oakley, the draft rights
to Sean Marks, and cash in June 1998. Led the NBA in
1997–98 in blocked shots (3.65 bpg). Named to the
1996–97 NBA All-Rookie First Team, averaging 14.8 ppg,
6.3 rpg, and 2.06 bpg (10th in the NBA) in 63 games.
STATS NBA Career: Five seasons, two with Toronto
Raptors, three with New York Knicks. Games played: 255.
Per game stats: points: 11.2; minutes: 28.2; rebounds: 7.2;
assists: 1.1, blocks: 2.36.

STRANGE BUT TRUE

- Marcus created the CambyLand Foundation in his native
 Hartford, which teaches underprivileged youngsters to
 stay out of foul trouble.
- Camby appeared on "Wheel of Fortune," hurt his back
 fielding a softball question from Pat Sajak, and was
 then traded to "Family Feud."
- Camby is a huge wrestling fan, and named his two dogs
 Stone Cold and Goldberg, both of whom spend half the
 season at the vet's.

CAMBY

RAW DATA

PLACE OF BIRTH New York City.
CURRENT RESIDENCE Las Vegas.
CREDITS Former Intercontinental Champion and Tag
Team Champion.
FINISHING MOVE The Pimp Drop, a variation on the
Death Valley Driver.
TRADEMARK MOVE The Ho Train.

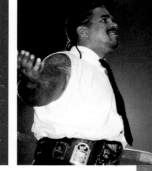

STRANGE BUT TRUE

• He is a former high school basketball standout.
• Well, Hello Dere, Mr. Bones: One of his former
 characters looked like a refugee from a minstrel
 show; he wore a top hat, a whiteface skull mask,
 a bone necklace, and he carried an African witch
 doctor staff.

the

THE INSIDE SCOOP

He peacocks into the ring, all 6'6", 320 pounds of Superfly Badddness, wearing a white derby, electric blue vest, 3D-like glasses, and a namesake gold necklace large enough to be a harness, and attended by a bevy of buff Ho's wearing outfits tight enough to cut off their circulation. He struts, lords, and urges the crowd to intone his mantra, "Pimpin' ain't easy." Only in the World Wrestling Federation could a comic-book ghetto procurer pass as a hero. It's hard to tell who the Godfather is offending more—women, African-Americans, the American Pimp Association, or anyone with a trace of politesse.

Yet the man behind the pimp, Charles Wright, didn't begin his WWF life as a street hustler. In fact, he's had more characters than a Russian novel, the first of which was a visitor from the dark continent, the mystic, quasi-African Papa Shango. When Papa failed to Ooh-Mau-Mau with the wrestling cognoscenti, Wright took a sabbatical, then re-emerged as Kama, the Supreme Fighting Machine, an expert martial technician who engaged in celebrated scuffles against Shawn Michaels in a "King of the Ring" tournament and the Undertaker in a casket match. (The last one to avoid rigor mortis wins.) But the Kama-rama soon ground to a halt, again the victim of public indifference. The indefatigable Wright realized he was missing something—the Arab angle—and so reincarnated as Kama Mustafa, one of the members of the "Nation of Domination"

(who, if the WWF had any nerve, should've been managed by Louis Farrakhan). Mustafa was among the brotherhood Farooq selected to form the all-New Nation of Domination. But radical fundamentalist Islam was a sucker's racket in the '90s, and at that point Wright was grasping at the bottom of his wardrobe closet. Then it came to him, like Proust's madeline—blaxploitation, the swagger, the cigar, the Mobuto-esque leopard skin hat and matching vest, the world's second oldest profession. He was the Godfather.

Half the suckers loved him, the other half disparaged him, but nobody ignored him. The WWF honchos quickly capitalized, and soon the Don of wrestling won the intercontinental title. After that belt was slipped off, he was teamed with ersatz porn star Val Venis (who reputedly could lift a dozen doughnuts without using his hands). It was just Wright's luck that the up-and-comer Venis became a star, leaving the Godfather to play the Survivor circuit. This brush with deadbeat-ude caused the Don to do some soul searching, the conclusion of which was that he had sold his soul. So he discarded the gaudy outfits, sent the ho's to finishing school and morphed into the Good Father, a leader of the WWF's Right to Censor group that purports to uphold traditional values and opposes ringside perversion and sin.

GODFATHER

SKIN DEEP

> His tattoos seem to have bled together into a blue-green mess that one wrestling source claims are his true finishing hold. "They're so ugly, his opponent becomes stunned, and the Godfather piledrives them and wins." Since his conversion, though, he covers the tattoos with a shirt, thus sparing WWF fans everywhere chromonausea.

THE INSIDE SCOOP

The erratic 6-foot point guard is one of the game's most dynamic players. To some courtside observers, the he is an iconoclastic leader of the post-Jordan vanguard. To others, he's yet another spoiled man-child athlete whose flouting of team rules and egocentric ball handling signify the death knell of team basketball. Yet those who would judge Iverson should first walk a mile in his Nikes. His Hampton, VA, childhood is a familiar montage of urban degradation: He was raised by a single mother in the projects that lay atop the city's sewers, and burst pipes regularly disgorged sewage into their apartment. His biological father was a dead-beat. The Iversons were so poor, they often went without water or electricity. Eight of his best friends were killed in one summer.

Like many ghetto kids, Iverson's only ticket out was stamped "Wilson." Encouraged by his mother, Iverson became a high school football and basketball star, until one tragic night when a bowling alley dispute turned into a brawl and left the 17 year old with a controversial five-year sentence for allegedly hitting a young woman with a chair. Four months into his sentence Iverson was granted a conditional release by Virginia governor L. Douglas Wilder, and two years later a state appellate court, ruling insufficient evidence, reversed what some said was a racially motivated conviction.

He was recruited by Georgetown, where he became an all-American player, leaving after two years to sign with the NBA's Philadelphia 76ers, who chose him first overall in the 1996–97 draft and signed him to a six-year, $71 million contract. Iverson entered the league, winning Rookie of the Year with quicksilver moves.

However, since that mercurial debut, Iverson's career has been aswirl with controversy. He hogged the ball, whined to reporters, and tangled with his coach, Larry Brown (he was fined 50 times and suspended during the 1999–2000 season). The Sixers tried trading him but couldn't. As if all this—and the Sprewellian corn-rows—weren't enough, before the 2000 season, Iverson announced the imminent release of a rap record, *Misunderstood,* some of the lyrics of which leaked to the press, were suitably offensive to luxury-boxed suits and other non-homies. If he continues leading the Sixers deeper into the playoffs, Iverson may earn the league MVP honor he so covets, but his size, suspect defense, and contentiousness may pressure him into turning it over.

>"I don't know what a pure POINT GUARD is. I just play the game and do whatever is necessary to WIN."<

allen

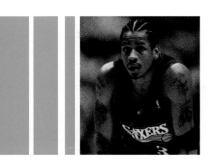

SKIN DEEP

> Allen's hidden weapons are his many tattoos, which mesmerize opponents and allow him to blow by them to the hole. On his right shoulder are the words, "Hold my own." Directly below that on his arm is a skull. Alongside the skull are the words "Cru thik diff" (repeated on his left forearm), a reference to his Virginia rap coterie, Cru Thick. The Grim Reaper on his right forearm probably has psyched out more than one defender. On his left shoulder is a cross, framed by the phrase "Only the strong survive." A bulldog growls from his left arm, below the words, "The Answer."

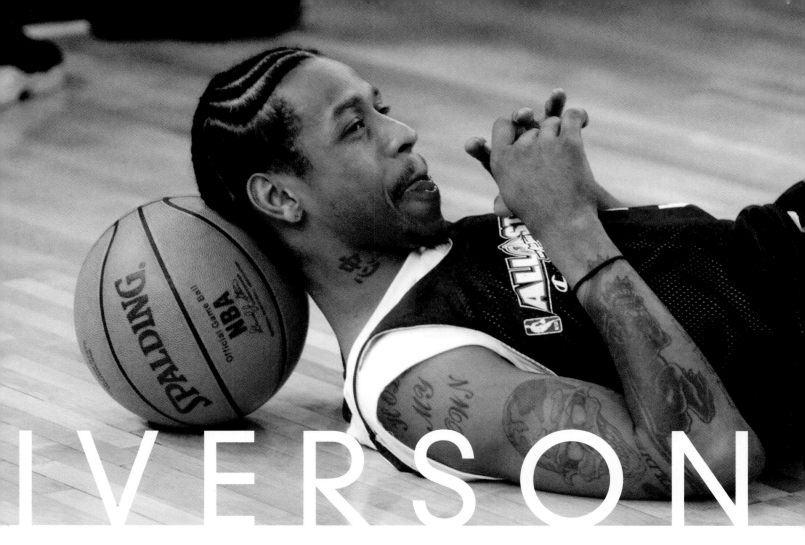

IVERSON

RAW DATA

DATE AND PLACE OF BIRTH June 7, 1975, in Hampton, VA.
CURRENT RESIDENCE Hampton, VA.
CREDITS First Team All-America, Georgetown University. First overall pick in 1996–97 NBA draft.
STATS NBA Career: Games played: 300 (all with Philadelphia 76ers); minutes per game: 40.3; rebounds per game: 4.1; steals per game: 2.15; points per game: 24.9. NBA Rookie of the Year in 1997 with 23.5 point average. Set NBA record for most consecutive 40-point games (five) that same year. Shortest player (6') to ever win the NBA scoring title, with 26.8 points per game in 1998–99 season. First team All-NBA 1998–99; Second team All-NBA, 1999–2000. Second in points per game (28.4), third in steals (2.06), third in minutes per game (40.8). In 1999–2000 playoff game, he broke an NBA record with 10 steals.

STRANGE BUT TRUE

- Allen's favorite book is *The Color Purple*, the same shade as Larry Brown's face after another Iverson brick.
- Iverson has already chosen his epitaph: "Misunderstood."
- Alumni News: His arms are so long, when the former Sixers guard, World B. Free, saw Iverson naked for the first lime, he said, "Yo, Al, they gave you somebody else's body!"
- I'm Ready for My Closeup, Mr. Stern: Iverson refuses to be seen or interviewed on camera if his cornrows are not perfectly coiffed. Local camerapersons can be spotted outside the Sixer locker room calling out "Rows in yet?"

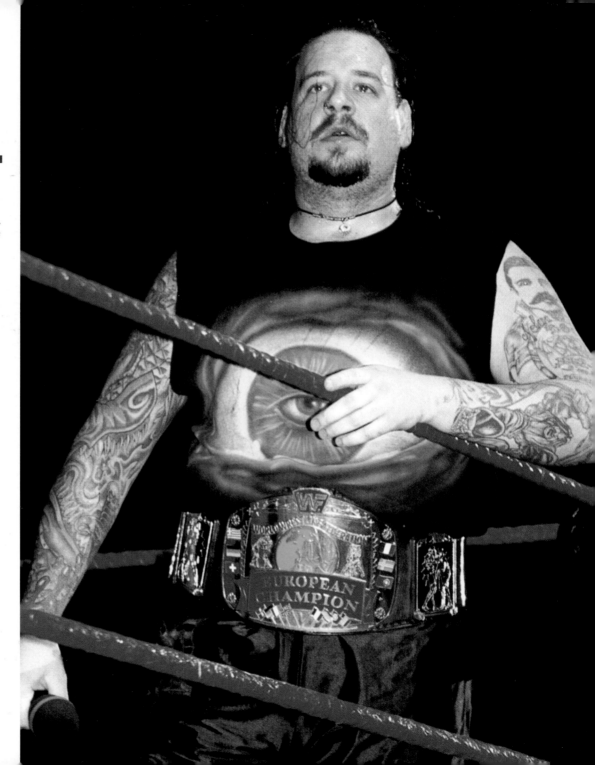

RAW DATA

DATE OF BIRTH December 26,1968.
CREDITS Two-time Tag Team Champion,
European Champion.
FINISHING MOVE The Eye Opener.

STRANGE BUT TRUE

• He claims his secret talent is making
 the Undertaker laugh. In return, he
 gets all the formaldehyde he can drink.
• A baby-naming Web site says someone
 named Mideon "would have difficulty
 achieving success in positions requir-
 ing aggressiveness and drive." No
 wonder so many WWF fans regard
 him as "lame" and "booorrring."
• Mideon adheres to his own New Math,
 wearing a T-shirt that reads "Acolytes
 + Mideon = Friends."

THE INSIDE SCOOP

The Undertaker's lackey? A junior embalmer? An oversized jabroni who looks like he got lost on the way to a biker convention? Mideon, a.k.a. Dennis Knight, is all of the above. Knight made his pro debut in 1990 as Tex Slazenger in World Championship Wrestling. He then jumped to the WWF, becoming Phineas I. Goodwin (P.I.G.), one-half of a hillbilly tag team (in the hallowed tradition of Haystacks Calhoun) who won two WWF tag titles. Then Vince gave Knight a makeover—and a demotion; he was allowed to wrestle under his given name but only as part of the wrestler-bodyguard team Southern Justice. At this point, tragedy befell the simple farmer: One day Dennis was out tending the back 40 when he was kidnapped by a group calling themselves Acolytes of an arch-fiend called the Undertaker. After a horrific week (during which Dennis was forced to comparison-shop caskets and read *Modern Mortician*), the Undertaker sacrificed Knight's soul, renamed him Mideon, and turned him into a wrestling version of a Secret Service agent, ready to take a suplex for the Lord of Darkness. For a while, the 6'3", 288-pound Mideon could be seen hanging obsequiously at the UT's side, surveying the landscape for ringside threats. Mideon became known to some as a loyal henchman who never sold out the Mortifying One, and was repaid with the European title, which he accurately described as "a gift from above." Soon, though, he was reduced to spear-carrier status, at one point playing an ersatz Mankind in a de-Generation X skit. In a desperate attempt to revive his shambles of a career, he interrupted a match by streaking. Thus was born Naked Mideon, who lasted about as long as it took to put his tights back on.

MIDEON

SKIN DEEP

> He has an asterisk on his forehead, the footnote for which reads, "Brain normally located here."

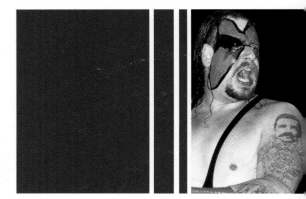

The dungeon master. Lord of the chamber. Captain of the Bermuda Triangle. The man known to half the planet as Shaq uses the paint like an Old Master, commanding the 16 x 18-foot area around the basket like no behemoth since Wilt Chamberlain.

Since arriving in the NBA as a embryonic rookie with nothing more than a slam dunk in his satchel, 7'1", 310-pound Shaquille O'Neal has dominated the sport so much that opponents can neutralize him only by employing a slash-and-burn assault known as Hack-a-Shaq. Yet despite his current fame, O'Neal wasn't always Shaq Daddy, but an ungainly adolescent who at 13, was 6'5" and too awkward for sports. (He was cut from the ninth grade hoop team.) In just a few years, though, O'Neal had progressed, leading his high school team to the state championship.

At LSU, he became the dominant player in college basketball, which he left prematurely to sign with the Orlando Magic as the first overall pick in the 1992 NBA draft. In about as much time as it takes to set a pick, O'Neal became a household name and a one-man conglomerate, whose subsidiaries included Shaq the actor, rapper, designer, pitchman, and record company exec. Shaq's off-seasons were spent in vanity-driven recording studios and on Hollywood movie shoots, which raised the ire of detractors who felt he should concentrate on his game.

In the 1994–95 season O'Neal led the NBA in points per game (29.3) and took the Magic on their first trip to the NBA Finals. (They lost to the Houston Rockets.) When he became a free agent, Shaq didn't hesitate to ink a seven-year, $120 million contract—at the time, the largest in sports history—with the L.A. Lakers. Many fans accused Shaq of mercenary intentions, but he vanquished his critics by developing a jump shot, upgrading his game, and taking the Lakers to an NBA title in 1999.

>"Kids should look up to their PARENTS. And instead of looking up to me, they should look at me and try to be BETTER THAN ME."<

SKIN DEEP

> Here we have yet another instance of a celebrity's infatuation with Superman, whom Shaq sports on his left shoulder. Does being a planetary demigod imbue one with a feeling of invulnerability? Does Shaq believe he's a hero with supernatural powers, such as dunking harder than Jumbo Mitumbo? Or is it an ironic recognition of his limitations, such as not being able to make free throws if his life depended on it?

shaquille

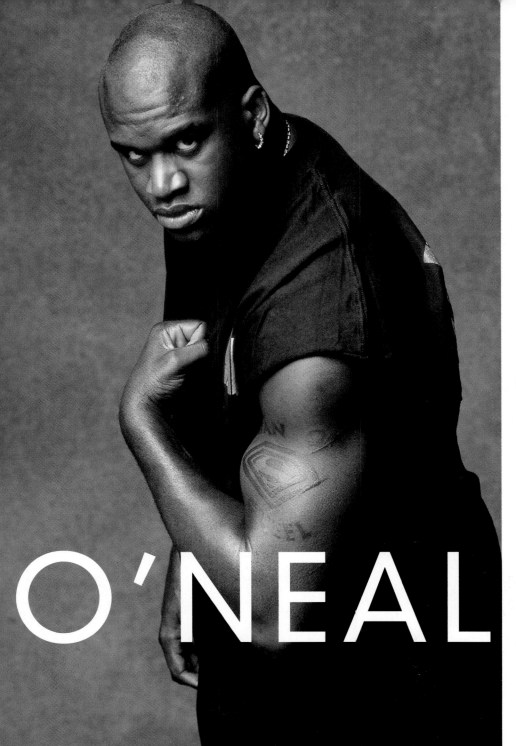

O'NEAL

RAW DATA

DATE AND PLACE OF BIRTH March 6, 1972, in Newark, NJ.
CURRENT RESIDENCE Los Angeles.
CREDITS Two-time consensus first-team All-America, Louisiana State University, 1991–1992. Selected as an undergraduate by the Orlando Magic in the first round (first pick overall) of the 1992 NBA draft. Signed as a free agent by the Los Angeles Lakers in 1996.
STATS NBA Career: games played: 562; minutes per game: 37.8; rebounds per game: 12.4; blocked shots per game: 2.71; points per game: 27.4. Selected to the 1999–2000 All-NBA First Team. Most Valuable Player in NBA, 1999–2000. Named to the 1998–99 All-NBA Second Team after leading the NBA in field-goal percentage (.576). Named to the All-NBA First Team in 1997–98, to the All-NBA Second Team in 1994–95, and to the All-NBA Third Team in 1993–94, 1995–96 and 1996–97. Selected in 1996 as one of the 50 greatest players in NBA history. A member of the men's basketball "Dream Team" that won the gold medal at the 1996 Olympics in Atlanta.
RECORDINGS *Respect* (1998); *The Best of Shaquille O'Neal* (1996); *Shaq Fu—Da Return* (1994); *Shaq Diesel* (1993).
FILMS *He Got Game* (1998); *Steel, Good Burger* (1997); *Kazaam* (1996); *Blue Chips* (1994); *CB4* (1993).

STRANGE BUT TRUE

- Why Shaq Can't Shoot Fouls: Because most of his points are made with his back to the basket, he says it's hard for him to shoot facing the hoop. He failed to convince the NBA to let him shoot free throws with the basket behind him.
- Basketball is Easy...: "Marriage is really hard," Shaq told *Ebony*.
- At one point, Shaq called himself "the Big Aristotle" quoting the philosopher's statement that, "Excellence is not a singular act but a habit." When this didn't help him with his free-throw shooting, he switched to Sartre and said life was meaningless.
- Drive on the Big Man and Be Squashed Like a Bug, Grasshopper: Shaq stars as a kung-fu warrior in his own action-oriented home video game, Shaq-Fu.

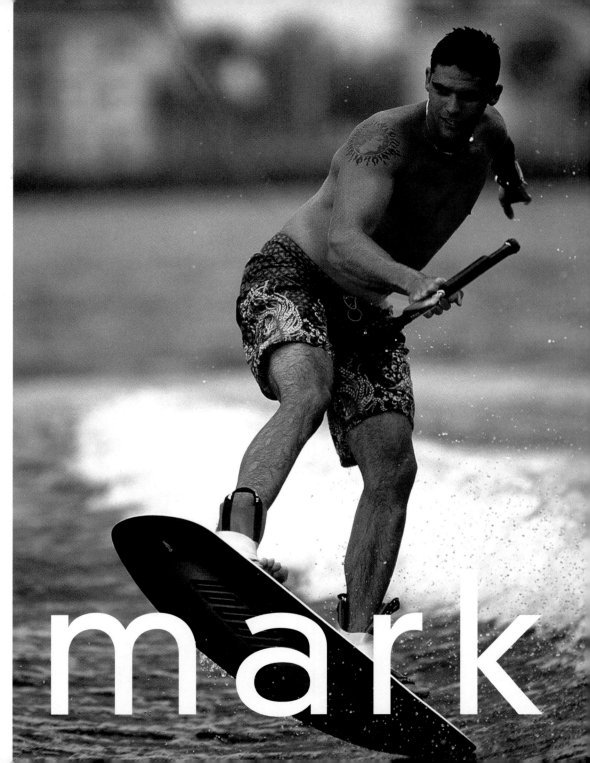

RAW DATA

DATE AND PLACE OF BIRTH November 7, 1976, in Melbourne, Australia.
CURRENT RESIDENCE Miami.
STATS As of 2000, he had 10 career titles and had won $4,362,255. He was a U.S. Open finalist in 1998, and in 1999 was ranked 19th in the world in singles. He's played in 23 ATP Tournaments, and his match record is 42-21. He's won one title, the Sybase Open.

STRANGE BUT TRUE

- Among the companies who pay Mark to promote their products are Fila, Dunlop, AAPT, Balsam Pacific, K-Tel, and Tennis Trainer. He's got more sponsors than an AA meeting.
- He had knee surgery in December 2000, which apparently also left him with blonde hair.
- Mark has recorded the fastest serve ever: 142 m.p.h.

mark

> "When I'm on the court I'm there to play, but when I'm off court you could say I'm PRETTY WILD. . . .I love my toys, my cars, I'm a bit of an ADRENALINE seeker."<

THE INSIDE SCOOP

Mark Philippoussis, one of the most prodigious of tennis stars, is called "the Scud." While the nickname initially referred to his missile-like serves, some sportswriters later appropriated it to describe the erratic nature of that serve—and his tempestuous personality. Philippoussis has crammed into his 24 years a Barrymore's worth of melodrama. Recently, he's worn out more coaches than Greyhound, alienated his fellow Aussies by backing out of Davis Cup matches, ticked off his teammates, and issued Ayatollah-like media bans including one on esteemed *Melbourne Age* tennis writer Linda Pearce for her flippant dig at Mark's sports car fetish. (He studied the celebrity manual: Tennis studs drive fast cars—he owns a Lamborghini, a Ferrari, and a Porsche—and date supermodels.)

All this controversy unfortunately has obscured Philippoussis' courtside gift: He boasts a fearsome serve, booming groundstrokes, and a net presence more menacing than Shaq. He's vanquished all the top players—he recorded the biggest victory of his career when he defeated world No. 1 Pete Sampras at the Australian Open—and is equally commanding on clay, grass, hardcourt, or carpet. He owes much of this to his father, Nick, a former soccer goalie (also known as the Patriarchal Missile, or Big Scud), who began teaching his son the rudiments of the game at age 6.

In 1994, Philippoussis turned pro, finishing third in the world junior ranks. In doubles, he and Ben Ellwood became the top junior team, winning Australian, Wimbledon, and Italian titles. Besides the personality issues, Philippoussis has been hindered by injuries and a designer addiction that causes him to drop thousands in tournament winnings on such items as Armani and Versace suits and Michael Hutchence sunglasses.

SKIN DEEP

> To reflect his Greek heritage, Mark had a profile of Alexander the Great impastoed on his shoulder. The image is based on a portrait of the ancient conqueror that appeared on a gold coin, and Mark said it was commissioned during "twenty minutes of pain" near his Florida home. As for why he chose this image, he explained, "I've got Greek blood in me, and it's better than a skull and crossbones." Or a picture of Anthony Quinn. Philippoussis realizes the potential danger of tattooing: "The dangerous thing about tattoos is once you get one, they're addictive." How true: You start with Alex the Great, and the next thing you know, you've got Aristotle Onassis and Maria Callas staging operatic quarrels all over your back.

PHILIPPOUSSIS

THE INSIDE SCOOP

Scottie Pippen knows how Harry Truman felt. And Roger Maris. And well, the Sherpa guide who helped Edmund Hillary scale Everest. Pippen is a 6'7", 230-pound multitalent who can rebound like Chris Webber, drain threes like Glen Rice, and run the point like Gary Payton. He consistently ranked among the NBA leaders in scoring, rebounding, assists, and steals, and is considered by many to have been the best all-around player in the 1990s. Yet he's viewed—by us and probably by posterity—as a kind of glorified admin assistant to CEO Mike, someone whose magnitude is fated to remain obscured by His Flakness, but without whom MJ might now be running a fantasy camp in Waukegan.

Admittedly, not even Nostradamus could've prophesized Scottie's fame. He grew up in Hamburg, AR, a town so small it had only one public basketball court, which may account for the fact that Pippen was a late hoops bloomer. He attended a virtually invisible NAIA college, the University of Central Arkansas, and was so unpolished in his freshman year, the closest he could get to the basketball team was equipment manager. However, his senior year he was a starting guard and the team's best player and found himself a hot commodity in the 1987 NBA draft. The Seattle SuperSonics took Pippen with the fifth overall pick, then traded his rights to the Chicago Bulls for the rights to Olden Polynice (whose NBA claim to fame was staging a hunger strike). Pippen posted modest stats in his rookie year, but cracked the starting five as a sophomore. The rest is hanging from the rafters at the United Center: Six NBA titles. A 1995–96 Bulls squad that won 72 games, the first team ever to crack the 70-win mark. Many All-Star selections, and two Olympic gold medals. Of course, playing second fiddle to the Almighty One occasionally ground on Scottie's nerves. His most ignoble moment occurred in a playoff game against the Knicks. Scottie, apparently miffed at being removed at a key moment, refused coach Phil Jackson's directive to return to the game, but all was forgotten in the aftermath of another title.

With Jordan's retirement prior to the 1998–99 season, general manager Jerry Kraus began dismantling the team like a demolition crew—he traded Pippen to the Houston Rockets for Roy Rogers (the player, not the fast-food franchise) and a conditional second-round draft pick. In Houston, Pippen joined fellow Dream Teamers Charles Barkley and Hakeem Olajuwon, but their title dreams were shattered by the Los Angeles Lakers in the first round of the playoffs. Pippen openly attacked Barkley, and Sir Charles had his henchmen in the front office dispatch Scottie to the Portland Trail Blazers for six players who combined couldn't tie Pippen's Nikes. Despite a chronically sore back that drastically curtailed his game, Pippen started all 82 games for the Blazers in 1999–2000 and helped them reach the Western Conference finals, where they blew a comfortable fourth-quarter lead in game seven and bowed again to Psychedelic Shaq and the Lakers.

scottie

SKIN DEEP

> Pippen sports small tattoos on his biceps and legs. He moves so fast on the court, they're practically indecipherable to the eye.

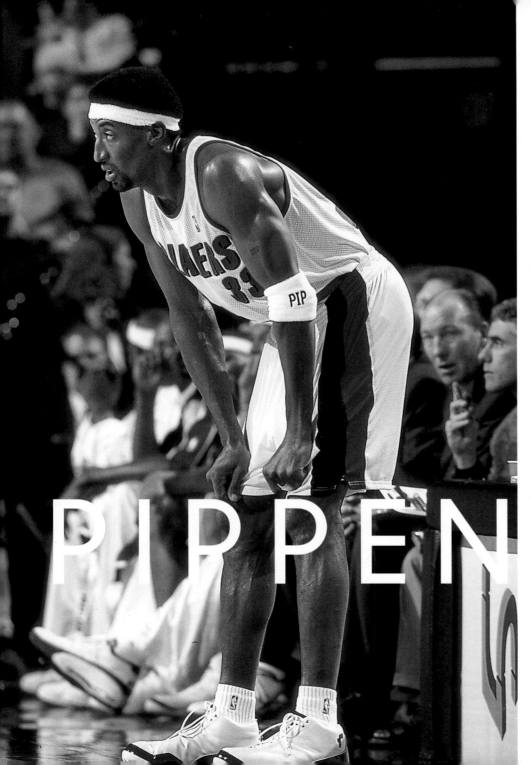

RAW DATA

DATE AND PLACE OF BIRTH September 25, 1965, in Trenton, NJ.

CREDITS He was selected by the Seattle SuperSonics in the first round (fifth pick overall) of the 1987 NBA draft, then traded to the Chicago Bulls. In 1999, the Bulls traded Pippen to the Houston Rockets, who later that year swapped him to the Portland Trail Blazers. Pippen was named to the All-NBA First Team three times (1993–94 to 1995–96). He was a member of the Chicago Bulls' six NBA championship teams (1990–91 to 1992–93, 1995–96 to 1997–98). He played in seven NBA All-Star Games (1990, 1992–97) and was honored as one of the 50 Greatest Players in NBA History.

STATS NBA Career: Games, 993; minutes per game: 35.8; points: 17.1; rebounds: 6.7; assists: 5.3. He's scored more than 17,000 points in an ongoing NBA career.

STRANGE BUT TRUE

- Let My People Jam: The person Scottie most admires is Martin Luther King, Jr.
- Pippen plans to visit Africa someday (when Kinshasa gets an NBA franchise).
- In 1997, Pippen published a children's book entitled *Reach Higher,* in which he recommends that inner-city kids stay in school, and if they can't, to grow as tall as possible.

PIPPEN

DATE AND PLACE OF BIRTH January 6, 1970, in
La Jolla, CA.
CURRENT RESIDENCE Marina del Rey, CA.
MODELING CREDITS *Women's Sports & Fitness, Outside,
Shape, Elle, Life, Playboy* (including artsy nude layout),
Vogue, Vogue Italia, Self, Harper's Bazaar, Men's Fitness,
and *Fitness.*
SPOKESPERSON Nike.
ATHLETIC ACCOMPLISHMENTS Volleyball position:
Middle blocker. Years in Two-Person Competition: 1
(1999). Years in Four-Person, Bud Light League: 5
(1993–97). Bud Light Pro Beach Volleyball League leader
in kills (1994–96). Bud Light Pro Beach Volleyball
League Offensive Player of the Year (1994–95). Bud
Light Pro Beach Volleyball League kills and blocks
leader (1993). Holds league records for kills per match
(11.9) set in 1994 and 1996, kills in a season (547) set in
1996, kills in a tournament (63), and total attempts in a
tournament (173). Named nation's Most Inspiring
Collegiate Athlete by the Dodge National Athletic
Awards Committee as a junior at Florida State in 1990.
TV Host, "The Extremist with Gabrielle Reece" (1995).
FILMS *Gattaca* (1997).
BOOKS *Big Girl in the Middle* (1997).

STRANGE BUT TRUE

- One popular Web site enables you to contact a
 "Gabrielle Reece expert" (whose dissertation was on
 "Gabrielle Reece and the Unified Field Theory").
- Here's some advice from Gabrielle to tall women who
 try to disguise their height: "Stand up straight!
 There's nothing more attractive than a tall woman
 standing up straight." Except a tall woman in a string
 bikini embossed with a swoosh.

gabrielle

> "Whatever gets people to pay ATTENTION." Gabby, when told that many BEACH VOLLEYBALL fans tune in for the BIKINIS. <

THE INSIDE SCOOP

Beach volleyball has as much sporting viability as Frisbee and miniature golf. It's a marketing vehicle disguised as an athletic contest that exists to sell beer (Bud Lite sponsors the primary league) by beaming sweating babes in bikinis to socially maladroit, 18–35 year old males. Its biggest star, 6'3" Gabrielle Reece, the so-called "vixen of volleyball," just happens to be a top international model who's served up her giraffe-ish size and no-fat physique to score with fashion mags, sneaker firms, and other launching pads to celebrity. (You really can't blame her—there's no money in beach volleyball; even a top player like Reece earned only $23,400 in 1999 on the two-person pro circuit.) You could say Reece had one advantage in taking up the game: She spent her formative years on the beaches of St. Thomas, until her mother packed her off to a Catholic high school in St. Petersburg, where she learned how to spike a ball down a classmate's throat. By the time she'd graduated from Florida State University, she'd seen more sand than Lawrence of Arabia, and become a nationally ranked athlete. In celebrity scenario #105, she was "discovered" by some emissary to the mannequin world, arrived in fashiondom just as the Kate Moss wave had crested. Within a few years, Elle had named her one of the five most beautiful women in the world, and Herb Ritts took a break from his obsession with naked musclemen to click Reece. At 21, she turned pro, and in 1993, she became the first female athlete to design a shoe for Nike. Reece competed for five seasons on the four-person tour and was twice named the tour's top offensive player. She led the league in kills four times, blocks once, and photo ops every year. For two years, Reece dated the guy who played Clark Kent on "Lois and Clark," then was married to Laird Hamilton, who is not an actual Scottish laird, but a leading big wave surfer. (At last report, their marriage had wiped out.) When she's spiked her last ball, Gabrielle can look forward to a future doing crush videos.

REECE

SKIN DEEP

> Her only inking is a cross she wears on the inside of her right calf, a hieroglyphic tribute to her father, who wore one (an actual cross, not a tattoo) on the day he died. If ESPN's ratings falter, though, expect Gabrielle to become a human signboard, all 75 inches of her covered, NASCAR-like, with corporate logos.

THE INSIDE SCOOP

If you can't smell what the Rock is cookin', then you're probably a roody poo who doesn't know a suplex from a duplex, don't know Raw is War, and haven't tuned into pro wrestling for the past five years. Dwayne Johnson (a.k.a. The Rock, the Chosen One, the Brahma Bull, and the People's Champion), is a third-generation grunt-and-groaner. His father, Rocky Johnson, was the first African-American (with Tony Atlas) to win the WWF Tag Team Title, and his grandfather was Samoan grappler and U.S. Tag Team champ Peter Maivia. (Even grandma may have hidden objects in her bloomers: She was the first female promoter in wrestling history.)

Yet Dwayne, in an attempt to forge his own identity, first tried his 6'7", 260-pound frame on the gridiron. After an injury-plagued stint at the University of Miami, he tried breaking into the Canadian Football League. However, he was soon cut from the squad, and was reduced to sleeping on a putrefying mattress filched in the rain from a motel dumpster. After this squalid experience, Johnson realized that having his head rammed into a turnbuckle every night was a useful job skill after all. He asked his father to train him and used Rocky's connections to get his size 14 boot in the WWF door.

After wrestling under his own name, then the unfortunate "Flex Kavana," and "Rocky Maivia" (as a babyface, or good guy), he settled on "The Rock," a snarling, megalomaniacal bully who refers to himself in the third person and became part of the WWF's Nation of Domination (think: the Black Panthers in tights). In the course of his ascent, the Rock invented many holds, not the least of which was the headlock he puts on the aimless proletarian young males—and females—of America. However, the Rock has realized that wrestling fame is fleeting and to avoid the fate of his father, who in his post-rasslin' days became a destitute, cauliflowered alcoholic, he's exploring a post-ring film career.

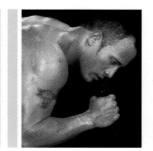

SKIN DEEP

> His grandfather, Peter Maivia, was a Polynesian High Chief who, according to custom, was covered head to toe in tattoos. Yet the Rock has much more modest ambitions—a longhorn steer on his right shoulder. He claims it's a Brahma bull whose character he compares to his adamantine self.

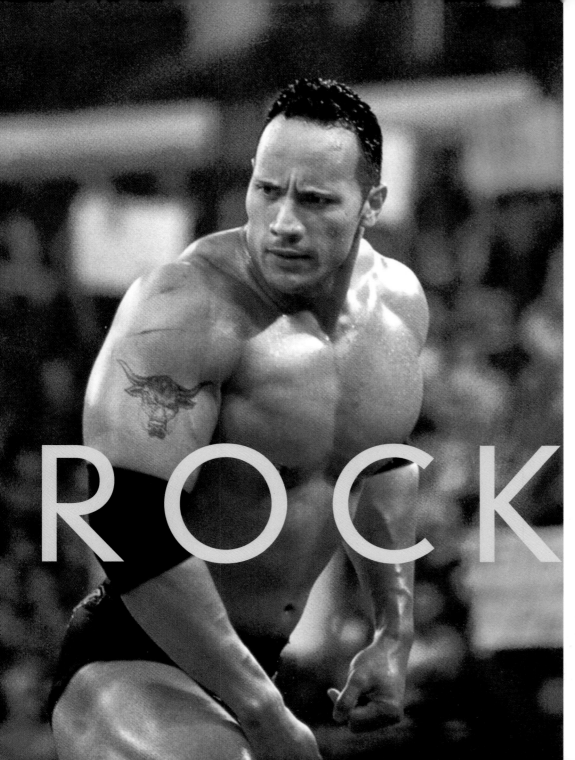

ROCK

RAW DATA
DATE AND PLACE OF BIRTH May 2, 1972, in Hayward, CA.
CURRENT RESIDENCE Miami.
CREDITS Pro career: 1996–present. Five-time WWF Heavyweight Champion. Four-time WWF Tag-Team Champion (most recently with the Undertaker).
RECORDS Fastest Ever PinFall Victory (4 seconds, 1997 Survivor Series against Big Bossman); Youngest ever WWF Intercontinental Champion; Youngest ever WWF World Heavyweight Champion (both at 26 years of age); First ever African-American WWF World Heavyweight Champion.
FINISHING MOVE The Rock Bottom.
OTHER MOVES The People's Eyebrow, DDT, The Spitty Smackdown, The Scoop Slam, The Samoan Drop.
TRADEMARK The People's Elbow (previously known as the Corporate Elbow).

STRANGE BUT TRUE
- Wrestling Tip of the Day: "The pile driver can be a dangerous move if you're not careful. But there's a way to do it safely: Just lodge the head tightly between your legs so that it's not protruding at all."
- One of the Rock's favorite moves is Layeth the Smacketh Down (Leviticus 28, 5–13, "Yahweh said to Moses…").
- The Rock lost a famous "Hell in a Cell" match in which he was locked in a small cubicle with Dick Vitale.
- Rock Advocates Campaign Finance Reform: To raise money for his hypothetical presidential campaign, he would "dance to 'I'm Too Sexy' wearing only a corduroy G-string and bowling shoes." (His bloodcurdling cabinet would include, "My wife, Vince McMahon, and a Mini Me.")
- The Rock told *Teen People* that his favorite non-wrestling activity is "calling ahead to a favorite restaurant, having it cleared out and going to eat."

>"I like my music LOUD, my alcohol HARD, my women HOT, and my food SPICY. Does that make me a BAD guy?"<

THE INSIDE SCOOP

To many, Dennis Rodman exemplifies the modern professional star athlete: an enigmatic, iconoclastic, chest-thumping, part-time transvestite. At age 20, Rodman's career prospects were about as broad as his nose ring—he was working the night shift as a janitor in the Dallas-Ft. Worth airport. However, with bullish determination and flamboyant orneriness, he ascended from junior college walk-on to perhaps the greatest rebounding forward in the history of the NBA—and a hard-court Liberace.

Rodman's career seemed to combine inordinate success with outrage and controversy. For more than a decade, he was a restive, recalcitrant, NBA vagabond, morphing teams and hair color. Despite winning five titles and improving every team he played for, he inevitably wore out his welcome. The combativeness with which he snatched balls above the rim led him to fight opponents, attack fans, head-butt referees, date (and dump) Madonna, and arrange a sham marriage with Carmen Electra (the romantic equivalent of a flagrant foul).

His breakthrough season was 1992–1993, when he averaged 18.7 rebounds, the highest mark since Wilt Chamberlain had averaged 19.2 boards 20 years earlier. The Bulls gambled by acquiring him prior to the 1995–96 season, which resulted in three straight titles as the Worm played peroxide Falstaff to Michael Jordan's corporate Prince Hal.

Dennis' career ended with a whimper, as he appeared in 23 games with the Los Angeles Lakers in 1998–99 and 12 games with the Dallas Mavericks in 1999–2000. Despite rebounding in double figures, he was waived by both clubs, and has expanded his celebrity by writing books, acting in films, and wrestling in the WWF. What else can you expect from someone who boasted that he could "play in the NBA with pink nails"?

dennis

SKIN DEEP

> Dennis has many tattoos—one for each personality. They include images of a Harley Davidson, a shark, a cross (the loop of which encircles his pierced navel), and a photo of his daughter, which we assume the proud papa displays by lifting his shirt instead of whipping out his wallet. How Rodman's daughter, who has enough karmic trouble, feels about her visage being stroked by the likes of Madonna is unknown.

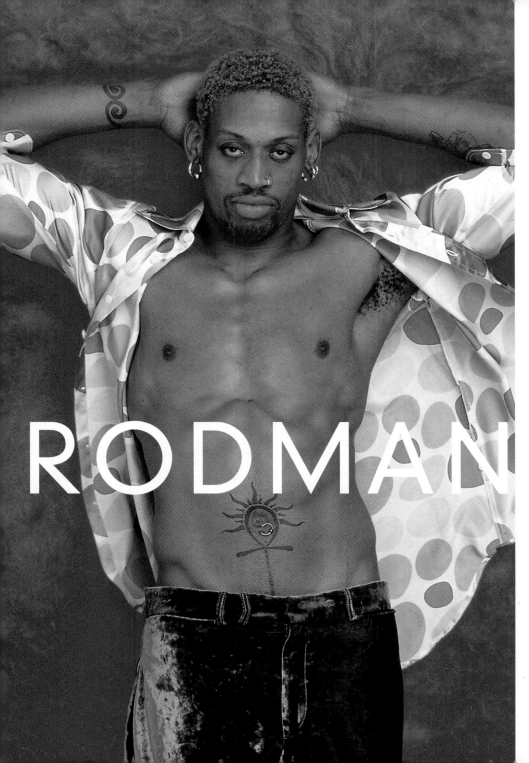

RODMAN

RAW DATA

DATE AND PLACE OF BIRTH May 13, 1961, in Trenton, NJ.
CURRENT RESIDENCE Newport Beach, CA.
CREDITS Selected by the Detroit Pistons in the second round (27th pick overall) of the 1986 NBA draft. Traded by the Pistons with Isaiah Morris to the San Antonio Spurs for Sean Elliott and David Wood in 1993. Traded by the Spurs to the Chicago Bulls for Will Perdue in 1995. Signed as a free agent by the L.A. Lakers in early 1999, and waived less than two months later. Signed as a free agent by the Dallas Mavericks in February 2000, and waived a month later.
STATS NBA Career Rebounds: 11954; Assists: 1600; Steals: 611; Blocks 531; Points 6683. Rodman was a member of the 1989 and 1990 NBA Champion Detroit Pistons and 1996, 1997, and 1998 NBA Champion Chicago Bulls—the only player in NBA history to win consecutive titles with two different teams. He holds the NBA record for most seasons leading the league in rebounds per game and most consecutive seasons doing same (7). He's a two-time NBA All-Star (1990, 1992) and two-time NBA Defensive Player of the Year (1990–91). He shares the NBA Finals record with 11 offensive rebounds in a game, achieving the feat twice during the 1996 NBA Finals
FILMS *Double Team* (1997). Starring Jean-Claude Van Damme, Rodman played Yaz, a flamboyant arms dealer.
BOOKS *Bad As I Wanna Be* and *Words from the Worm* (1997); *Rebound: The Dennis Rodman Story* (1994).

STRANGE BUT TRUE

• Dennis didn't play high school basketball, but grew 9 inches afterward.
• He owns the Rodman Excavating Company in Dallas. Their first major project was unearthing Dennis's true hair color.
• Accused of taking drugs, he said, "I'm the most anti-drug person you'll ever meet. I've got enough problems keeping myself under control without putting stuff in my body that's supposed to make me wild."
• He once admitted: "I like tight clothes. I like women's clothes. I enjoy dressing like a woman. I don't do it to blow people's minds, but if it has that effect, so be it. I do it to explore my feminine side. Most men are scared to death of exploring that side....That's especially true in the sports world, where everyone thinks they have to be so macho."
• One of the many Web sites devoted to him has a "Hair Archive" featuring "the ever-changing colors of the Worm's head."

RAW DATA

DATE AND PLACE OF BIRTH June 30, 1966, in Brooklyn, NY.
CURRENT RESIDENCE Maryland.
CREDITS Professional boxing record: 47-3-0-1 (41 KOs).
Titles: Former WBC Heavyweight Champion, WBA Heavyweight Champion, and undisputed champion.

STRANGE BUT TRUE

- One Web site enables you to buy Tyson gear, including a "Tiny Tyson" teddy bear. (Insert ear-biting joke here.)
- Tyson has a 71-inch reach.
- Joyce Carol Oates wrote of Tyson, "There is an unsettling air about Tyson, with his impassive death's-head face, his unwavering stare, that the violence he unleashes against his opponents is somehow just; that some hurt, some wound, some insult in his past, personal or ancestral, will be redressed in the ring." Tyson then knocked her out.

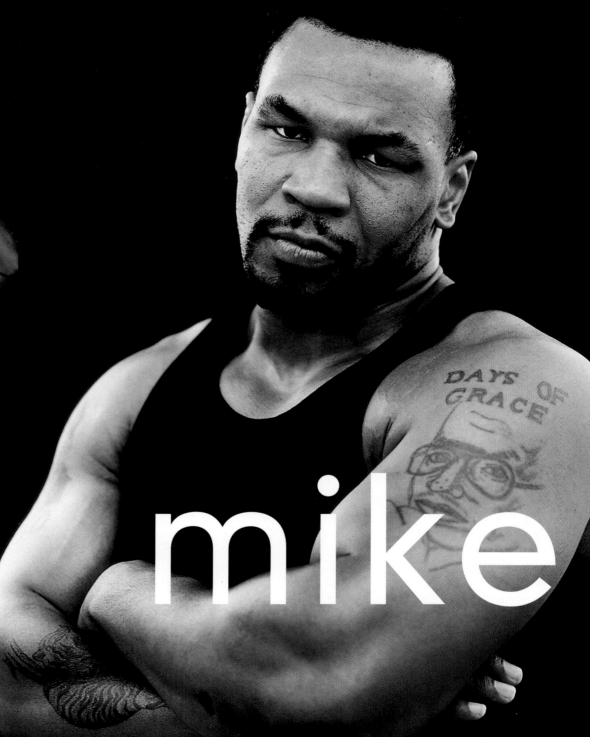

mike

> We're people who make MISTAKES. We have disgusting thoughts. We have PERVERTED thoughts. But we hide under the bill of SANITY and it's just ridiculous."<

THE INSIDE SCOOP

Like Richard Wright's Bigger Thomas, Michael Gerard Tyson was a black man prodded by white people to unleash his natural brutality, then punished when he did just that. Mike's Native Son-like chronicle formally begins in 1979 when, after committing a series of robberies, he was sent to reform school in upstate New York, where he met a Pygmalion with a stogie, famed boxing trainer Cus D'Amato. The trainer, who'd guided Floyd Patterson to the heavyweight title in 1956, took one look at Tyson in the ring and heard orisons auguring his next world champ.

In the Tyson biopic, here would appear a montage alternating scenes of Cus driving Iron Mike relentlessly in the gym with shots of a feral Tyson dropping opponents like tenpins to the canvas. 1985: Tyson makes his pro debut with a first-round knockout of Hector Mercedes. 1986: A 20-year-old Tyson vanquishes Trevor Berbick for the World Boxing Council (WBC) heavyweight title. 1987: A 12-round victory over James "Bonecrusher" Smith adds the World Boxing Association (WBA) belt to Tyson's growing collection. August 1, 1987: Tyson becomes the undisputed world heavyweight champion, holding all three factional titles.

In a Faustian scene, Tyson sells his soul to promoter Don King, who becomes his manager. Tyson then makes six consecutive title defenses, mowing down everybody, including former champ Larry Holmes and then-undefeated former champ Michael Spinks.

For his 91-second demolition of Spinks, Tyson earns more than $20 million, at the time the largest fee ever paid to an athlete. Mike is proclaimed the most dominating pugilist of his time and becomes a globally recognized boxing superstar (which he later says is "very overrated").

Act II: 1990: Tyson coughs up his heavyweight crown to Buster Douglas in one of the greatest upsets in boxing history. 1992: Tyson is convicted of raping an 18-year-old woman and sentenced to 10 years in prison. In prison, Mike reads widely and experiences several epiphanies. 1995: A seemingly more mature, reflective man, Tyson is released after serving three years. Showing no ill effects from his layoff, Tyson dispatches his first post-prison opponent, Peter McNeeley, before latecomers are even seated (7 seconds).

After recapturing the crown, Tyson loses a scintillating fight to Evander Holyfield. In their rematch in 1997, Tyson takes perhaps the most celebrated bite in the history of homo sapiens, twice gnawing off part of Holyfield's right ear. He is disqualified and suspended from boxing for a year. 1998: Tyson sues King for $100 million, alleging the Mephistophelean promoter with the electrified hair cheated him out of millions of earnings. In latter years, a chastened Tyson continues to fight, although his untamed desire seems dampened; he claims he boxes only to support his second wife, Dr. Monica Tyson, and their four children.

TYSON

SKIN DEEP

> Mike emerged from his hellish descent into the American penal system with a marked sympathy for the underdog and the glimmerings of a political consciousness, which he's reduced to radical chic by displaying it on his body. When Iron Mike steps into the ring, Mao and Che Guevara are his seconds, the latter emblazoned on his abdomen. And it's a Great Leap Backward for Mike's opponents when he connects with a right cross, for the Chinese potentate's face and name are the last thing they see before they thud to the canvas. (It's said that revolutionary leader's image has supplanted a homemade inscription of Tyson's first name.) On his left shoulder, Tyson has installed a picture of Arthur Ashe and the words "Days of Grace," the title of Ashe's book, which inspired Mike in the big house.

>"Be not PROUD, the spirit of the Undertaker lives within the soul of all MANKIND. Soon all mankind will witness the rebirth of the Undertaker! I will not REST IN PEACE!"<

THE INSIDE SCOOP

If you're seeking a final resting place for your brain, you're probably a fan of The Undertaker. Hardly the grave, oleaginous memorialist, he's 6'10", 325 pounds and offers one-stop mortuarial shopping: Before he embalms your loved one, he'll break his neck, and afterwards cart away his soul to the Stygian depths. At least that's the ringside M.O. of one of the most popular stars to have ever clomped his way into the WWF.

Dead Man, Mean Mark Callous, The Punisher, Master of Pain, Texas Red, Dice Morgan…like many aspiring wrestlers, Mark Calloway struggled for years to find a character that would resonate with the fans and catapult him to Pay-Per-View glory. Sometime in the late 1980s, inspired by memories of a job he'd had digging graves—or the brainstorm of one of Vince McMahon's flaks—Calloway assumed the role that would make him the scourge of the mortuary sciences. Hence The Undertaker, modeled after Wild West funeral directors (go figure), a hulking, lantern-jawed behemoth managed by Paul Bearer, whose accoutrements include body bags, caskets, and a labyrinthine back story full of cut-rate mysticism. Somehow, it all clicked with death-obsessed wrestlemaniacs who became his "Creatures of the Night" (probably because they don't have jobs), flicking their Bics

to support his "eternal flame of life." Let's go to the highlight reel:

- In 1991, he snatches his first WWF title from Hulk Hogan, and then joins him in the Tag Team Suburban Commando. (Look out, or they'll stomp all over your lawn!).
- After a 1994 Royal Rumble, where it takes 10 huge men to secure him in his own casket, he disappears, and an unlicensed imposter takes his place.
- He's reincarnated as The Lord of Darkness, sporting a more medieval look (also more makeup). He becomes really sensitive about opponents fondling his urn.
- He forms the Ministry of Darkness, a sort of Mafia for dead people. The Undertaker now claims he answers to a higher power—Vince McMahon.
- He merges the Ministry of Darkness with Shane McMahon's Corporation, in an attempt to wrest control of the WWF from Vince. The new firm, MinDarCorp, goes public and helps the Undertaker grab the WWF title against Stone Cold Steve Austin.
- In 2000, he alters identities again, emerging as the Mad Biker from Hell. But fan apathy has the Federation scriveners ready to turn him back into a heel.

SKIN DEEP

> UT's body is a virtual rune. The images on his left arm purportedly describe his existence in a past life. Staring out from his upper left shoulder is an image he calls the "Thinking Demon." Other pictographs are a moon sitting above a dragon and a zombie on a cliff. All of these are purportedly inspired by dreams (or too many blows to the head). His right arm symbolizes his present life and is filled with skulls, spirits, and other creatures of the night. Don't have an aneurysm trying to figure all this out: Calloway has admitted that the tattoos were simply personal preferences that just happen to mesh with his character.

the

RAW DATA

DATE AND PLACE OF BIRTH March 24, 1962, in Houston.

CURRENT RESIDENCE Nashville, TN.

CREDITS WWF Championship (3); Tag Team Championship (1); USWA Heavyweight Championship (once, as Master of Pain).

SHOE SIZE 16.

FINISHING MOVE Formerly the Tombstone Piledriver, but it got "too rough on the knees," so he now uses The Last Ride (also known as the Powerbomb).

OTHER MOVES Choke hold, choke slam (formerly called one-hand slam), snap-mare from the top of the ropes, and walking the top ropes while holding his opponent's arm in a lock.

TV "Poltergeist: The Legacy," in which he played the Soul Chaser.

STRANGE BUT TRUE

- Caution, May Cause Rigor Mortis: The Last Resort Biker Bar in Daytona, FL, sells the "The Undertaker's Hot and Spicy Embalming Fluid," which features on its label the verse, "Ashes to ashes, dust to dust, let's get on the Undertaker's bus."
- His favorite band is Black Sabbath.
- His hobbies include hunting, riding his Harley, and performing unauthorized autopsies.

UNDERTAKER

RAW DATA

DATE AND PLACE OF BIRTH December 19,1971 in New York City to Lloyd Beckford, a Jamaican, and Hillary Beckford, a Chinese-American ex-fashion model.
CURRENT RESIDENCE New York City.
CREDITS *Details, Noir, GQ, Vogue, Essence, Vibe, Men's Health, The New York Times, Paper,* Ralph Lauren Polo Jeans ads, and music videos for Toni Braxton, Mia X, Adina Howard, Notorious B.I.G., and Shaquille O'Neal.
FILMS *Boricua's Bond* (2000).

STRANGE BUT TRUE

- He still resides in Harlem with his best friend, D'von (he's helping him search for lost vowels).
- He auditioned for, but didn't win, the role of Winston in *How Stella Got Her Groove Back.* (See Taye Diggs.)
- One year he boycotted the Milan runway shows when he learned that he was the only African-American male model invited to walk (and was even further steamed to discover there were no Eskimo models, either).
- Among his published books is *The Tyson Beckford 16-Month 2000 Calendar.* (When he was told that there are only 12 months in a year, he fired his agent.)
- His hobbies include collecting and racing motorcycles, watching cartoons, snowboarding, and listening to hip-hop.
- He's said to be happiest when eating Cap'n Crunch while sitting on top of his washing machine.
- He says he's thinking of making a video called, "You, Too, Can Be a Suave Dude."
- He once dated Mike Tyson's girlfriend. Good thing the boxer didn't find out, or Beckford's next shoot would've been on the cover of *The Journal of Reconstructive Surgery.*

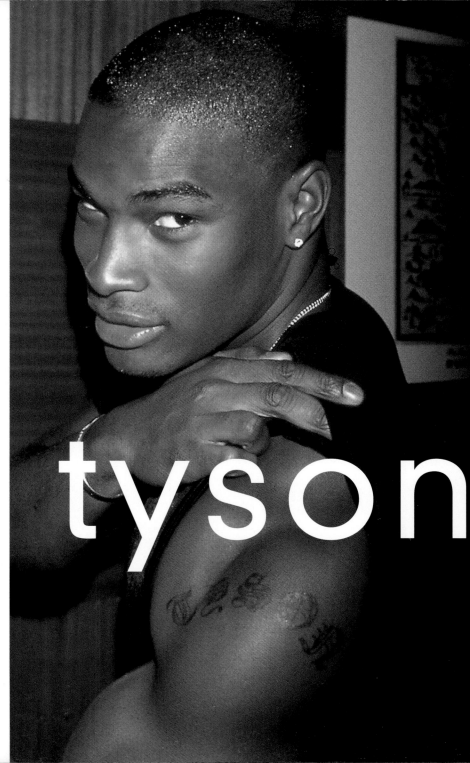

tyson

>Perhaps the most FRIGHTENING statement you will ever hear: "I'm going to try to flood the industry WITH ME."<

THE INSIDE SCOOP

In 1991, an editor from *The Source* plucked Tyson Beckford off the mean streets and, with the help of photographers Bruce Weber and Herb Ritts, created the first male African-American supermodel. Beckford's youth in Jamaica and Rochester, NY, was punctuated by gang-banging, drug-taking, and other criminal activities (about which, understandably, he is silent). And long before he was the face du jour, he scuffled on the runway to oblivion. He was about to retire from the business when he was booked as in a fill-in for Jason Olive to do a group Arena magazine cover. It redefined his career; by 1995, Beckford's exotically chiseled visage was gracing the covers of major magazines, and his Godzilla-sized image loomed down from Coliseum-like billboards everywhere. He became the first black model to be signed exclusively with a top designer when Weber brought him to Ralph Lauren. He was named 1995 Model of the Year at the VH1 Fashion Awards and one of *People* magazine's "50 Most Beautiful People." Beckford also starred in videos such as Toni Braxton's "Unbreak My Heart," and his oeuvre included a series of calendars and an exercise video, securing him a privileged place in the hearts of women and gay men everywhere.

BECKFORD

SKIN DEEP

> Sources say he has eight tattoos, although he's been quoted to the effect that he doesn't know how many times he's gone under the gun (a kind of tattoo-induced brain damage scientists are calling Popeye's disease). However, he's admitted that his goal is to have more than Dennis Rodman. He wears diamond earrings originally intended for his girlfriend. After they broke up, he decided to get his ears pierced and wear them himself.

OK, you're playing the Celebrity board game, and you're Angie Everhart.

As a child, you're mistaken for a boy and feel like a total geek. Cliché! Move back 10 spaces.

Your mother sends teen photos of you to a modeling agency, and they sign you up. Do not pass New York, move directly to Paris.

Land on the cover of *Elle* and *Glamour* (where you're their first-ever red-headed cover girl), and then become the "rear-end" girl for Levi's. Land in Hollywood.

Break your back falling off a horse and end up in a wheelchair for months. Thirty big ones for mega-sympathy P.R.

A three-month marriage to Ashley Hamilton, the son of George. You go, girl. Ten spaces for kitsch value.

Make your film debut in The Last Action Hero. "I really want to act" cliché. Retreat seven spaces.

Trying to sleep your way to movie stardom, you mate with Sly Stallone. Go directly to Hollywood Correctional Institute.

Appear in the sequel to *9 1/2 Weeks* with Mickey Rourke. Stephanie Seymour leaves you in the dust.

Do the *Sports Illustrated* swimsuit issue. Win pardon.

Land parts in *Jade, Bordello of Blood,* and other B flicks so bad, they're tested on chimps. Spend the rest of eternity in Hollywood Hell.

>"Every day of my life, I FEEL FAT. It's not correct thinking in the NATURAL, normal human being's WAY OF LIFE."<

angie

SKIN DEEP

> Everhart's most prominent tattoo depicts an angel playing a horn. The image runs from her lower back dangerously in a southern direction, stopping just in time. On her right ankle are a shamrock and the ace of hearts. At one point, she had her navel pierced, but she said, "It wasn't me, so I took it out." More recently, Everhart was seen sporting a diamond-studded adornment from Howard Stern, which her publicist calls a "friendship ring," but more accurately might be called ritual scarification.

DATE AND PLACE OF BIRTH September 7, 1969, in Akron, OH.

CURRENT RESIDENCE Los Angeles.

CREDITS Angie has done more than 100 covers for such magazines as *Glamour*, *Cosmopolitan*, *Elle*, and *Marie Claire*, as well numerous appearances in the *Sports Illustrated* swimsuit issue. She has appeared in commercials for Pantene Pro-V, Finesse, Schick (her legs were insured for $1 million to protect against defective razors), Diet Dr. Pepper, and Levi's 501 jeans.

FILMS *The Substitute 4: Failure Is Not an Option* (2000); *Bittersweet* (1999); *Welcome to Hollywood* (1998); "Executive Target" (TV), *Another 9 1/2 Weeks*, *Love in Paris* (1997); *Bordello of Blood*, *Mad Dog Time* (1996); *Jade* (1995); *Last Action Hero* (1993).

STRANGE BUT TRUE

- Her dog is named Edward Van Halen II. He eats chateaubriand and trashes his doghouse.
- In *Bordello of Blood*, Angie plays Lilith, the head vampire queen. Her servants bring her perverts looking for prostitutes, and she eats their hearts for energy. (She claims they taste better than Power Bars.)
- At Harvey S. Firestone High School in Akron, Angie was the mascot known as the "Firestone Chicken."

EVERHART

RAW DATA

DATE AND PLACE OF BIRTH May 5, 1966, in Rouen, France.
CURRENT RESIDENCE France.
CREDITS Magazines: *Elle* France, Sweden, and others; commercials: Guess, Cartier, Christian Dior, Lord & Taylor, Mixa, Revlon, Samsung, Sanger Harris, Thierry Mugler, and Vichy.
FILMS *Gross Fatigue* (1994).

STRANGE BUT TRUE

• Those who dare betray Estelle suffer the consequences. Valentin Lacambre, master of the French Internet domain www.altern.org, allowed one of his Web sites to post nude photos of Ms. Hallyday. A French court upheld Estelle's virtue by castigating the pornographer-by-default, claiming that he was responsible for the content of his cyber-tenants. Lacambre promptly closed up shop. The decision has nettled netizens in France and prompted criticism from the European Parliament, but who are they to mess with the modern Aphrodite?

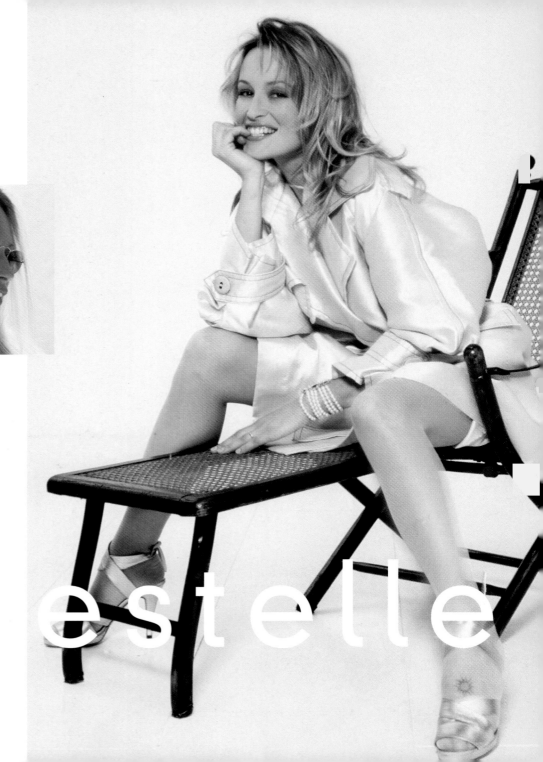

estelle

>"I hope to represent a MODERN, DYNAMIC, AND LIVELY France, but one which does not forget its traditions, especially the family." No, it's not Lionel Jospin, but Hallyday who bleated these words upon having her image nominated as a model for the face of Marianne, the SYMBOLIC STATUE in every French mayor's office.<

THE INSIDE SCOOP

You were first riveted by those Guess? advertisements, her cheekbones glinting like Mount Rushmore. When she splashed through *Sports Illustrated,* you felt the ocean's spray in your face (watch the jellyfish!). Her walk is the sinuous, sensual gait of a thoroughbred, a march that commands attention from her loyal subjects! And who could forget her famous "handlebar" ensemble in George Michael's "Too Funky" video, which has lingered long after Michael's career? She is a French icon, the equal of the Eiffel Tower, the Marseillaise, and the croissanwich. Cerulean-eyed, flaxen-haired, with the natural elegance of a gazelle—we could be discussing no one other than Estelle Hallyday.

Although supermodelologists say she was born to be adored, even the gods were jealous of her supernatural beauty and tried obstructing her from her deserved Olympian status. She was already 19—an age when many models suffer a midlife crisis—when she first arrived in the Parisian glamourhood. In the time it took her to strut down the catwalk, she assumed her place in the pantheon, outshining even such '90s divinities as Jill Goodacre, Yasmin Le Bon, and Carla Bruni. In 1993, her *SI* swimsuit appearance was so transcendent, cults sprang up around her tankini. The following year, she received the ultimate imprimatur of the *People* when she was named one of the 50 most beauteous.

Estelle is divine: Ichor runs in her blood—as well as adrenaline. She defies the Fates by racing fast, exotic chariots of the goddesses. Although an idol, she has the work ethic of a mere mortal and extends a courtesy to her votaries that melts them to the core. Estelle understands the importance of socializing and maintaining healthy relationships with her fellow deities, for even the gods must network. When she finally married a French musician it was declared a national Hallyday. Equally celebrated were her birthings: Ilona and Emma (now five and three).

Most of her compatriots realize they can never bask in her immediate glory, so in her tender mercy, she beams her image into their homes, addressing them on fashion, adventure, and her mythic lifestyle. And though we can never even fantasize about resembling her (indeed, it would be blasphemy) she has provided us with a sacred tome—*Estelle by Estelle: My Beauty Secrets*—that allows us to enhance our grimy visages by basking in her rays.

HALLYDAY

SKIN DEEP

> Estelle sports a panther's head on her foot. From a live panther.

>"The word exotic is very ALIEN to me. When I think of EXOTIC, I think of fruit rather than a PERSON."<

THE INSIDE SCOOP

Her story's got the trappings of a Sunday night made-for-TV movie.

Born Iman Mohamed Abdulmajid in the remote East African country of Somalia, as a child, Iman is nerdy and awkward. At her high school (ratio of boys to girls: 10 to 1), the bookish teen can't find a prom date. But her luck soon changes. As a poli-sci student at the University of Nairobi in Kenya, Iman has a chance encounter with a man who would change her life forever (fade to commercial).

Hotshot photographer and adventurer Peter Beard spies Iman and is taken with her exotic beauty. Beard offers to pay Iman to take her picture—the shrewd student demands he pay her college tuition. Beard agrees, takes more than 600 photos, returns to the U.S., and—in a story that will go down in modeling history—portrays Iman as a 20-year-old goat-herding beauty from the bush. (Reality: Her father is a diplomat and Iman speaks five languages.) The modeling world eats it up.

Iman up and moves to New York, signs with Wilhemena, and before long is commanding unheard-of amounts of money for modeling, garnering $100,000 for showing just one designer's collection. Quite a windfall for a girl who came from a country where the average yearly income was $150.

In 1978, Iman, 23, and NBA star Spencer Haywood get hitched. Almost immediately, the celeb couple adds a baby girl, Zulekha, to the family. Iman makes the requisite foray into films. But in 1983 (cue the dramatic music), the supermodel is nearly killed in a taxi accident. She dislocates her shoulder, breaks three ribs and her collarbone—and her famous cheekbones shatter. Her career hangs in the balance, but she pulls through, only to watch her personal life falter. Her husband becomes a heavy cocaine user, and in 1987, they sign divorce papers. She retires from modeling, still in hot demand.

It seems only fitting that Iman finds her true love three years later in the form of Glam Rocker David Bowie. They marry in 1992 in Florence, Italy, and live a fairy-tale marriage. She cooks for him; he dotes over their newborn, Lexie. She continues to champion humanitarian efforts and becomes a successful businesswoman, with the launch of Iman Cosmetics. They live happily ever after, but for this savvy siren, it's surely not The End.

RAW DATA

DATE AND PLACE OF BIRTH July 25, 1955, in Mogadishu, Somalia.
CURRENT RESIDENCE New York City and the Bahamas.
TV Guest appearances on "The Cosby Show" and "Miami Vice" (1984).
FILMS *The Deli* (1997); *Exit to Eden* (1994); *L.A. Story, Star Trek VI: The Undiscovered Country* (1991); *No Way Out, Surrender* (1987); *Out of Africa* (1985).
CREDITS A favorite model of Calvin Klein, Ralph Lauren, and Bill Blass. First woman of color to grace the cover of French Vogue and first black model under contract for a major cosmetics company—Revlon. Spent 16 years at the top of the business.

STRANGE BUT TRUE

- When Iman first arrived in New York from Africa, in October of 1975, the city garbage workers were on strike. She says she got used to the smell.
- Where's the Beef?: In 1996, Iman was recruited to hawk chicken sandwiches for Wendy's. In the spot, she gushes in a letter to Dave Thomas, "Darling, I saw your Grilled Chicken commercial the other day, and you looked fabulous." Kate Moss was subsequently spotted hitting the drive-thru window.
- Iman Ban: Allegedly acting the diva (*quelle surprise*), the supermodel was uninvited to participate in NYC radio station Hot 97's hip-hop fundraiser some years back.
- Hip-hop artists L'il Kim, Lauryn Hill and Mary J. Blige wax poetic when it comes to Iman Cosmetics. Rapper Missy Elliott's favorite lip shade: Misdemeanor.
- According to African custom, if a woman is trying to conceive, she should hold another woman's baby. After Iman and rock-icon husband David Bowie tried to get pregnant for a year with no luck, it seems a brush with Christie Brinkley's baby beckoned the stork.

SKIN DEEP

> Iman has a tattoo on her right ankle, and perhaps others on her body. (She allegedly surprised husband David Bowie on his birthday with a new tattoo.) Celebrating the birth of her daughter with a Moroccan friend, she partook in the ritual of having her feet painted with elaborate henna design. Her husband is also no stranger to body art. Although scarcely revealed, he has a massive design (10 x 8 inches) on his right calf, "done by the yakuza, the Japanese Mafia," he says.

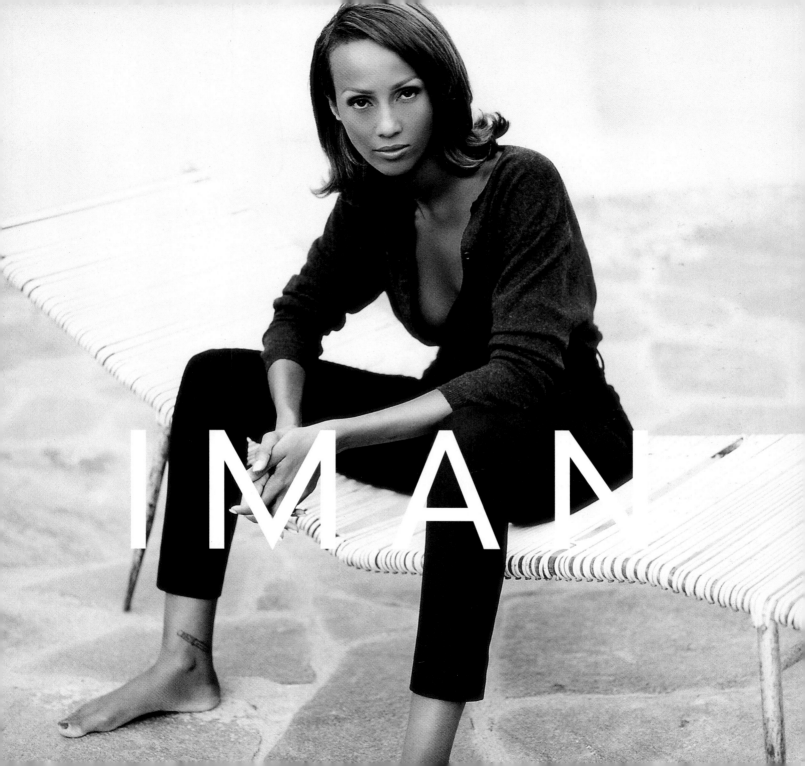

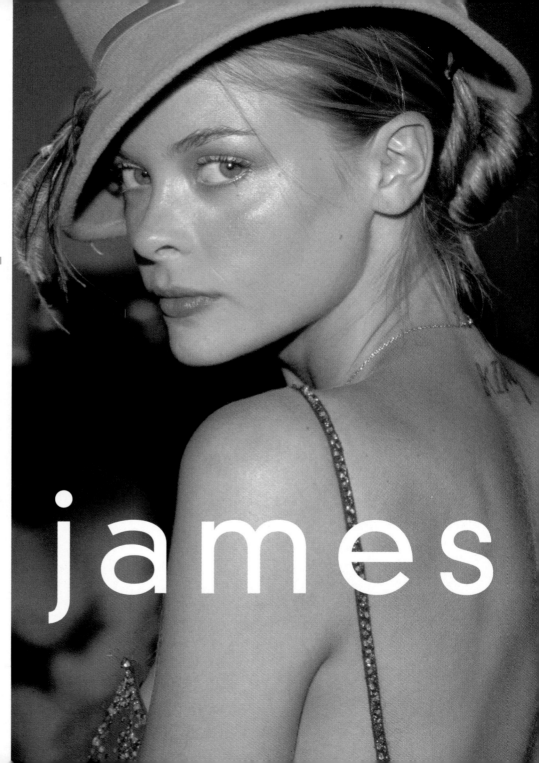

RAW DATA

DATE AND PLACE OF BIRTH April 23, 1979, in Omaha, NE.

CURRENT RESIDENCE New York

TV/VIDEOS Co-host, MTV's "House of Style"; appearance in Filter's video, "Take a Picture"; TV: "Inferno" (1992), appearances in "Catwalk," "Unzipped," "Naomi Conquers Africa."

FILMOGRAPHY *Bar Hop, Blow, The Happy Campers, Pearl Harbor* (2001); *Four Faces of God* (1999).

CREDITS Editorial: *Vogue, Mademoiselle, Allure, Seventeen, Glamour, Harper's Bazaar, Cosmopolitan, Details;* Advertising: Bebe, Benetton, Guess?, Kenneth Cole, Macy's, Mondi, and Nordstrom; Runway: Chanel, Christian Dior, John Galliano, Marithe & Francois Girbaud, Gucci and more.

STRANGE BUT TRUE

- James, nee Jamie, was named after Jamie Sommers, the '70s TV character on "Bionic Woman."
- Cut the Kid Some Slack: Although a natural on the catwalk, at age 15, James spilt red nail polish all over a Gucci dress right before strutting down the runway. Couture being what it is, we're guessing nobody noticed.
- Wild Child: Back home in Omaha, King's mother used to screw James' window shut so she wouldn't sneak out at night. It didn't work. Reportedly, her mother was upset when her daughter got her first tattoo (fairies on her lower back) at age 15. Wonder how she took the news of the nipple piercing...
- King of the World: At age 16, *The New York Times Magazine* featured James in a cover article about fashion's prepubescent up-and-comers entitled: "James Is a Girl." The following year, James took the term heroin chic a little too seriously—she jeopardized her career by arriving to shoots high.
- Despite being draped in thousand-dollar duds, James affirms that her fashion taste is more in line with mere mortals: "Banana Republic rocks." Attention teens: she's also admitted she's a big Britney Spears fan. (Now, is that a smart PR move?)
- Royal Couplings: James dated Kid Rock, the musician *Rolling Stone* called "the trash-talking, hard-rocking, rhyme-slinging king of the world," and is rumored to have been linked romantically to Sean Lennon. Recently, she's been seen canoodling with model and personal trainer Alex Burns.

james

>"When I was in junior high... I started getting my BREASTS earlier than EVERYONE, and people really made fun of me."<

THE INSIDE SCOOP

"When I was 12 or 13... I became literally obsessed with designers and models. Like, I would stay up till 3 o'clock in the morning slicing the best pictures out of *Harper's Bazaar* and *Vogue* and making collages and posting them up on my door..." James King's obsession with the fashion world paid off when she was discovered at the age of 14 while attending a modeling school in Nebraska. The blonde, blue-eyed Midwestern beauty packed up for Manhattan, launching her career on the catwalk.

Welcome to life in the fast lane. It didn't take long for James to be photographed by the industry's top photographers and appear on the covers of fashion magazines. By age 15, she quit school and had already worked the runway and posed for *Vogue, Mademoiselle, Allure,* and *Seventeen,* pulling down more than $300,000 a year.

But James' life was anything but picture perfect. Swept up in the scene, 16-year-old King ran with a fast crowd and became addicted to smack. When her fashion photographer boyfriend David Sorrenti died of a heroin overdose in 1997, James cleaned up. She has been known to wear an "SKE" necklace, an item that was passed on to her from Sorrenti's mother.

The publicity surrounding her addiction has dogged her, but King has risen above it. Having made herself comfortable in front of the fashion photographer's lens, and in front of the TV cameras (as an MTV personality, she's already part of teenage America's staple diet), King's next conquest is Hollywood. Who knows? With roles alongside Johnny Depp in *Blow* and Ben Affleck in *Pearl Harbor,* who's to say she won't transition to Queen of the Screen?

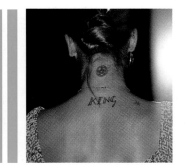

KING

SKIN DEEP

> James has nine tattoos: a diamond on her wrist, two fairies on her lower back, "King" between her shoulders (helpful in the case that she forgets her name), a design on her lower abdomen, and some more hidden from, ahem, sight (but we suspect Kid Rock knows intimately). Her nipples and tongue are pierced. Maybe that explains why she's the first model designers select to show off their sheer tops?

> On NUDE modeling:
> "Put clothes on me and
> I wouldn't look PRETTY
> anymore."<

THE INSIDE SCOOP

Species pass into extinction, planets devolve into black holes, civilizations rise and fall—yet the life cycle of a supermodel endures: exploitative dalliances with model-predators, romantic skirmishes with abusive rock stars, marriages to much older millionaires whose lives parody the Edwardian gentry.

This, alas, is the Stephanie Seymour story. Seymour began life as a mannequin at the age of 14, modeling for newspapers and department stores in her hometown San Diego. A year later, she entered the Elite Look of the Year contest and lost, as did another entrant, Cindy Crawford (they commiserated over a bowl of Evian). However, she was inspired to move to New York, and eventually Paris.

Adhering to the first rule of celebrity genetics, she married rock musician Tommy Andrews in 1989; the union lasted barely long enough to conceive a son, Dylan. Seymour found her star in 1991, when *Playboy* requested to shoot her on a Florida beach, a gig blessed by her mother. She walked the runways of Europe for two years and forged deep, lasting bonds with world-class reptiles Warren Beatty and John Casablancas, Elite's founder. In 1993, she appeared in *Playboy*'s Valentine's issue, then dumped Beatty for current pop trivia answer Axl Rose. According to the tabloids, the marriage was an underground pharmacist's wet dream, and it ended in court, with mutual accusations of physical abuse.

In 1994, two striking Avedon-shot spreads for Egöiste and Versace jeans ratcheted up Seymour's fame. That same year, *Paris Match* named her Most Beautiful Model, and. she also began her longstanding link to Victoria's Secret. Her mature phase ensued when she met and married Peter Brant, aristo publisher of *Interview* magazine. They have two sons: Peter Jr., and Harry. Seymour spends her down time riding her string of polo ponies and collecting art at her family's rural estate. She's abandoned the runway, and although in recent years she's appeared on the covers of *GQ, Vogue,* and *Cosmopolitan,* she severed her ties to Victoria's Secret, out of concern for her son, Dylan, whose schoolmates teased him about his supermodel mom.

stephanie

SKIN DEEP

> She has a band of flowers tattooed around her right ankle, a cruel reminder of her relationship with Axl. (They must now seem like kudzu.) Her other tat is a beauty mark on the inside of her left thigh.

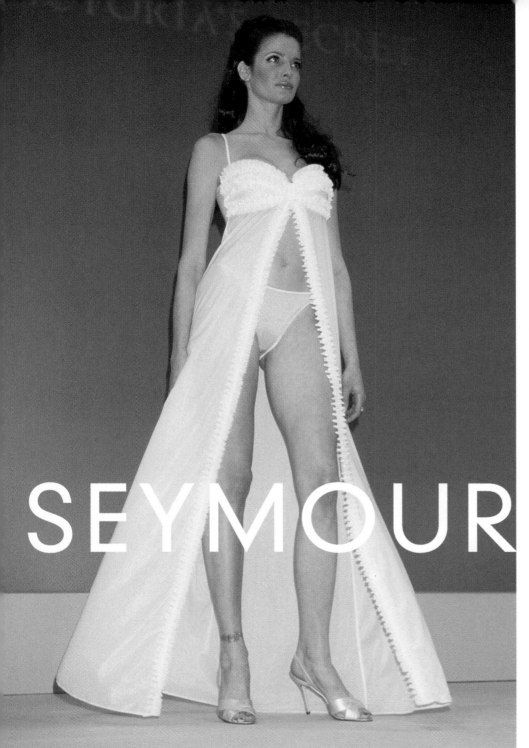

SEYMOUR

DATE AND PLACE OF BIRTH July 23, 1969, in San Diego, CA.
CURRENT RESIDENCE Greenwich, CT.
CREDITS Magazines: *Sports Illustrated, Elle, Self, Vogue, Allure, Marie Claire UK, GQ, Cosmopolitan.* Ad campaigns: Victoria's Secret, Guess?, Egoiste, Versace, Chanel, L'Oreal, and Laurèl Jeans, Capezio Bags, Cesare Paciotti, Diet Pepsi, Gerard Darel, Theresa König, and Yves Saint Laurent. Videos: "November Rain," by Guns 'n' Roses. CD-ROM game "Hell," developed by Take 2 Interactive Software, a company owned by her husband's son, Ryan. Signed with the Ford Modeling Agency.
BOOKS *Stephanie Seymour's Beauty Secrets for Dummies* (1998).

STRANGE BUT TRUE

- At her wedding to Peter Brant, guests included Naomi Campbell, Nadja Auermann, Claudia Schiffer, Kate Moss, and Kristen McMenamy. A caterer was unnecessary.
- Her estimated worth is $24.6 million.
- She has put out *Stephanie Seymour's Beauty Secrets for Dummies,* which includes a 16-page, full color Makeup Workbook. Readers are tested, and those posting an "F" are exiled to the Tammy Faye Baker Cosmetology Re-education Camp.
- She told *People,* "I prefer my body after I've had kids to before." (Beauty Secret for Dummies #28.)
- She calls herself a "model, a mom, but basically a normal girl."

RAW DATA

DATE AND PLACE OF BIRTH December 8, 1947, in Nashville, TN.
CURRENT RESIDENCE Marin County, CA.
DISCOGRAPHY (With The Allman Brothers Band) *Peakin' at the Beacon, Still Rockin'* (2000); *Back to Back: At Their Best* (1996); *2nd Set* (1995); *Where It All Begins* (1994); *An Evening with the Allman Brothers, Ramblin' Man, The Fillmore Concerts* (1992); *Shades of Two Worlds* (1991); *Seven Turns* (1990); *Brothers of the Road* (1981); *Reach for the Sky* (1980); *Enlightened Rogues* (1979); *Wipe the Windows, Check the Oil* (1976); *Win, Lose Or Draw* (1975); *Beginnings, Brothers and Sisters* (1973); *Eat a Peach* (1972); *Allman Brothers Live at Fillmore East* (1971); *Idlewild South; Live at Ludlow Garage* (1970); *The Allman Brothers Band* (1969). (Solo) *Searching for Simplicity* (1997); *Just Before the Bullets Fly* (1988); *I'm No Angel* (1987); *Playing Up a Storm* (1977); *The Gregg Allman Tour* (1974); *Laid Back* (1973). (With Cher) *Allman and Woman* (1977).
VIDEOS "Brothers of the Road Concert" (1994); "Live at Great Woods" (1992); "Brothers of the Road" (1982). Solo: "One Way Out" (1988).
FILMS *Rush* (1992); *Rush Week* (1988).
AWARDS Grammy, Best Rock Instrumental Performance, "Jessica," from the album *2nd Set* (1995).

STRANGE BUT TRUE

- His nine-day marriage to Cher resulted in Elijah Blue Allman, who sings with Deadsy, a goth-pop band. Musical success may not be congenital, though; it took Deadsy three years to get their first gig.
- As if Gregg's drug problems weren't enough to alienate Cher, it was rumored that the marriage broke up over her refusal to address him as "Mr. Allman." That's enough to drive anybody to hook up with salamander-tongued Gene Simmons of Kiss.
- Roadie!: Discussing his dissolution, Gregg said, "I was at 251 pounds. That's big. I went out to get in my 'Vette one day, and got in the seat and said, 'What the hell's wrong with this seat?' but it wasn't the seat—I wouldn't fit in there."
- Gregg cites jazz organ virtuoso Jimmy Smith as one of his great influences.
- The brothers' early bands were named Hour Glass, Allman Joys, and initially, the Allman Act.

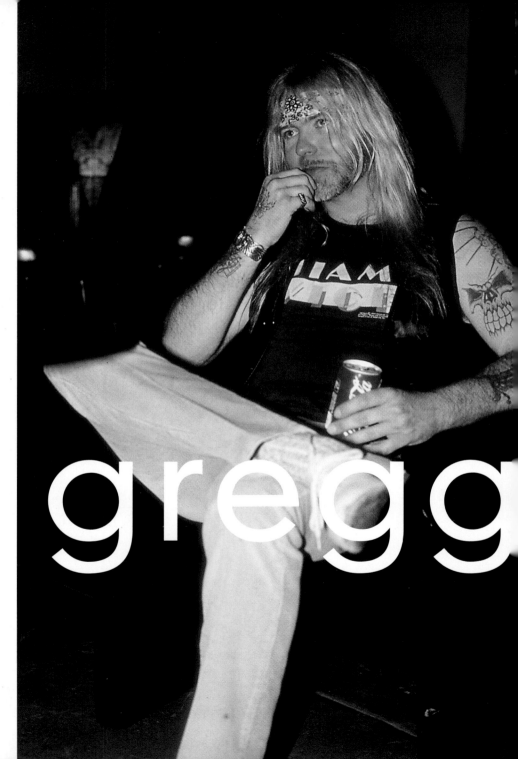

gregg

> "People and PAPARAZZI can drive you crazy. On the other hand, if I walked through the Atlanta airport and nobody recognized me, it would BREAK MY HEART." <

THE INSIDE SCOOP

Gregg Allman, lead singer, organist, and songwriter for The Allman Brothers Band, paid sufficient dues to justify his position as possibly the pre-eminent white blues shouter of his time. First, the Allmans' father was murdered when Gregg was two. In 1971, just two years after the band was formed in Jacksonville, FL, his brother, Duane, the band's premier guitar soloist, died in a motorcycle accident. A year later, the band's bassist, Berry Oakley, perished in an eerily similar chopper mishap. As the Allmans' fame escalated, Gregg developed numerous addictions, induced by guilt over helping to spawn Lynyrd Skynyrd. (Or was it from marrying Cher more than once?)

It's undeniable that the Allman Brothers' first four albums—*The Allman Brothers Band, Idlewild South, At the Fillmore East,* and *Eat a Peach*—were seminal recordings, and the boys even boasted a No. 2 pop single, "Ramblin' Man." As progenitors of the jazz, country, and blues bouillabaisse called "Southern rock," the Allmans exerted a wide influence on pop music. Yet their midnight ride was flagged down in 1976, at the height of their acclaim, when Gregg testified against band employee Scooter Herring in a federal drug case. This eventually led to a band breakup that lasted nine years.

In the interim, Gregg launched a solo career that emphasized a softer, more soul-influenced sound but never recaptured the brothers' glory. The Allmans reformed in 1979 for a year, then reunited again in 1989, to acclaim from a new generation. In 1994, they were voted into the Rock & Roll Hall of Fame in their first year of eligibility. The twilight of the Allmans may be upon us, though; in 2000, Gregg awoke from a lifelong alcoholic fog, learned how to work the fax machine, and notified founding guitarist Dickey Betts that, due to "creative differences," he was ousted from the band.

ALLMAN

SKIN DEEP

> Gregg boasts a coyote on his lower arm. This makes sense, since they're both feral, howling creatures of the night. In fact, the coyote is also known as the prairie wolf, a small swift creature that's found in deserts, prairies, open woodlands, and brush country. Although its prime habitat is the West and Southwest, like Allman, it is occasionally seen in New England. It's considered dangerous to livestock—as is Gregg, if you've ever seen him attack a plate of ribs.

THE INSIDE SCOOP

In 1983, Pantera was formed by founding members guitarist Darrell (Dimebag) Lance Abbott, his brother, drummer Vincent Paul Abbott, and bassist Rex Robert Brown. That year, they released their first album, *Metal Magic.* After several years of playing the rubber mosh-pit circuit as a Kiss-y-faced, glam-metal band, in 1987 they recruited "the original circus freak," Phil Anselmo, who transformed their sound into the raw, thrashing, and aggressive speed metal rock critics universally disdain. They recorded the most successful of their three independent albums, *Power Metal,* and alienated, black-trench-coated teens everywhere took notice.

In 1990, Pantera had their first worldwide success, the album, *Cowboys From Hell,* and performed at the Monsters of Rock festival in Moscow. The Russian audience, in the words of one observer, went "BUGFUCK at the band's earth-shattering brutality," and Pantera was retroactively credited with toppling the Soviet Union. In 1992, "Mouth for War" became the first metal single ever to debut at number one in the charts. *Guitar World* magazine raved "Anselmo sings with the fury of a post-office psycho." Somewhere between then and their 1996 release, *The Great Southern Trendkill,* Anselmo became suicidal and took up painkillers and heroin in a big way. In July 1996, after one near-lethal spike, he was pronounced dead for four minutes, during which time the band courageously continued touring.

>Paraphrasing Emerson, Anselmo told an interviewer, "NOTHING IS FOREVER; we are all going to croak. Death hits you about as gradually as a fucking mosquito hits a windshield. Have a FUCKING GOOD TIME, for God's sake."<

phil

SKIN DEEP

> Phil has more ink than the Sunday *New York Times.* Highlights include a howling demon on his right forearm, a snake on his left, and above that, a three-leveled existential equation that has been interpreted to mean: "Life today is not worth the pain." There's a fist with the words "Phil Core," another that depicts his face, tongue extended, as if razzing the world, and perhaps his most popular, the word "Unscarred" across his belly.

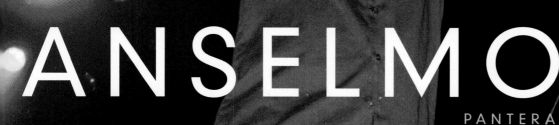

ANSELMO
PANTERA

RAW DATA
DATE AND PLACE OF BIRTH June 30, 1968, in New Orleans, LA.
CURRENT RESIDENCE New Orleans, LA.
DISCOGRAPHY *Reinventing the Steel* (2000); *Official Live* (1997); *Great Southern Trendkill* (1996); *Far Beyond Driven* (1994); *Vulgar Display of Power* (1992); *Cowboys from Hell* (1990); *Power Metal* (1988); *I Am the Night* (1985); *Projects in the Jungle* (1984); *Metal Magic* (1983).

STRANGE BUT TRUE

• The band is named after Pantera, TX, home state to Darrell, Vinnie, and Rex.

• Vinnie, Dimebag, and Rex own a strip club in Dallas.

• Every October in Jefferson, LA, Pantera runs a haunted house called the "House of Shock," featuring authentic-looking burned corpses, disemboweled swine and, as Anselmo says, "a crucified deer with his guts spilled out." ("Trick or treat? It's the ASPCA!")

• Phil plays in another band, Super Joint. "I play guitar and sing with Jimmy from EyeHateGod, Kevin from Crowbar on bass, and this guy Joe [a generic human] on drums."

• Phil almost left the band over his refusal to continue wearing black spandex.

• In the same vein, Pantera has cyberenemies, such as "Panterasucks: The Official Anti-Pantera Web site," at which they are accused of being "a bunch of homophobic rednecks who were afraid to look gay."

• One of Phil's song titles is "Good Friends and a Bottle of Pills," which leads one to believe he has a future in advertising.

RAW DATA

DATE AND PLACE OF BIRTH November 21, 1965, in Reykjavik, Iceland.
CURRENT RESIDENCE Iceland and London.
DISCOGRAPHY *Selmasongs: Music from the Motion Picture Dancer in the Dark* (2000); *Homogenic* (1997); *Telegram* (1996); *Post* (1995); *Debut* (1993); (with Sugarcubes) *Stick Around for Joy* (1993); *Gling Glo* (1990); *Here Today, Tomorrow, Next Week* (1989); *Life's Too Good* (1988); (with Kukl) *Eye* (1984); *Björk* (1977).
VIDEOS "Air Is Full of Love," "Bachelorette," "Joga," "Hyperballad," "I Miss You," "Possibly Maybe," "It's Oh So Quiet," "Army of Me," "Big Time Sensuality," "Venus as a Boy," "Human Behavior."
FILMS *Dancer in the Dark* (2000); *The Juniper Tree* (1987).
AWARDS Cannes Film Festival, Best Actress, *Dancer in the Dark* (2000).

STRANGE BUT TRUE

- Her last name is Gudmundsdottir.
- The filming of *Dancer* was said to be so tense that during one scene Björk tore her blouse to shreds and began eating it, before storming off the set. You can't blame her, considering that Iceland's national dish is hákarl (putrefied shark meat buried for up to six months to ensure sufficient decomposition).
- When she was 15, Björk played the drums in an experimental band with a friend who played the popcorn machine. They recorded the friend's grandmother snoring for their rhythm loop (creating a new dance form called geezeronica).
- She performed on Icelandic TV at 20 with her pregnant midriff exposed, reportedly inducing cardiac arrest in one viewer.
- If Not Björk, Then Who? Dept.: "Strákarnir á Borginni," the Icelandic Frank Sinatra and Dean Martin, are one of the country's favorite musical acts.
- About Iceland's hermetic atmosphere, she said, "I've done gigs where you're singing and they're shouting 'Hey, you didn't make your English degree! Your uncle is fucking my niece!'"

She's the vocalist du jour of angst-ridden, neurasthenic coeds everywhere, and Iceland's most popular export since sturgeon eggs. Her discordant keening (known to induce frenzy in lab rats), eclectic musical ragout, and pixie-ish persona combine to make Björk a quirky international pop presence. Björk's professional saga began at age 11 when, as a child chanteuse, she recorded an album of pop covers. She formed various punk groups in Iceland during the 1980s, including the Sugarcubes, who became a cult favorite here and in the U.K. After releasing a jazz album called *Gling Glo,* she gauged the musical winds, dissolved the Cubes in 1992, and launched a dance-and-club-oriented solo career. Her first all-Björk record, *Debut,* was a surprise international hit. In its wake, she left her husband, ex-Cubist Thor Eldon, and moved to London in 1993 with son Sindri. *Post,* her next release, was more eclectic, ranging from techno to balladry. For all her professed aversion to celebrity, Björk made headlines for her liaison with jungle artist Goldie, and her first-round knockout of a journalist seeking an unauthorized interview with Sindri. Though her music continued to garner critical praise, her Björk-ness made her biggest splash playing the tragic heroine of Lars von Trier's *Dancer in the Dark.* Both the film and Björk won awards at Cannes in 2000.

>"When fans write 'I LOVE YOU,' it makes me sick. They don't know me! I'm a difficult BASTARD in real life!"<

BJÖRK

SKIN DEEP

> Björk proudly boasts a Viking compass on her upper arm. "It's so I don't get lost," she says. Thor knows, the touring itinerary of a rock queen can be disorienting. "If the Vikings had bad weather or fog, they used to draw it on their foreheads with a piece of coal. I thought that was a bit much, so I put it there." If it doesn't help her find her way, she can always ask her manager. The tat is composed of either a Galdor Stave or Aegishjalmar (Icelandologists aren't sure)—Norse magical signs made of runes. These symbols were thought to be good luck charms that would aid their bearer, or to strike terror in one's enemies.

>"My new image is bein' MARY FOREVER! And whatever Mary wants to do, as long as it's the RIGHT THING, do it right, and do it well."<

THE INSIDE SCOOP

A jazz musician father who played his last family chorus when Mary was four. A high school dropout who hard-knocked her way through the ghetto jungle of Yonkers, N.Y. The neo-Lana Turner-ish discovery while cutting a demo at a local mall. A contract with Uptown Records, a top-selling debut album, *What's the 411?,* and a rapid ascension to the throne as queen of hip-hop. Egomaniacal tantrums. Disastrous love affairs. Drug addiction. Discovery of Jesus. Public remorse.

Mary J. Blige has truly lived the American Dream.

Through it all, she held fast to music, from her childhood singing hymns in a Savannah, GA, Pentecostal church, to her dues-paying early career, backing up one-hit wonders like Father MC, who soon hung up their Tommy-gear. *What's the 411?* went platinum, and the single "Real Love" topped the R&B charts and made her one of the biggest crossover artists since Ray Charles went C&W.

Other albums followed, of which she's sold over 19 million in the U.S. and 17 more overseas and won many awards. Critics credit her as the first R&B singer to storm the barricades of hip-hop.

mary j.

SKIN DEEP

> She has six tattoos, reflecting conventional celeb themes—vanity, Eastern philosophy, Western religious symbolism, flowers: (1) her name inscribed like a bracelet on her right arm; (2) the Japanese symbol for strength on her right hand; (3) a cross on her left arm; (4) a butterfly on her back; (5) a rose on her right inner thigh; and (6) one on her derriere that she refuses to discuss, along with a mark under her left eye, which she got at an L.A. scarring parlor.

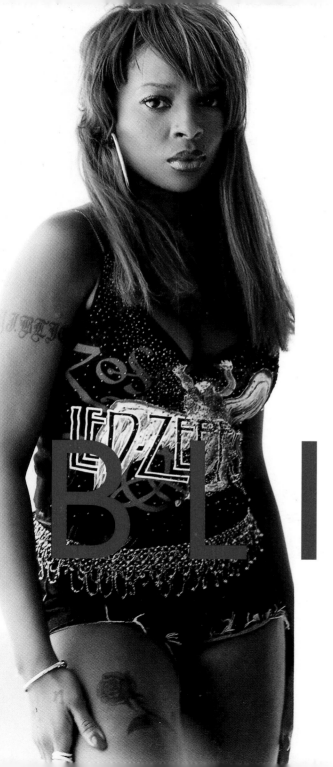

RAW DATA

DATE AND PLACE OF BIRTH January 11, 1971, in the Bronx, NY.
CURRENT RESIDENCE Long Island, NY.
DISCOGRAPHY *Mary* (1999); *The Tour* (1998); *Share My World* (1997); *My Life* (1994); *Love No Limit* (1993); *What's the 411?* (1992); *You Remind Me* (1992).
AWARDS Grammy, Best Rap Performance by a Duo or Group (with Method Man), "I'll Be There for You/You're All I Need to Get by" (1995); Soul Train Music Awards/The 2000 Sammy Davis Jr. Award, Entertainer of the Year (2000).

STRANGE BUT TRUE

- She's a celebrity spokesdiva for the MAC lipstick shade Viva Glam III (along with Lil' Kim) and Dark & Lovely hair coloring (the latter an ironic choice, considering that she's credited with introducing peroxide to the hip-hop community). Her dread extensions were constructed by the U.S. Army Corps of Engineers.
- She collaborated with animator Stan Lee to create an Internet series in which she appears as "Protector of the 'Hood," a hip-hop super heroine who vanquishes criminals by threatening to stretch out single vowel sounds for 36 bars.
- She has had affairs with K-Ci and Case. Someday she hopes to meet a man with a last name.
- If she were invisible, Mary said she would "go to Bulgari and all the designer clothes shops. And I'd take everything outta there."
- Mary has a pet Pekinese dog named Popeye, who wears a tattoo of an anchor on his left paw.
- Someday—after she becomes a billionaire with her own branded empire—she plans to get her high school diploma.

BLIGE

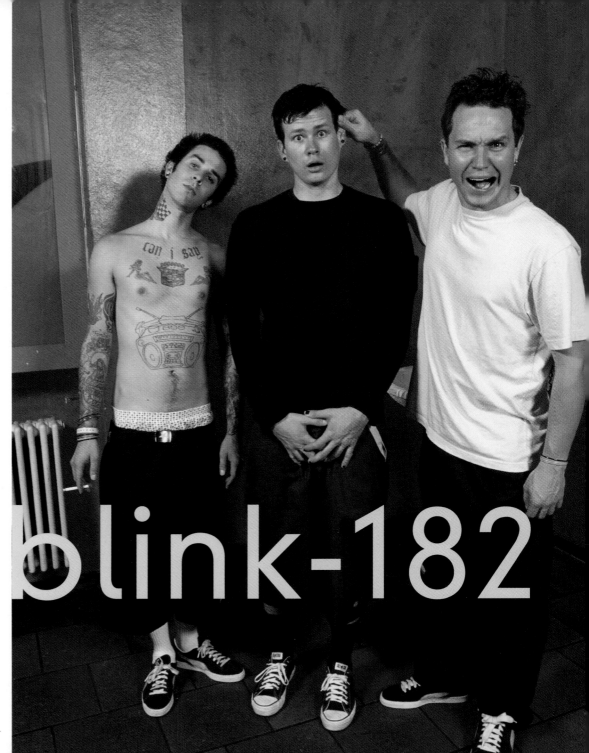

RAW DATA

BAND MEMBERS Tom DeLonge (guitar, vocals), Mark Allen Hoppus (bass, vocals), Travis Landon Barker (drums).
DATE AND PLACE OF BIRTH Tom: December 13, 1975; Mark: March 15, 1972; Travis: November 14, 1975, San Diego, CA.
CURRENT RESIDENCE Tom: Encinitas, CA; Mark: Carmel Ranch, CA; Travis: Riverside, CA.
DISCOGRAPHY *The Mark, Tom, and Travis Show (The Enema Strikes Back)* (2000); *Enema of the State* (1999); *Cheshire Cat* (1998); *Dude Ranch* (1997); *Buddha* (1994); *Fly-Swatter* (1993).
TV "Two Guys and a Girl," "Shake, Rattle, and Roll: An American Love Story" (1999).
FILMS *American Pie* (1999).

STRANGE BUT TRUE

- Mark's first band was called Pier 69; Tom was in a band called Big Oily Men.
- The band's original name (before Blink) was Duck Tape, which was so inane no other band dared sue over it.
- Their concerts include mocking impersonations of the Backstreet Boys, 'NSync, and Britney Spears.
- They have been rumored to heckle fellow customers in McDonald's (perhaps part of a promotional tie-in?).
- It Could Be Worse: Band members have voiced interest in doing a stand-up comedy tour.
- The number 182 was chosen at random (just like their music).

blink-182

> "If we had a DOLLAR for everyone that wants to kill us, we'd be PRETTY RICH right now." —Tom DeLonge of BLINK-182<

THE INSIDE SCOOP

If Beavis and Butt-head had started a band, it would be something like Blink-182: raw, unself-consciously puerile, obsessed with sex and scatology. Like the animated morons, this hugely popular, second-generation punk trio had humble beginnings. Initially called Blink, it was spawned by Tom, Mark, and original drummer Scott Raynor at a San Diego summer resort (Camp Sid Vicious?) and its first gigs were weddings and birthdays.

Blink became a crossover band, from Hokey Pokey to punk-ska, and released their debut album, *Fly Swatter* in 1993. When an Irish band named Blink threatened a lawsuit, the Americans blinked…182. After releasing the album *Buddha* in 1994, the trio signed with Grilled Cheese/Cargo. Soon after their hit album, *Cheshire Cat,* was released in 1995, Raynor left the band and formed the Axidentals and was replaced by Travis Barker of the Aquabats (he was known as "Travis Baron von Tito"). They gained national attention when they joined Pennywise and NOFX on the 1996–97 Warped Tour. Their third LP, *Dude Ranch,* was released in 1997, and garnered them a contract with MCA, who in the summer of 1999, released their fourth album, *Enema of the State,* which sold far too many copies.

Their music has been labeled "bubblepunk," and they've been called "the class clowns of punk" for their adolescent onstage shenanigans. For example, one live set list included the tunes "Dick Lips" and "Shit Piss," and their concert jaunts have included the "Poo-poo Pee-pee Tour" and "Race Around Uranus" (an event in the X Games, with which Blink is heavily involved, having appeared in boogie- and snowboarding videos).

SKIN DEEP

> Travis gets the honors of having the most body art in the band. In fact, he has so many tattoos, they require a separate roadie. His collection includes a Virgin Mary on his arm (for his mom), the word "Familia," drums, devils, birds, a dollar sign, a microphone, a girl astride a rocket, Jesus Christ—and that's just on his arms. Moving to the torso, we find an abdominal boom box, "trucker ladies," the Cadillac logo, and the words "Can I Say" ("for DagNasty"). On his leg he sports the words "I don't want to grow up," which he credits to the Descendents because "that band changed my life." (Before that, his ambition was to tend to lepers in Africa.) After all the spilled ink, Travis must have realized it was cheaper to open his own shop, and so he did, called Famous Stars and Straps.

> Tom sports a few ink splotches as well, and Mark has a pierced nipple and an earring but is tat-less.

> "I'm DESPONDENT when I see the cover of *Rolling Stone* assigned to BRITNEY SPEARS or 'N Sync." <

THE INSIDE SCOOP

Sayreville, NJ, 1983. A young John Francis Bongiovi records a demo record called "Runaway," and it becomes a surprise local radio hit. To support the song, the erstwhile rocker assembles a band with David Rashbaum, guitarist Dave Sabo, bassist Alec John Such, and drummer Tico Torres. Bon Jovi—and the roots of "hair metal"—is born. Over the next few years, Bon Jovi hone their coifs, and it pays off. Their third album, *Slippery When Wet,* goes platinum, and two of its songs, "You Give Love A Bad Name" and "Livin' on a Prayer," go to No.1. Fueled by videos that showcase his collagenated visage, the former Italian-American becomes a certified rock deity. The subsequent album, *New Jersey*, features five Top-10 singles and the band continues mining platinum.

After a grueling tour in 1990, Jon takes time off to write the soundtrack for the film *Young Guns II* (released as *Blaze of Glory*). The sales of 1992's *Keeping the Faith* slide, though, and the band's next record, *These Days* sells better in Europe than the U.S. Jon takes this as a sign to take a four-year sabbatical, becoming a solo artist and film actor. Reunited in 2000, Bon Jovi returns from the metalhead graveyard with the release of another platinum disk, *Crush.* It spikes the band's career total album sales to 75 million, thus causing alien civilizations to abandon all plans to visit Earth.

SKIN DEEP

> The most prominent of Jon's numerous tattoos are a longhorn skull on his right arm and a Superman insignia on his left bicep, which according to several top scientific studies, apparently triggers elevated heart rates and respiratory levels in his female fans. Perhaps some of them envision Bon Jovi as a be-vinyled superhero who arrives on the crime scene in a Bentley and thwarts evildoers by keeping them off the guest list at the Viper Room. Jon also has a feminine side, illustrated by some flowers on his ankle.

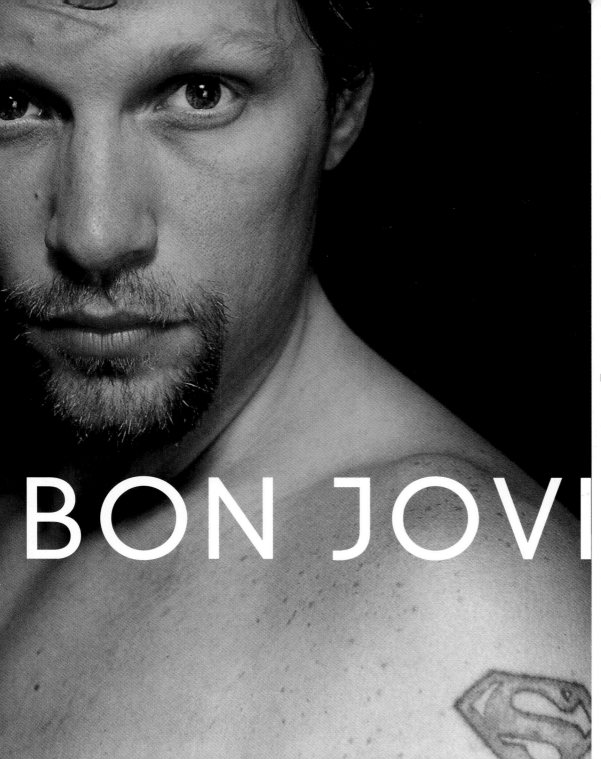

BON JOVI

RAW DATA

DATE AND PLACE OF BIRTH March 2, 1962, in Perth Amboy, NJ. CURRENT RESIDENCE Rumson, NJ. DISCOGRAPHY *Crush* (2000); *Destination Anywhere* (1997, solo); *These Days* (1995); *Cross Road* (1994); *Keep the Faith* (1992); *Blaze of Glory* (1990, solo); *New Jersey* (1988); *Slippery When Wet* (1986); *7800 Fahrenheit* (1985); *Bon Jovi* (1984). Soundtrack: *Blaze of Glory*. VIDEOS "It's My Life," "Something for the Pain," "Bed of Roses," "You Give Love a Bad Name," "I Wish Everyday Could Be Like Christmas." FILMS *Vampires: Los Muertos* (2001); *Pay It Forward, U-57* (2000); *Homegrown, Little City, No Looking Back, Row Your Boat* (1998); *The Leading Man* (1997); *Moonlight and Valentino* (1995).
AWARDS American Music Award, Best Pop/Rock Band, Duo or Group (1987); Golden Globe, Best Song, "Blaze of Glory" (1990).

STRANGE BUT TRUE

- Jon didn't exactly top the Penis Chart at Donna's Domain, a Web site that evaluates the anatomical endowments and lovemaking skills of more than 150 metal stars.
- At a gig at New York's China Club, Jon "married" a fan who proposed to his girlfriend on stage. (The marriage was later annulled by Def Leppard.)
- When forming the band, Bongiovi and Rashbaum changed their names to Bon Jovi and Bryan, respectively—a fit of assimilation not seen since Ellis Island.
- Jon campaigned strongly for Al Gore, which cost Bon Jovi several million in record sales.

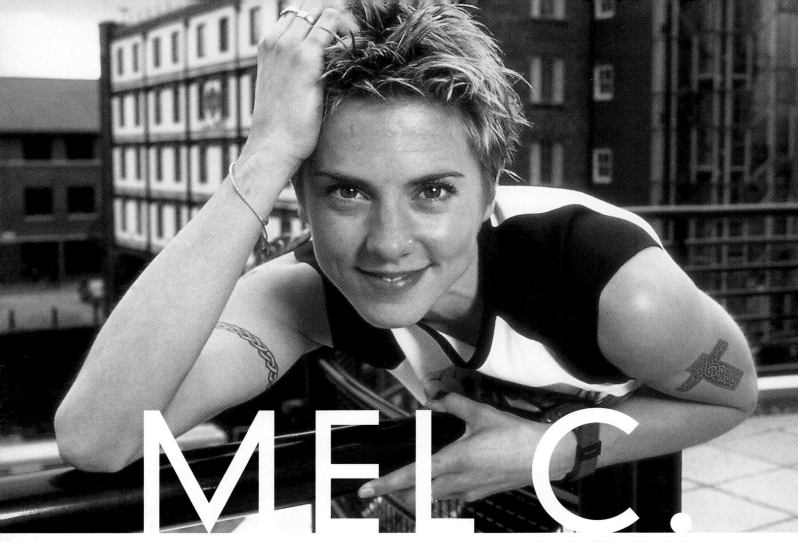

MEL C.

SPORTY SPICE

RAW DATA

DATE AND PLACE OF BIRTH January 12, 1974, in Liverpool, England, to Joan O'Neill and Alan Chisholm. She has a stepfather, Dennis, and stepmother, Carol; two step-brothers, Jad and Stuart; half-brothers Paul, Liam, and Declan; and a half-sister, Emma.

CURRENT RESIDENCE London.

DISCOGRAPHY *Forever* (2000); *Star Profile* (1999); *Interview* (1998); *Spiceworld* (1997); *Spice* (1996).

FILMS *Spice World* (1997).

STRANGE BUT TRUE

• The Spice nicknames—Scary, Ginger, Baby, Sporty, and Posh—were given to them by the British teen magazine *Top of the Pops* (after they discarded the original names—Fyodor, Alyosha, Dmitri, Ivan, and Raskolnikov).

• Victoria (a.k.a. Posh Spice) named her son Brooklyn. We hear that, for her first-born, Melanie C. is leaning toward "Newark."

• Her musical ambition is to learn the guitar.

• Non-musical—and more realistic—ambition: to be a top footballer.

• Mel is another dateless superstar who supposedly refers to herself as Sad Spice. She claims, "I haven't met anyone yet who interests me. My idea of the perfect night would be to go down the pub, have a few beers, go to a football match, then back to the pub for a few more beers."

>Mel C. once said, echoing John Lennon, "If OASIS are bigger than God, what does that make us? BIGGER than BUDDHA? Because we are a darn sight bigger than Oasis."<

THE INSIDE SCOOP

The Spice Girls sprang full blown from the lizard brains of a father-son management team in London, who in 1993 placed an ad seeking young women who could sing, dance, and find their navel. The five finalists—Victoria Adams, Melanie Chisholm, Geri Halliwell, Melanie Brown and Emma Bunton—were locked in a house and put through Pop Star Boot Camp. They emerged a year later as the Spice Girls: Scary (Melanie Brown), Ginger (Geri Halliwell), Baby (Emma Bunton), Sporty (Mel C.), and Posh (Victoria Beckham, nee Adams). Their first single, "Wannabe," released in 1996, sold 4 million copies and made the girls international sensations. Their next two singles, "Spice," and "2 Become 1" also sold a million copies each, setting a record (three straight million sellers out of the gate). They became pop icons and ascended to the pantheon of celebrity, meeting Prince Charles and appearing with Luciano Pavarotti (Big Fat Mozzarella Spice?).

Over the next few years, they solidified their hold on the tabloid imagination, repeatedly floating rumors of a break-up whenever their Q ratings began to slide. (Ginger did leave the band in 1998 to pursue a solo career.) The Spice Girls will be remembered best for their slogan, "Girl Power," which means being masterminded by powerful male record executives and exploiting their nubility.

Over the past few years, the girls have branched out to do solo albums, leading even their fans to wonder if they were being overspiced. As for Mel C., she's considered the best singer, and Dennis Miller once called her, "the least superficial Spice Girl."

C's first Spice-less disk, *Northern Star,* was released in 1999 and became a huge smash in her native U.K. That same year, she had a No. 1 solo single "Never Be the Same Again," featuring TLC's Lisa "Left Eye" Lopes.

SKIN DEEP

> Eight tattoos: (1) a Celtic chain around her right bicep; (2) Chinese pictographs on right shoulder that say "Girl Power" or, literally "Woman and Strength" (Note: Her Mom has the same tattoo on her right shoulder); (3) A large Celtic cross on her upper left arm; (4) the word "Angel" gently curving up in an arc below her navel; (5) A lotus flower and Tibetan writing at the base of her spine; (6) A phoenix across her back; (7) a Chinese dragon on her right calf; (8) a small star on her right hand. She got the dragon to complement the phoenix, because in China, the phoenix represents the female and the dragon represents the male. She says, "I was a little out of balance," leading her to over-tip at Chinese restaurants.

> Piercings: The left side of her nose; her right ear (twice up near the tip). She also has a gold tooth cap (upper left, 2nd incisor, according to X-rays *Celebrity Skin* surreptitiously procured from her dentist).

> "I'm not a MC, I'm a VIBE-GIVER."<

- Puff Daddy Settles Lawsuit. [1]
- Puff Daddy, Lil' Kim, Lil' Crease Sued for $200 Million. [2]
- Puff Daddy, Lopez Arrested After Shooting. [3]
- Club Owner Sues Puffy for $1.8 Million.
- Driver Sues Puffy for $3 Million.
- Puff Daddy Pleads Not Guilty to Weapons Charges.
- Notorious B.I.G. Gunned Down in Los Angeles.
- Puff Daddy Charged With Bribery.
- Puff Daddy Hit With $100 Million Lawsuit by Club New York Bouncer.
- Sean "Puffy" Combs Pleads Guilty in Assault on Record Exec.

And so it goes… Trailing the career of Sean "Puffy" Combs, who has risen from local party promoter to hip-hop impresario, is a string of murders, shoot-outs, assaults, riots, and more lawsuits than Court TV. Along the way, he's created a multi-million dollar industry around Bad Boy Entertainment, a record label whose stable of stars has included Notorious B.I.G., Craig Mack, Faith Evans, 112 and Total, all of whose records Combs has produced.

Combs dropped out of Howard University to take his first music job at his friend Andre Harrell's Uptown Records, where he produced hit singles by Jodeci and Mary J. Blige. These successes encouraged Combs to launch his own label, Bad Boy. One of the acts he signed was the Notorious B.I.G., whose mammoth success ignited a feud between Puffy's East Coast rappers and Suge Knight's L.A.-based Death Row records that was fueled by rumors of cuckoldry (Puffy and B.I.G. wore the horns) and ended in the shooting deaths of first Shakur, then Mr. Notorious. In the wake of B.I.G.'s death, Puffy recorded a tribute to his friend called "I'll Be Missing You" that stole its melody from "Every Step You Take," by the Police. Combs's subsequent LP as Puff Daddy, *No Way Out,* shot (excuse the term) straight to No. 1 and went multi-platinum. He released another bestseller, *Forever,* in 1999, but has spent most of the ensuing time giving depositions.

Besides Knight, his mentor Harrell, and his countless lawsuit opponents, Puffy has drawn the wrath of hip-hop fans, who have accused him of being a sample-heavy rapper wannabe. To escape the chaos, Combs has "recreated" himself, a lá The Artist Formerly Known As. Enter P. Diddy. (What happens to the monogram towels?)

SKIN DEEP

> Evidently, Puffy knew a while back that he'd need a little help from above. In addition to large tats on both of his upper arms, he's got lines from Psalm 23 tattooed on one forearm and the words "God's Child" stenciled on his neck.

[1] By a woman who was injured during a 1991 stampede that occurred after a charity basketball game sponsored by Combs, for which he was held partially liable.

[2] Puff, Lil' Kim, and Lil' Crease–everybody but Lil' Abner–are named in a $200 million lawsuit filed by a Brooklyn woman who claims that her good name was muddied when a risqué conversation between herself and Lil' Crease ended up on Crease's 1999 hit, "Play Around."

[3] The scene: Club New York in Manhattan, late 1999. Shots that injured three people were fired after a patron reportedly tossed some Benjamins in Combs's face (in an attempt to give Puffy an American history lesson). Bad Boy "recording artist" Jamal "Shyne" Barrow, who arrived with Combs's party, allegedly fired the shots and is currently facing three counts of attempted murder. Puffy then took a powder, as he, his then-Puff Mommy, Jennifer Lopez, and bodyguard Anthony "Wolf" Jones fled the scene in an SUV driven by chauffeur Wardel Fenderson. Combs and Jones now face charges for possessing stolen handguns and attempting to bribe a witness, as Puffy reputedly offered Fenderson $50,000 and a diamond ring if he would claim ownership of the gun found in the vehicle.

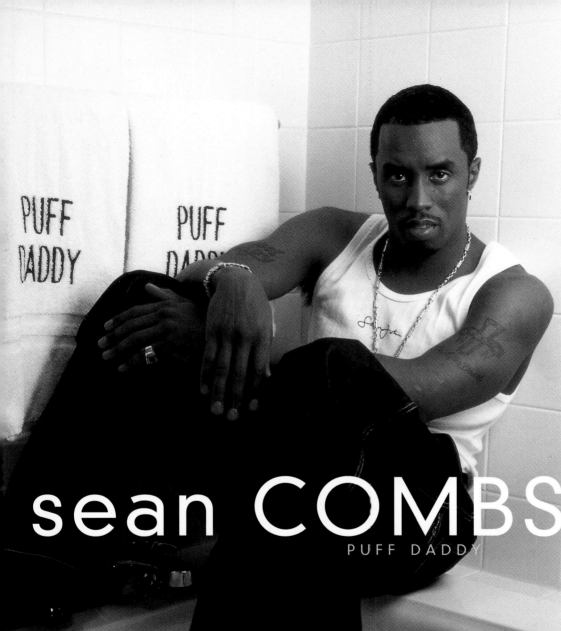

sean COMBS
PUFF DADDY

RAW DATA

FULL NAME Sean "Puffy" Combs,
a.k.a.: Puff Daddy, P. Diddy.
DATE AND PLACE OF BIRTH 1970 in Harlem, NY.
CURRENT RESIDENCE New York City.
DISCOGRAPHY *Forever* (1999);
No Way Out (1997).
VIDEOS "Friend," "P.E. 2000," "Satisfy You,"
"Come With Me," "It's All About the
Benjamins," "Been Around the World,"
"Can't Nobody Hold Me Down," "Victory,"
"I'll Be Missing You."
AWARDS Grammy, Best Rap Album, *No Way
Out*; Grammy, Best Rap Performance by a
Duo or Group, "I'll Be Missing You" (1998).

STRANGE BUT TRUE

- Puffy said "My Best Friend" was not, as assumed, written about Notorious B.I.G., but about the Omnipotent G.O.D. "I love the Lord," says Puff the Magic Litigant, "and I want people to know that you don't have to be perfect to have a relationship with God."
- You Say Daddy, I Say Diddy: After being acquitted on charges surrounding a highly publicized NYC nightclub fracas, Combs claimed that he was going to change his name. Alas, out with Puff Daddy, in with P. Diddy. Letterman offered alternative suggestions: "Puff Boy-Ar-Dee, Howdy Diddy, Milk Duddy, P. Blicity Stunt and J. Lonely."
- Combs hosted a special "Kid's White Party" for some 100 foster children from New York City. This was part of his annual East Hampton White Grownups Party (and not part of the annual White Party held by gay men in South Beach). It was Puffy's version of the Fresh Air Fund, in which he has Martha Stewart teach inner city kids how to make "perfect Christmas ornaments" out of used syringes.
- Puffernutter has wailed that "At times I feel like I'm trapped inside of a movie starring me, but I'm not the director, and I don't know what the next scene is."
- Puff Man recorded rock, rap, and Spanish versions of his single, "P.E. 2000." He claims the diversification reflects his desire to overcome musical and racial barriers, not a niche marketing ploy. (Then he released a version through AARP.)

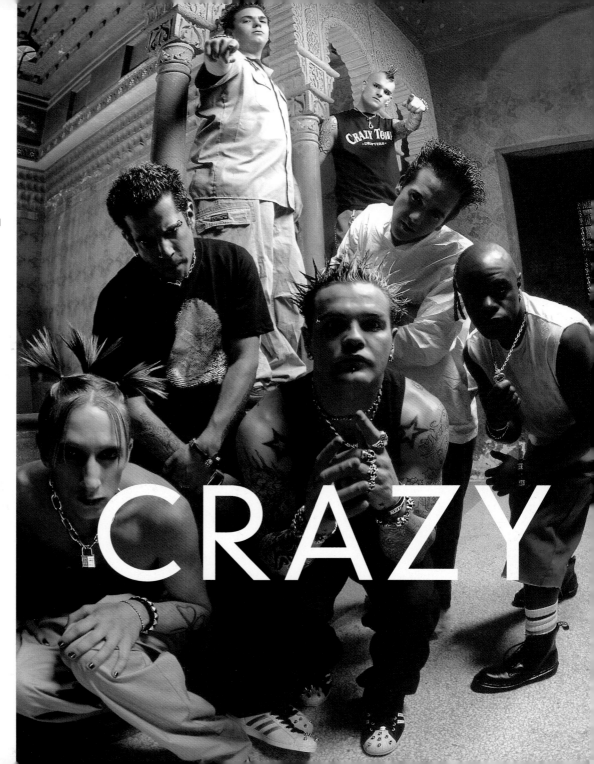

RAW DATA

BAND MEMBERS Seth "Shifty Shellshock" Binzer (lead vocalist); Brett "Epic" Mazur (lead vocalist); Faydoedeelay (bass); Trouble Valli (guitar); JBJ (drummer); and Squirrel (guitar).
DATE AND PLACE OF BIRTH Most of the band members are 26. (You do the math.) Shifty is from L.A.; Epic is from New York.
CURRENT RESIDENCE Los Angeles.
DISCOGRAPHY *The Gift of Game* (1999).
VIDEOS "Butterfly" (1999).

STRANGE BUT TRUE

• X Marks the Spot: CXT is short for Crazy Town. What does the "X" stand for? Well, nothing. It's just a graffiti thang.
• Epic's favorite cereal is Lucky Charms.
• All in the Family: Shifty's uncle, and his dad, a former art director for Chess Records (a blues label), designed *The Gift of Game* album cover.
• All in the Family, Part 2: Following an outburst that got the band kicked out of Ozzfest, Shifty went on a bender. His mom called good friend and Red Hot Chili Peppers frontman Anthony Kiedis to intervene. Says Shifty: "Anthony's the angel that apperared in my life."
• Rite of Passage: Shifty's dad wouldn't allow his son to get a piercing until he "got into a shipwreck." So at age 8, Shifty took a sailing class and crashed the boat on purpose. He was then rewarded with an earring.
• Bad Boys, Bad Boys: Nearing age 20, Shifty ended up on L.A.'s Most Wanted list as part of a drug-related debacle. Trying to run from the cops, he ended up surrounded at a 7-eleven, and serving a three-month sentence. He claims he's been "pretty good" ever since.

CRAZY

> "I'm all for PEOPLE GETTING MUSIC. I think music and weed should be FREE."—Brett "Epic" Mazur, on downloading MP3s. <

THE INSIDE SCOOP

Just when they would have given up on their gig, *The Gift of Game* hit The *Billboard* 200. Record industry folks believe the rock/hip-hop/rap ensemble Crazy Town has its third single, "Butterfly," to thank for that. A groove-oriented ballad, "Butterfly" has found an audience with the Top-40 crowd (read: radio and MTV's Total Request Live).

Band co-founder Epic Mazur attributes the turmoil that threatened to wreck the band to their inability to catch a break. In 1992, Shifty Shellshock and Epic formed Crazy Town. The album's first two singles were essentially ignored by most mainstream media. Over a yearlong period, Crazy Town toured smaller acts, building momentum until the "Ozzfest incident," where an emotionally bent Shifty pitched a chair out of a window. Says Epic, "We were pulled off of Ozzfest because of the breakdown, and some of us had drug problems, too."

For Shifty, drugs are as much a part of his lifestyle as the music he creates. "For years, we made music on drugs in a loft in downtown L.A. We'd do one song and celebrate for six months," he told *Rolling Stone*. Although he seems to still dabble in illicit substances, we're unclear whether the D.A.R.E. tee sported in the "Butterfly" video is meant to be taken seriously (or perhaps part of a parole arrangement?).

On any given day, band members will cite different musical influences—from the Beasties and A Tribe Called Quest to Public Enemy and Nine Inch Nails. While the band considers new tour plans, Crazy Town is hard at work on its next album, due out at the end of 2001. Fans shouldn't get used to what they hear from Crazy Town. Says Epic: "I want to continue to confuse people."

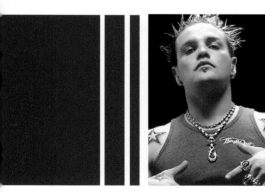

SKIN DEEP

> Though most members are tattooed to some extent, Shifty's body art is most flaunted. He says that all of his tats are special to him. His reverence for Mary Jane is displayed on his right arm. His first tattoo, applied for his 18th birthday, is a marijuana leaf surrounded by a tribal band because "weed was the biggest part of my life at that point." He also cites a guardian angel image, which invokes the spirit of his grandmother.

>WHEN asked who would play him in his BIO PIC, he replied, "He got to be a smooth cat.... DENZEL could play me, most definitely. He's DOPE."<

THE INSIDE SCOOP

D'Angelo: Contains soul, funk, blues, gospel, hip-hop. May contain traces of Curtis Mayfield, Sam Cooke, Marvin Gaye, James Brown, and assorted funkadelics.

In the tortured taxonomy of pop music critics, no one knows exactly in what pigeon-hole to sequester D'Angelo. "Hip-hopped R&B"? "Steamy funk"? "Smooth neo-soul"? Whichever way you slice him, the 26-year-old singer and multi-instrumentalist they call "sex on a stick" already has two top-selling albums to his credit.

Born Michael Archer, the son and grandson of preachers in Richmond, VA, D'Angelo began playing the piano when he was 5, as well as soaking up the musical gospel at church. When he was 18, a record agent scouring the bushes got a hold of his demo and signed him to EMI. D'Angelo made good by co-writing and -producing the hit single "U Will Know," performed by a high-profile ensemble including Jodeci, R. Kelly, and Tevin Campbell that went by the posse-nym Black Men United. (The tune also was featured prominently in the film *Jason's Lyric*.) Further displaying his chops, D'Angelo entered the Apollo Theater's amateur contest—the showbiz equivalent of Roman capital punish-ment—and won it three times in succession. For his debut album, Brown Sugar, D'Angelo aped Stevie Wonder and the Artist Formerly Known As—he wrote the music and lyrics, played every instrument, and produced the album, which sold more than two million copies and was thumbed-up by the critics. Many testified that D'Angelo had reinvigorat-ed an R&B genre so stupid and stale that its initials stood for "repetitive and boring."

When almost five years had elapsed without a sequel, the jaded cognoscenti were beginning to write him off as the VH-1 Ralph Ellison. At long last, in 2000 D' cast *Voodoo* on the public, and millions of record buyers staggered in a zombified stupor to their local Virgin megastore to snap it up.

D'ANGELO

SKIN DEEP

> He's got a Christ-like figure sporting angel's wings on his left shoulder. He says he's been doing some research on angels (maybe that's what delayed his record for so long), during which he discovered that every angel controlled an element and its opposite, such as fire and water. Or fame and anonymity.

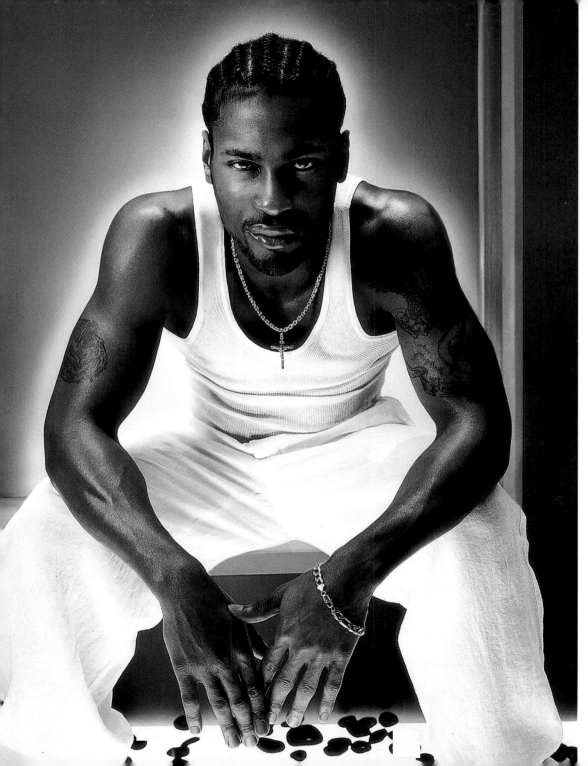

RAW DATA
FULL NAME Michael Archer.
DATE AND PLACE OF BIRTH 1975 in Richmond, VA.
CURRENT RESIDENCE New York City and Virginia.
DISCOGRAPHY *Voodoo* (2000), *Brown Sugar* (1995).
VIDEOS "Send It On," "Untitled," "Left & Right," "Brown Sugar," "Lady," "Cruisin'," "Me and Those Dreamin' Eyes of Mine."

STRANGE BUT TRUE
- D'Angelo suffered from rapper's block before he was able to produce *Voodoo*.
- Before each show, D' and the band pray, and they start off the prayer with a song. (Maybe "Jesus Christ, Superstar"?)
- In Case His Records Don't Do the Trick: While on the Web, if you attempt to visit the Ultimate D'Angelo Fan Page, you're taken to a company that sells Viagra in bulk.
- "I'm not really going after the sex symbol thing. I'm not here to be no sexy man or no model," claims D'. Not long after making this declaration, his video for "Untitled (How Does It Feel?)" featured him, in the description of one observer, in "teasing midshots cropping the singer's nude body so that the frame stopped just above his crotch."

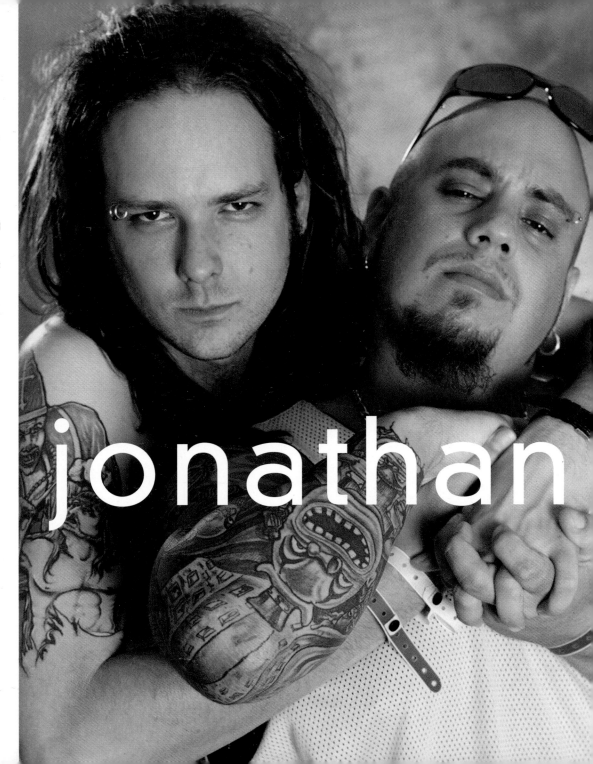

RAW DATA

DATE AND PLACE OF BIRTH January 19, 1971, in Bakersfield, CA.

CURRENT RESIDENCE Hollywood.

DISCOGRAPHY *Issues* (1999); *Follow the Leader* (1998); *Life is Peachy* (1996); *Korn* (1994).

VIDEOS "Somebody Someone," "Make Me Bad," "Falling Away from Me," "Freak on a Leash," "Got the Life," "A.D.I.D.A.S.," "Shoots and Ladders."

AWARDS Grammy, Best Short Form Music Video, "Freak on a Leash" (1999).

STRANGE BUT TRUE

- As a teen, Davis worked as an assistant coroner for Kern County, CA. He prepared for the job by first becoming a manager at Pizza Hut.
- The fan site www.explicitkorn.com says, "Fieldy is known for his alcohol-related antics," such as slurring his speech, passing out, and vomiting.
- For his 16th birthday, Jonathan had a Motley Crue birthday cake (it blows you out).
- Munky, too, worshiped Crue: He dressed up as Nikki Sixx for Halloween—twice.
- Jonathan has a fear of driving, and is chauffeured around by his bodyguard. Fieldy has a fear of flying. They should rename their band the Phobics.

jonathan

> "I have PROBLEMS, but I have an outlet. Everybody needs an outlet, whether it be writing poetry, DOING ART, killing people, WHATEVER"—Jonathan Davis <

THE INSIDE SCOOP

Inside Jonathan Davis's head a David Lynch movie is waiting for distribution. The be-kilted, bagpipe-playing, highly disturbed lead singer of Korn lyricizes about childhood sexual abuse and suicidal tendencies in small-town America. Far more distressing is the ardor with which his angst registers with America's youth. Korn had its roots in the agricultural city of Bakersfield, CA., in 1992, when guitarists James "Munky" Shaffer and Brian "Head" Welch, bassist Reginald "Fieldy" Arvizu, and drummer David Silveria played for the heavy metal outfit LAPD. They added vocalist and mortician-in-training Jonathan Davis, moved to Huntington Beach, and crowned themselves Korn. By the accretion of nonstop touring, the rap-metal quintet built an underground fan base to become one of the top draws of the 1990s. Their 1994 self-titled debut initially came a cropper, but after nearly two years of touring with Ozzy

Osbourne, Marilyn Manson, and Megadeth, Korn had sold over 700,000 copies, built a large, loyal fan base of alienated teens, and put up with more camp Satanism than *Rosemary's Baby*.

Their 1996 follow-up, *Life Is Peachy,* was a top seller, capturing the much-desired despairing teen male demographic and spawning the radio hit "A.D.I.D.A.S." The Kornballs then highlighted the Lolapalooza tour and, in 1998, launched their own Family Values excursion (which they, of course, headlined). That same year, the group lucked into a major publicity coup. After school authorities in Zeeland, MI, suspended a student who wore a Korn T-shirt to school because their lyrics were "obscene," the band detoured their bus to Zeeland and gave away free tees outside the school. In 1999, Korn released their most recent album, *Issues,* to mixed reviews.

DAVIS

KORN

SKIN DEEP

> Touring in an internationally known rap-metal band can be chaotic, to say the least. Some days you wake up without a grasp of essential facts. You don't know what town you're in, what time the show starts, even the name of your band. That's why it's a good idea to have it tattooed on your person, as the members of Korn have done. Jon, David, and Munky all have "Korn" inscribed on their back; Fieldy has it on his left leg. Jon takes the art of prophylactic tattooing one step further—he has the initials "HIV" plastered on his left arm as a kind of visual reality check on his surging libido. On his right arm he sports a Boschian tableau: a clown dressed as a pope

peeling away Jon's flesh to reveal a cowering Christ. David has the band's name spelled out in blocks. On his left arm is an evil Cheshire cat, while on his right is a grimacing man with a lizardly tongue pierced by a stud the size of a railroad tie. David tattooed his wife's name (Shannon Bellino) on her back, should she contract metallica amnesia. Munky has his name running down his right forearm, and on his back, next to the band's name, dictionary style, is an eponymous nonhuman primate mammal (no, not Fred Durst). Brian apparently shops at a discount tattoo parlor; on his lower back is the word "Norn."

>"I've sinned so many ways it's UNBELIEVABLE. I've robbed stores. I've had plenty of SEX. I've lied terribly. I've cheated. I've been GREEDY. I've lusted. I need some SUPPORT AND HELP from above now."<

THE INSIDE SCOOP

Fred Durst is the poster boy for the decline of Western civilization. He's the lead singer of Limp Bizkit, the most popular band in America. Their latest record, *Chocolate Starfish and the Hot Dog Flavored Water,* sold more copies in its first week than any album in history. Hollywood gave him six-figures to direct a feature film. His record company made him an executive vice president. All this for a guy *Rolling Stone* called "an oafish asspipe" who's often made his stage entrance from a gigantic, befouled toilet.

It was 1994 in Jacksonville, FL, that Durst founded Limp Bizkit with guitarist Wes Borland, bassist Sam Rivers, and drummer John Otto. The band jumbled the two most dysphonic musical genres, heavy metal and rap (they added DJ Lethal from the appropriately titled House of Pain), into a Bizquik that youth consumed ravenously. Limp's first album, *Three Dollar Bill, Y'All,* sold 1.5 million copies, and they marketed it with overblown histrionics (break dancers,

sci-fi sets), shrewd promotion (a free Napster-sponsored tour, Ladies Night in Cambodia—first 200 groupies gratis), and cease-less touring, including Warped, Ozzfest, Family Values, and Woodstock, Inc. This was all pretty heady for Durst, a former Navy plebe, convict, and tattoo artist. (The latter proved a valuable skill, since Durst used his gun to ink members of Korn, who eventually forwarded Limp's demo to their record company.)

Durst has been called (among less flattering things), one of the hardest-working men in show business. He's A&R'd for Flip Records (signing the band Staind and producing the second album from Jacksonville neighbors Cold); and he directed the heavily-rotated video for Bizkit's "Faith" as well as the one for their hit single, "Nookie." The rasping vocalist also helps design and build Limp's stage sets. If, as one rock critic states, rap-metal is the hair-metal of the late '90s, then Fred Durst is the lead hairdresser.

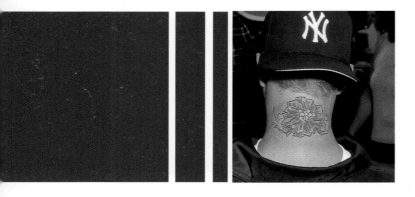

fred

SKIN DEEP

> Fred must've been a walking ad campaign for his tattoo business: Both arms are "sleeved," (completely inked), there's a large angel on his back, a flower on his neck, some sort of spiral design on his lower left leg, a ring on his left middle finger, and other designs yet to be unearthed.

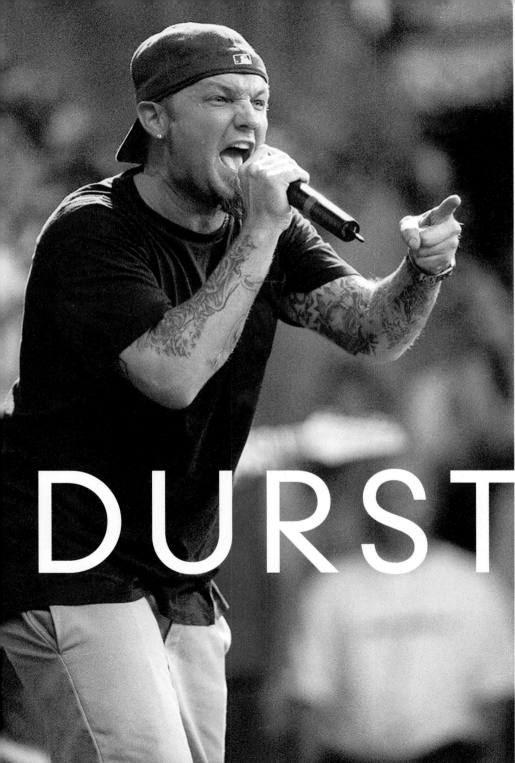

RAW DATA

DATE AND PLACE OF BIRTH August 20, 1971, in Gastonia, NC.

DISCOGRAPHY *Chocolate Starfish and the Hot Dog Flavored Water* (2000); *Significant Others* (1999); *Three-Dollar Bill, Y'All* (1997).

VIDEOS "My Generation," "Rollin'," "Take a Look Around," "Break Stuff," "N 2 Gether Now," "Re-arranged," "Nookie," "Faith," "Counterfeit," "Sour."

STRANGE BUT TRUE

- The Emperor's New Mosh Pit: Of his early promotional efforts, Durst says, "I was acting like I was my own manager on the phone. I'd change my voice and my name and was talking shit to all these record companies. I didn't know a thing about the industry, but they believed me because I'm a good bullshitter."
- "I want everybody to be thinking I'm having the time of my life, but I'm single and miserable," says Durst.
- Courtney Love told *Rolling Stone* that she went on three dates with Durst, and "he didn't take his stupid red hat off once."
- Durst punched out a backstage intruder during the Chicago leg of the band's Anger Management Tour.
- Mom Rules! In a behind-the-scenes video, Fred's mom tells him, "You rule on stage, but I rule in the house."

DURST

LIMP BIZKIT

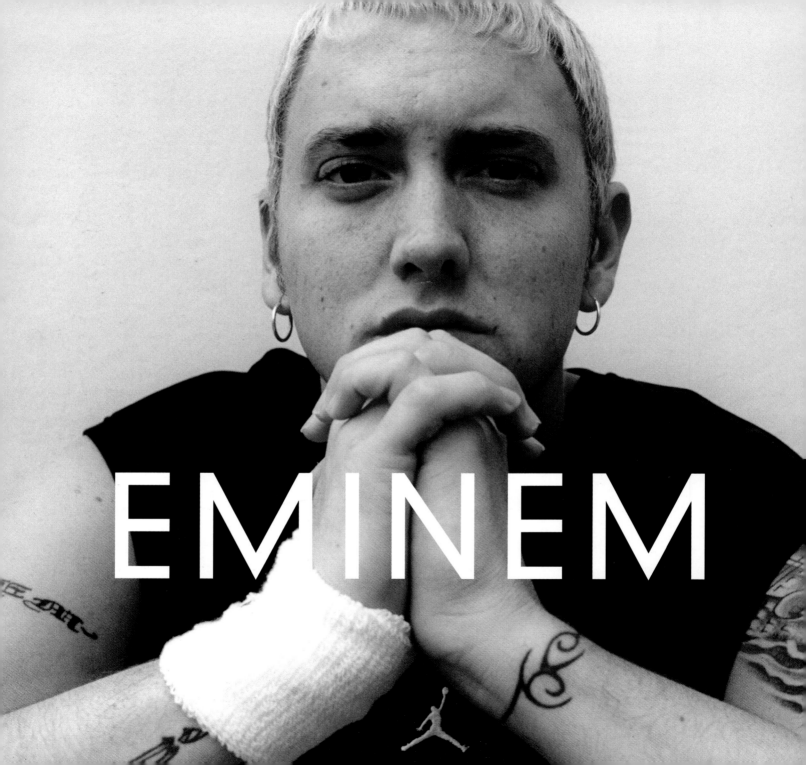

>"There's millions of WHITE KIDS and BLACK KIDS coming to the tour, throwing their MIDDLE FINGERS up in the air, and all having the common love—that's HIP-HOP."<

THE INSIDE SCOOP

Marshall Bruce Mathers III grew up a poor-fatherless kid stuck in a Springeresque landscape of minimum-wage trailer park poverty. As a teen, he became an agile rhymer and, inspired by LL Cool J, he bailed high school in the ninth grade and spent his time jousting with other rappers. In 1997, he released an album, *Infinite,* through a local company, but the local hip-hopsters scotched it. Undeterred, Mathers—now going by the name "Eminem"—took home a silver medal in the "Rap Olympics," an annual freestyle rhyme-athon.

For his next record, he needed to express his darkest, most revolting thoughts, and so created an alter ego, Slim Shady. *The Slim Shady LP* made its way into the hands of Dr. Dre who, while not a licensed physician, was head of Aftermath Entertainment and creator of N.W.A. and other rap luminaries. Dre was keyed up by Em's vulgar, venomous quatrains, signed him to Aftermath, and the two began preparing *The Slim Shady LP* for national release, adding songs such as "My Name Is…" *The Slim Shady LP,* with its depiction of drug abuse, rape, and other violent acts, became a No. 3 bestseller on the *Billboard* charts, but it horrified some (who had apparently been spending the late 20th century on another planet). What really rattled the girdles of bluenoses were obscene insults Em directed at his mother, and songs like "'97 Bonnie and Clyde," in which Eminem fantasized about killing his child's mom—the very things that endeared him to his fans.

Over the next year, Eminem brought his panorama of American pathology on the road and made appearances on disc with Sway and Tech, DJ Spinna, and Missy Elliot. In 2000, he released *The Marshall Mathers LP,* which contained more graphic violence, plus more than a soupçon of racism and homophobia—and which promptly sold 1.76 million copies its first week, making it the fastest-selling hip-hop record of all time. Since then, Eminem's done his best to live up to his B-boy rep: He was busted for pulling a gun at a nightclub. His wife attempted suicide amid an impending divorce. The Gay and Lesbian Alliance boycotted him. A Senate subcommittee on violence in the entertainment industry condemned his lyrics. A year from now, Eminem will be: (a) forgotten; (b) in prison on a weapons charge, or (c) hosting his own talk show—the dysfunctional Oprah.

RAW DATA

FULL NAME Marshall Bruce Mathers III.
DATE AND PLACE OF BIRTH October 17, 1972, in Kansas City, MO.
CURRENT RESIDENCE Los Angeles.
DISCOGRAPHY *The Marshall Mathers LP* (2000); *The Slim Shady LP* (1999); singles: "Just Don't Give a F***" (1999).
VIDEOS "Stan," "The Way I Am," "The Real Slim Shady," "Role Model," "My Name Is," "Guilty Conscience."
AWARDS Grammys: Best Rap Album, *The Marshall Mathers LP,* Best Rap Solo Performance, "The Real Slim Shady," Best Rap Performance by a Duo or Group (Dr. Dre featuring Eminem), "Forget About Dre" (2000); Best Rap Album, *The Slim Shady LP,* Best Rap Solo Performance, "My Name Is Eminem" (1999). Eminem also received three MTV Music Awards in 1999.

STRANGE BUT TRUE

- His wife sued him. His mother's suing him. And his grandmother threatened a suit. It sounds like a "Court TV" sitcom.
- Eminem talks trash about teen groups, yet the cover of his recently lost notebook (containing some new rhymes using only consonants) featured a photo of Britney Spears. Is Em a closet teenybopper?
- Em starred in the 2000 film, *The Hip-Hop Witch,* in which "a reporter searches for the truth after several well-known rap artists claim they were attacked by a supernatural force." (This bypassed theatrical distribution, home video, even airlines, and was shown only in Turkish prisons.)

SKIN DEEP

> Em has so many tattoos that, in an earlier era, he could've been a Barnum & Bailey regular. Here's a breakdown:
 Dog tags inked around his neck (U.S. Army, M.C. Division; "OK, men, when you see Charlie coming, start sampling!");
 A large mushroom on his left shoulder;
 "Hailie Jade," his daughter's name, on the inside of his right arm;
 A gothic style bracelet on his left wrist;
 The words "Slit Here" on his right wrist (a helpful reminder for the busy celebrity);
 The name of his group, "D 12," on his right forearm. "D" stands for Detroit. The meaning of "12" is anybody's guess;
 A tattoo standing for Eminem on one side of his chest;
 Another standing for Slim Shady on the other side.

>"I'm every THUG'S dream wife."<

THE INSIDE SCOOP

Eve Jihan Jeffers was born in Philadelphia's Millcreek Projects, the only child of a 17-year-old mother. Eve's parents separated when she was 12; her mother remarried two years later and gave birth to Eve's brother, Farrod.

As a teenager, the precociously artistic Eve began putting forced rhyme to rhythm tracks under the nom de rap "Gangsta," then "Eve of Destruction." She suffered through bouts of delinquency and even spent a sordid month not only stripping (under the names "Mystique," "Cinnamon," and "Ginger") in a Bronx nightclub called the Golden Lady, but commuting nightly from Philadelphia to do it.

Still, she was driven to succeed and tried everything to reach the Valhalla of rap—even infiltrating Dr. Dre's Aftermath Entertainment offices posing as a drug runner. In a scene straight from *A Star Is Born,* Eve let loose with some impromptu raps, which so impressed the good doctor that he had her cut a demo.

One of the singles from that demo, "Eve of Destruction," landed her a recording contract and a place on the soundtrack of Warren Beatty's film, *Bulworth.* Eve then joined forces with DMX (for the hip-hop-a-phobes, he's a rapper, not a pesticide) and Ruff Ryders producer Dame Grease. She went mano-a-mano with Drag-on and Infra Red and bested the two veterans, impressing Ruff Ryders CEOs Dee and Waah Dean (don't even ask who the other board members are) enough to garner a contract.

Eve appeared on the label's own *Ryde or Die Vol. 1,* and the hit singles "Baby, You Got Me" (with The Roots) and "Girlfriend/Boyfriend" (with Blackstreet). She guested on former SWV member Coko's, debut release, *Hot Coko,* but truly went national when she (along with other rap divas) flakked for Sprite in a series of commercials with a kung-fu theme.

Eve's debut single, "What Ya Want," in which she demonstrated her nascent mambo talents, was heavily rotated on video networks. Her first solo album, *First Lady of Ruff Ryders,* led critics to consider her one of the most important contemporary rap artists of 1999. She's now considered the most in-demand female emcee in rap, and has worked with everybody from Will Smith to Prince.

SKIN DEEP

> Dog paw prints on her chest. She had it done on a dare to prove that, in her words, "I'm the bitch of the litter." This continues a canine motif in Eve's life that manifests not only in her choice of skin adornments but her language ("My dogs believe in me"), song titles ("Dog Match" with DMX), and even her self image—she extols herself as the "illest vicious pit bull in a skirt."

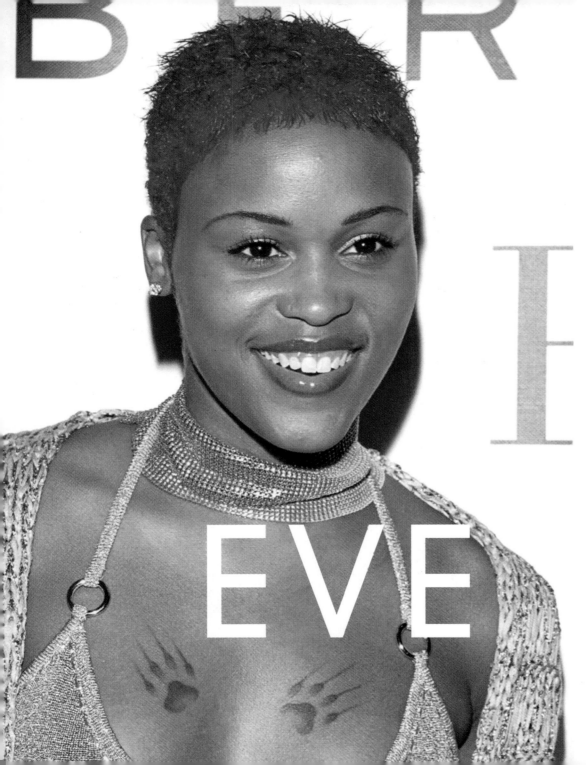

EVE

RAW DATA

DATE AND PLACE OF BIRTH November 10, 1978, in Philadelphia (The City of Brotherly Thugs).
CURRENT RESIDENCE Los Angeles
DISCOGRAPHY (with the Ruff Ryders) *Got It All* (2000); *Ryde or Die, What Ya Want, Bullworth, Finally, Girlfriend/Boyfriend, Things Fall Apart, You Got Me, Hot Coko* (1999); her debut solo album: *First Lady of Ruff Ryders* (1999); *The Professional* (1998).
VIDEOS "Got It All," "Ryde or Die," "Chick," "Love is Blind," "Gotta Man," "What Ya Want."

STRANGE BUT TRUE

- Her only pet is a Yorkshire terrier named Spunky J. ("He be fetchin'"), who sports an eerily similar moniker to a producer she recently dated (Stevie J.).
- She owns a Yamaha Banshee, a four-wheeled vehicle she calls "my toy."
- She's expressed an interest in dating Eminem because she's "never dated a white boy, and "with our blonde hair, we're like twins."
- She wants to record with Hole.

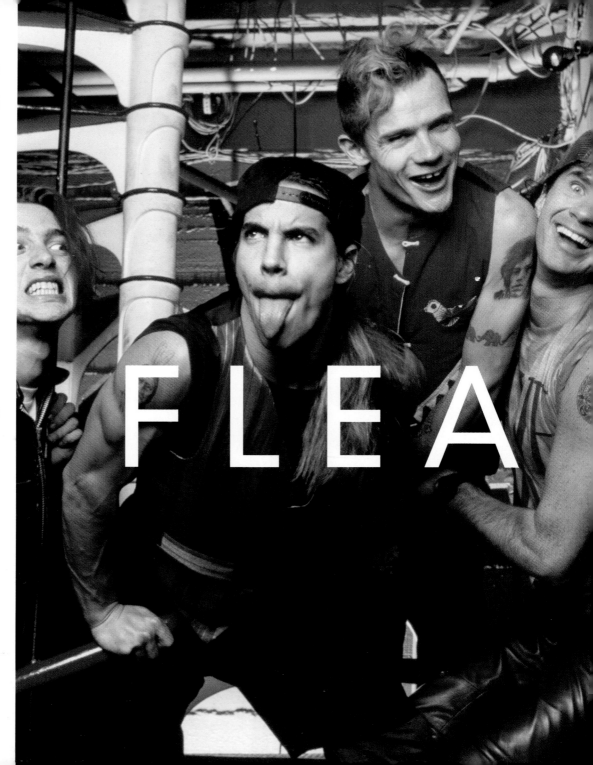

RAW DATA

DATE AND PLACE OF BIRTH Flea (Michael Balzari): October 16, 1962, in Melbourne, Australia, (bass); Jack Irons: July 18, 1962, in Los Angeles (drums), replaced by Chad Smith; Anthony Kiedis: November 1, 1962, in Grand Rapids, MI (vocals); Hillel Slovak: April. 13, 1962, in Haifa, Israel, died June 25, 1988 in Los Angeles (guitar), replaced by John Frasciante, Dave Navarro, and Frasciante again.
CURRENT RESIDENCE Los Angeles.
DISCOGRAPHY *Californication* (1999); *One Hot Minute* (1995); *Greatest Hits* (1994); *Out in L.A.* (1994); *What Hits?* (1992); *Blood Sugar Sex Magik* (1991); *Mother's Milk* (1989); *The Uplift Mofo Party Plan* (1988); *Freaky Styley* (1985); *Red Hot Chili Peppers* (1984).
VIDEOS "Californication," "Other Side," "Around the World," "Scar Tissue," "Coffee Shop," "Aeroplane," "My Friends," "Warped," "Soul to Squeeze," "Breaking the Girl," "Under the Bridge," "Give It Away," "Taste the Pain."
AWARDS Grammys: Best Rock Song, "Scar Tissue" (1999); Best Hard Rock Performance with Vocal, "Give It Away" (1992).

STRANGE BUT TRUE

- Flea, a jazz lover, named the band after a 1920s Jelly Roll Morton recording unit.
- E.R., I Got a Hairball!: Flea once worked at an animal hospital.
- Flea had his Mercedes Benz rainbow-colored, like a circus clown car. When the doors open, a hundred groupies pop out.
- He disseminates cyber-notes to his fans called "Fleamail."

FLEA

>"JAZZ IS WHAT IT'S ALL ABOUT. I suggest people STOP WATCHING MTV and start buying old Blue Note records. Start listening to John COLTRANE, Lee MORGAN, guys who really had something to say." —FLEA<

THE INSIDE SCOOP

We live in the kind of society where a man who plays the bass dressed only in a tube sock can sell his Hollywood "castle" for $3 million. The seller was Flea, an Australian-born, New York-raised musical idiot savant who for almost two decades has spearheaded the Chili Peppers, whose signature tunes include such Cole Porter-esque titles as "Party on Your Pussy" and "Suck My Kiss."

This L.A.-based band, formed in 1983, has endured more personnel moves than a temp agency, enough junkies for a shooting gallery, and more indecent exposure than the Show World Alumni Association. In the process, the Peppers have melded elements of vert-defying skateboard culture, thrash metal, grunge, and funk into a musical microorganism that's spontaneously generated bands such as Offspring and Sugar Ray.

Throughout the 1980s, the Chilis struggled to discover their voice, and their progress was stunted by the 1988 death of guitarist Hillel Slovak from a heroin overdose and the convictions of Flea, Smith, and Kiedis on battery charges. Despite these obstacles, the band gained popular momentum, scoring with albums such as 1991's *Blood Sugar Sex Magik* and *One Hot Minute,* which went platinum in about as long in 1995. After many years of instability, the band seems to have reached a stasis point. Their 1999 record, *Californication,* was released to mostly favorable reviews, and temporarily distracted the infamous Woodstock '99 crowd from raping and pillaging. In 2000, the band won two MTV Music Video Awards, and showed up to receive them in matching mohawks.

red hot chili peppers

SKIN DEEP

>When tattooing inevitably becomes an Olympic sport, the smart money has to be on Flea. In the qualifying heats, he could summon his name (inscribed on the back of his head); Jimi Hendrix's head (on his left shoulder), a thorn bush extolling the name "Clara," a reference to his daughter (left upper arm); a herd of pink, blue, and yellow elephants holding each other's tail in a kind of pachydermic daisy chain (left upper arm); a triangle (left forearm); the word "love" spelled out, one letter on each of the first four fingers of his left hand; and two snakes (right shoulder), one with a skull, the other with two heads. In the finals, going mano a mano against, say, the body art champion from Romania, Flea would produce two small black dolphins swimming around a smiling mouth, set inside of which is a perfect reproduction of Flea's gap-toothed dentures (right shoulder); a Native American eagle (right inside forearm); a triskele—an ancient Celtic triple spiral symbol symbolizing perfection and the threefold nature of many Celtic deities (right chest); the name "Loesha," Flea's ex-wife (left chest); and an Aztec mask. Of course, as Flea climbed the victory platform to accept his gold medal, the results of the drug tests would come back, and he'd be disqualified.

>"I've been SCREAMING with my body for the past six years, so NOW it's time to scream with MY MOUTH."<

THE INSIDE SCOOP

In the late 1980s, a British classically trained pianist and acid house DJ named Liam Howlett came to a crossroads in his musical destiny: Down one path was a lifetime of playing cocktail piano at a darts pub or Chopin nocturnes for blue-rinsed aunties; the other promised fame, fortune, and babes just for stitching together snippets of pop detritus in a way that would grab Ecstasy-tripping moppets. No brainer.

Howlett descended into the London club scene and encountered rave dancers Keith Flint and Leeroy Thornhill. They formed The Prodigy in 1990. A year later, they released their first single, "What Evil Lurks," which the neo-psychedelics glommed onto like the shroud of Jimi Hendrix. Their next single, "Charly," sampled a 1970s public service message and became Top of the Pops. (Next, he tried putting out a rhythm track under the Emergency Broadcast System, but it didn't click.) Howlett then injected hip-hop MC Maxim Reality into the Prodigal mix and the result was *Music for the Jilted Generation,* one of the first creations of the "drum 'n' bass" genre.

With the 1996 single, "Firestarter," The Prodigy's music became more and more eclectic. There was nothing Howlett wouldn't sample—hip-hop rhythmic, synth sound, Ninja Turtles games; if you recorded anything in the 20th century, you were fair game. With the album *Fat of the Land,* the band received contributions from Crispian Mills of Kula Shaker and Doctor Octagon (who graduated from the same medical school as Dr. Dre), and became more punk- and thrash-oriented. Howlett refuses to get subsumed by what he calls "the fame game." The band still controls their own record producing, tours, videos, and merchandise (Keith Flint Self-Piercing Kits?). A large part of The Prodigy's appeal lies in their frenzied stage show, featuring the dancing and stage-diving of the long-legged Thornhill (the Tommy Tune of the rave set) and Flint, a maniacal-looking figure with two spikes of pastel-color hair and a ghoulish, studded face.

SKIN DEEP

> Keith is said to have a tattoo done in every city he visits, including one across his stomach that reads, "Inflicted." Global economic policy is important to the high school dropout: The words "Drop the Debt" are permanently inscribed on his back, a potential weapon should The Prodigy ever gangbang with Alan Greenspan and the World Bank. A team of tattoo artists embroidered his legs with tribal designs. (He tried to join several indigenous peoples, but they said they'd sooner lose the rainforest.)

keith

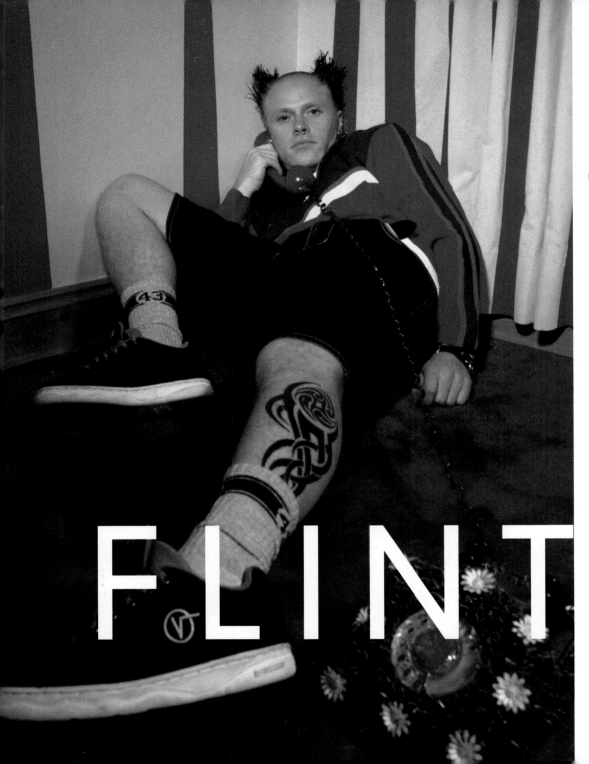

FLINT

THE PRODIGY

RAW DATA
DATE AND PLACE OF BIRTH September 17, 1969, in Chelmsford, U.K.
CURRENT RESIDENCE England.
DISCOGRAPHY *The Fat of the Land* (1997); *Music for the Jilted Generation* (1994); *The Prodigy Experience* (1992).
VIDEOS "Smack My Bitch Up," "Firestarter," "Breathe."

STRANGE BUT TRUE

- The Impossible Dream: Keith's goals in life are to enjoy the "ultimate sex experience with a lot of chicks," to have every part of his body perforated, and to try every hair color in the salon.
- Since a conflict-ridden session 10 years ago, the band has never once rehearsed.
- Letter of Recommendation: The Prodigy's official Web site says of Keith, "His grades in school were terrible, and he has no skills."
- Calling Dr. Octagon: When the band's "Firestarter" video aired on BBC, it triggered a blizzard of hate mail, including a letter from one irate viewer who raged, "This young man is clearly in need of urgent medical attention."
- Howlett named the band after his first Moog keyboard.
- Keith's hobbies include gardening and professional motorcycle racing. He suffered a chopper accident while going 120 m.p.h., but surgeons pierced him back together.

RAW DATA

DISCOGRAPHY *All for You* (2001); *Velvet Rope* (1997); *Janet* (1993); *Rhythm Nation* (1989); *Janet Jackson* (1987); *Control* (1986); *Dream Street* (1984).

VIDEOS "All for You," "If," "Again," "Any Time, Any Place," "Got 'Til It's Gone," "Together Again" "I Get Lonely" "Nasty" "Control" "Rhythm Nation" "Love Will Never Do (Without You)"

TV Fame (1982); Diff'rent Strokes (1981–82); Good Times (1977–79).

AWARDS Grammys, Best Short Form Music Video, "Got 'Till It's Gone" (1998); Best Short Form Music Video, "Scream" (with Michael, 1996); Best Rhythm and Blues Song, "That's the Way Love Goes" (1993); Best Long Form Music Video, "Rhythm Nation 1814" (1989). MTV Icon Award (2001).

STRANGE BUT TRUE

- They're Not for Me, They're for My Chef: Although the singer is an active anti-drug proselytizer, their former chef has filed a lawsuit against Jackson, her ex-husband Rene Elizondo, and two of their doctors, claiming that his name was being used without his knowledge on the couple's prescriptions, which included antidepressants, opiate/heroin addiction blockers, herpes antivirals, appetite suppressants, and a hepatitis B vaccine.
- Interactive TV: Jackson had to get a restraining order against Eric Leon Christian, a deranged fan, who sent letters to Janet claiming that she was trying to communicate with him through the television.

janet

>"If I could just HELP one person's life, that's more WORTH it to me than any-thing. Of course, I want to SELL ALBUMS. To tell you that I didn't, I'd be lying through my butt-hole."<

THE INSIDE SCOOP

Global fame, androgyny, hermetic eccentricity, cosmetic engineering, and an extra helping of macabre perversion. Those are big family shoes to fill, but Janet's compensated with old-fashioned titillation and anal-retentive production values to become the club queen of bland.

Janet grew up under the mediascope. After joining her brothers in the Jackson 5 at age seven, she served time on the sitcoms "Good Times" and "Diff'rent Strokes." After several unremarkable records, she hit it big with 1986's *Control,* which topped the pop and R&B album charts and spawned hits such as "What Have You Done For Me Lately." Then, like Goneril and Regan (who were not Jacksons), she betrayed her father, firing him as manager. Guiltlessly, she recorded the monster hit *Rhythm Nation 1814,* signed a $30 million record deal with Virgin, and spewed forth another number one record, *Janet.* After some painful realiza-tions—such as that she'd never be as much of a woman as Michael—she released a somewhat more introspective, yet equally popular album, *The Velvet Rope* in 1997.

JACKSON

SKIN DEEP

>Janet's most notorious tattoo—on her upper right leg—fancies Minnie Mouse performing fellatio on Mickey. Beyond the tired iconoclasm, who wants to be reminded of Michael Eisner every time you put on your under-wear? Janet complements this image with more prosaic tattoos on the small of her back, her wrist, and (it's alleged) her privates. But it's the motivation for her piercings that's truly fascinating. One former family employee snitched that Jackson had her tongue pierced as a dietary aid. (It would force her to forego her passion for French pastries.) And she told *Ebony* that her now ex-husband, Rene Elizondo, was responsible for her nipple puncture. (She gave him a choice of two areas...) Last but not least, what's the fun of getting a clit ring if you can't blab about it to Jane? The grrlll-empowering mag reported that a friend telephoned Janet in mid-puncture. Well, let Janet tell it: "The friend asked what I was doing and René goes, 'Well, she's sitting on the table getting her [privates] pierced.' And she goes, 'Put her on speaker phone, I want to hear this.' She's talking to me, and I'm laughing so hard, I can't stay still, and the guy's trying to center the thing. At the same time, I'm getting excited 'cause he's touching me down here. Then René says, 'I've got to get the video camera.' I'm going, 'Don't you film this! If you lose this tape, I'm in trouble.'" It almost makes you long for Michael and Jacko.

>"I think a TATTOO can be SEXY depending on where you put it."<

THE INSIDE SCOOP

Kravitz, who's parlayed exotic good looks, questionable talent, and the appropriation of just about every post-Elvis musical style into pop superstardom, is the son of "Jeffersons" actress Roxie Roker and NBC-TV producer Sy Kravitz. He grew up on the Upper East Side of New York City in a rarified cultural atmosphere (among his parents' celebrated friends were Duke Ellington and Ella Fitzgerald) before moving with his parents to Los Angeles. Lenny attended Beverly Hills High School, where he befriended future Guns N' Roses guitarist Slash. Before he'd even signed a recording contract, Kravitz was tabloid material, thanks to his brief marriage to actress Lisa Bonet of "The Cosby Show." (For a while, he was derided in the press as "Mr. Bonet."). He and Bonet separated in 1991 and divorced two years later. They have a daughter, Zoe, who is 11.

He first hit the charts in 1989 with the album *Let Love Rule,* then followed it up with *Mama Said, Are You Gonna Go My Way, Circus,* and *5,* his most critically acclaimed album.

Kravitz also has had a wide-ranging career as a producer, spanning the *Superfly II* soundtrack, Madonna's "Justify My Love" (which he helped write) and an album by French singer Vanessa Paradis. And he co-wrote a track on Aerosmith's platinum-plus *Get a Grip* album.

Throughout his career, he has created a musical stew of rock, gospel, funk, R&B, and anything else he could appropriate from idols such as Jimi Hendrix, John Lennon, David Bowie, James Brown, Curtis Mayfield, Sly Stone. His devoted fans find him a unique synthesizer; his critics, a derivative poser with a shallow talent of recreating sounds of the past

When it comes to fashion, Kravitz is sort of a walking '70s museum, and some credit him with reintroducing such now-ubiquitous retro elements as bellbottoms, dreads, piercings, and psychedelic rock to the '90s masses. If nothing else, he's proven that you can have a CPA's name and still make it on MTV.

lenny

SKIN DEEP

> When he was 19, Kravitz first visited the tattoo man, and many return trips later he emerged an inkstained wretch, sporting a nearly life-size Japanese dragon tattoo that starts across his right shoulder and crawls down his arm. His mother, normally unfazed by Lenny's larks, was dumbfounded by the not-so-hidden dragon. "But after awhile, I think she dug it," Lenny says. Lenny took this maternal approval and ran with it, getting seven more tats, including his favorite, the words, "My Heart Belongs to Jesus Christ," inscribed on his back.

KRAVITZ

RAW DATA

DATE AND PLACE OF BIRTH May 26, 1964, in Brooklyn, NY.

CURRENT RESIDENCE Los Angeles, but he also has homes in New York, New Orleans, Miami, and the Bahamas.

DISCOGRAPHY *Greatest Hits* (2000); *5* (1998); *Circus* (1995); *Are You Gonna Go My Way* (1993); *Mama Said* (1991); *Let Love Rule* (1989).

VIDEOS "Again," "I Belong to You," "American Woman," "Fly Away," "If You Can't Say No," "Rock and Roll Is Dead," "Can't Get You Off My Mind," "Is There Any Love in Your Heart?," "Let Love Rule," "Give Peace a Chance."

AWARDS Grammys, Best Male Rock Vocal Performance three years straight for: "Again" (2000); "American Woman" (1999); "Fly Away" (1998).

STRANGE BUT TRUE

- Early in his career, he went by the pseudonym Romeo Blue (not to be confused with Buddy X, the name he used when signing into a hotel and the title of a song by his friend, Neneh Cherry). His ex, Lisa Bonet, now goes by Lilakoi Moon.
- He has a messianic complex. The lyric from "Are You Gonna Go My Way" reads, "I was born long ago/I am the chosen/I'm the one/I have come to save the day."
- The messiah is only 5'7".
- Kravitz is terrified of flying, and uses a tour bus whenever possible.
- An Italian author has written a book about Kravitz, called *Che Amore Sia* (Let Love Be), with an introduction by Nobel Prize literary candidate Nestor Olivera.
- Kravitz plans a benefit concert called Kidzstock, to benefit children (especially those who can't spell).
- He once broke a nose ring falling out of bed.
- As a child, he used to dress up in his mother's clothes (which apparently he still has in his wardrobe).
- He says his original ambition was to be a studio session man.

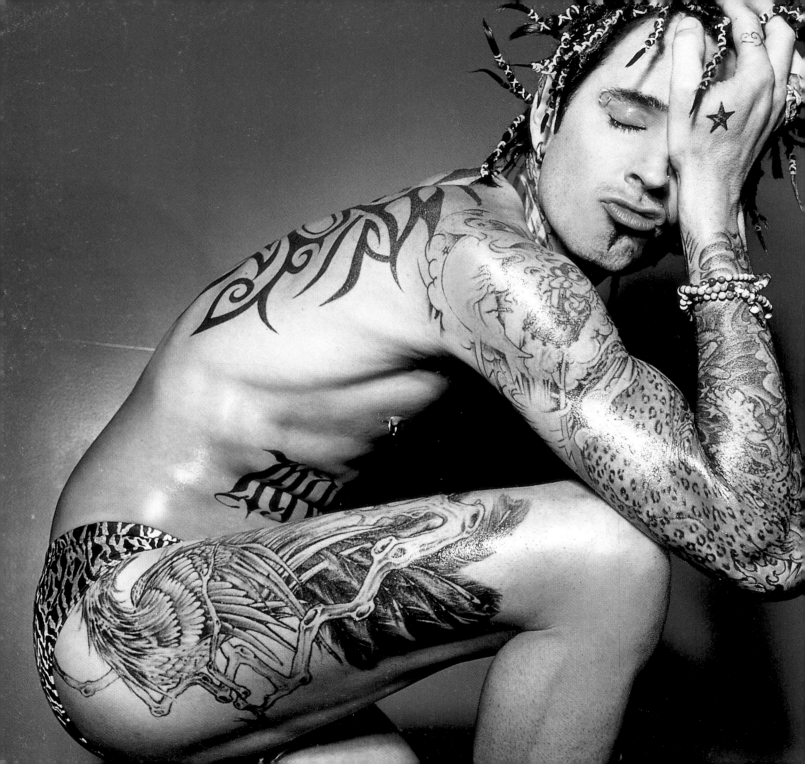

>Tommy's Big EXISTENTIAL Moment: "I landed myself in jail for a while, and it gave me some time to THINK about why I'm here. Why am I in jail? Why am I having TROUBLE in my personal life? Why am I unhappy? WHY? WHY? WHY?"<

TOMMY LEE

RAW DATA

DATE AND PLACE OF BIRTH October 3, 1962, in Athens, Greece.
CURRENT RESIDENCE Los Angeles.
DISCOGRAPHY *New Tattoo* (2000); *Live: Entertainment or Death* (1999); *Generation Swine* (1997); *Motley Crue* (1994); *Dr. Feelgood* (1989); *Girls Girls Girls* (1987); *Theatre of Pain* (1985) *Shout at the Devil* (1983); *Too Fast for Love* (1981).
VIDEOS "Afraid," "Kickstart My Heart," "Smokin' in the Boys Room," "Looks That Kill," "Too Young to Fall in Love," "Home Sweet Home," "Dr. Feelgood," "Without You," "Don't Go Away Mad (Just Go Away)," "Same Ol' Situation," "Girls Girls Girls," "Wildside," "You're All I Need," "All in the Name Of...," "Primal Scream," "Anarchy in the USA."

STRANGE BUT TRUE

- Somebody Call an Ontologist!: "The press gets so many details wrong, it really makes me wonder when we watch shit about the president, or situations when we're in war, is any of this fuckin' real?"
- Tommy suspended a swing over his piano in the living room, so that Pamela could swing back and forth over his head naked while he composed music, a motivational tool first employed by Franz Lizst.
- At Royal Oak High School, Hollywood, Tommy was a member of the marching band, but dropped out (because he couldn't march and punch out cheerleaders at the same time).
- Raging Hen: On *Celebrity Deathmatch*, Lee fought porn star Ron Jeremy, both in chicken suits. As Lee puts it, "We were pecking at each other. He rips off my arm, and I give him shit about ruining my tattoos. Then I jump up on the ropes, unzip my pants, and kill him with my dick."

THE INSIDE SCOOP

Drummer for a Spinal Tapped metal band. Telebimbo abuser. Ex-con. Involuntary co-star of a best-selling adult video. If Tommy Lee never existed, a hack screenwriter would've had to invent him.

Along with Nikki Sixx and Vince Neil, Lee, and Mick Mars formed Motley Crüe in 1980. By the time they recorded their third album, the prophetically titled *Theatre Of Pain,* the Crüe were Swiss cheese for millions of mall rats. Motley changed direction with *Girls, Girls, Girls,* which rivaled Led Zeppelin on *Billboard*'s heavy metal charts, and saw the band experimenting with organs, pianos, and other instruments of torture.

Yet, the tinnitus-inducing ensemble had to pay for its Faustian bargain. First a DWI. Neil killed close friend Nicholas Dingley of Hanoi Rocks and was convicted of vehicular manslaughter. (The other victims suffered brain damage and subsequently became big Motley Crue fans.) Three years later, Nikki Sixx had a heroin-induced near-death experience after a Guns N' Roses tour. Around this time, Lee married Heather Locklear, and all four members of the band went into rehab (taking advantage of a group discount). *Dr. Feelgood* provided them with their first number one record in 1989. Over the next seven years, John Corabi, formerly of Scream, and Neil took turns being hired and fired by the Crue of metalheads trying to stave off rust and corrosion.

In 1998, after the band's unfortunately titled "Greatest Hits" tour, Lee was arrested for spousal abuse against wife and amateur lifeguard Pamela Anderson. He was sentenced to jail time for most of the year (in the Ozzy Osborne House of Detention). After a 1999 jail cell epiphany in which a vision of Puffy Combs appeared in his cell, Lee decided to leave Motley and go hip-hop with his new ensemble, Methods of Mayhem.

SKIN DEEP

>Lee is a walking billboard. The word "Mayhem" is etched on his stomach, and on both arms he sports what looks like a graphic novel. A baroque pattern covers his entire back. He once had a swastika tattoo, but had it removed after slugging a Jewish paparazzo whose lawyers wanted the jury in his subsequent case against Lee to see it. "The swastika was not a reflection of Mr. Lee's views," Tommy's lawyer noted in court papers. "Instead it was simply a stupid tattoo."

>"I'm GRANDIOSE. I've wanted to be a ROCK STAR since I was two."<

THE INSIDE SCOOP

Is she a supreme manipulator who sought to piggyback to fame on the fragile shoulders of tortured rock misfit Kurt Cobain and in the process destroyed his band? Or a maverick star in her own right, whose talents justify a volcanic personality deemed a "train wreck" by one journalist? Does anyone with a life really care? Courtney Love is one of those celebs whose outré but banal escapades make you wish she would retire to the Suzanne Somers Rest Home for the Disproportionately Famous. But the bio is obligatory, so here goes: Born Love Michelle Harrison to hippie parents in San Francisco at the dawn of Haight-Ashbury. (Her father claimed to have briefly managed the Grateful Dead.) By age 12, she was in reform school for shoplifting, and at 16 left home, touring the world on her grandma's trust fund. When the matriarchal juice ran out, she stripped for cash. Returning home, she joined various bands before forming Hole and moving to L.A. in the late 1980s. Some hit singles and Love's brazen onstage shtick—she'd cut herself, rebuke and assault her audience, simulate fellatio on fans, Townsend her guitar, and stage-dive into the mosh pit, where jackal-like followers ripped her clothes off—buzzed the band's profile.

In 1992, her pursuit of and marriage to Cobain, whose band, Nirvana, was cresting, altered her identity from act-out riot grrrl to one-half of an Ozzie & Harriet show for junkies. When *Vanity Fair* implied that Love had been smacking up while pregnant, their daughter, Frances Bean, was almost impounded. Not long thereafter, a despondent Cobain emptied a shotgun into his head, and the grief-stricken widow's first public act was reading his suicide note to mourners, then conducting them in a Cobain-directed chant of "asshole." Two weeks later, right as Hole's *Live Through This* album was going platinum, their bassist, Kristen Pfaff, was found dead in her bathtub of a heroin overdose.

Love plowed forward with a reconstituted Hole, and crossed over to film in 1996, with a well-received portrayal of Larry Flynt's wife in *The People vs. Larry Flynt.* Recently, she's become part of the gossip industry—embroiled in lawsuits, diva tantrums, even a provocative defense of Napster—while remolding her image from a "kinderwhore" of baby doll dresses and red lipstick, to a Versaced fashionista with a taste for obscenely expensive gowns.

courtney

SKIN DEEP

> An efflorescing angel floats across Courtney's dorsal area. There are more flowers on her ankle, and a "K" around the front of her rib cage. It's in honor of either her late husband, Kurt Cobain, or a cryptic tribute to faded baseball star Dwight Gooden.

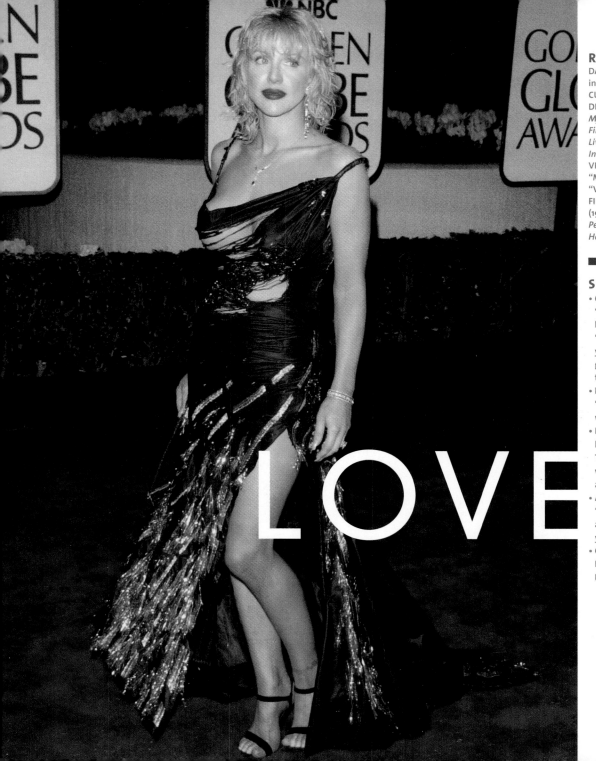

LOVE

RAW DATA

DATE AND PLACE OF BIRTH July 9, 1965, in San Francisco.
CURRENT RESIDENCE Los Angeles
DISCOGRAPHY *Celebrity Skin* (1998); *My Body the Hand Grenade* (1997); *First Session* (1997); *Ask for It* (1995); *Live Through This* (1994); *Pretty on the Inside* (1991).
VIDEOS "Be a Man," "Celebrity Skin," "Malibu," "Awful," "Gold Dust Woman," "Violet," "Miss World," "Doll Parts."
FILMS *200 Cigarettes, Man on the Moon* (1999); *Basquiat, Feeling Minnesota, The People vs. Larry Flynt* (1996); *Straight to Hell* (1987); *Sid and Nancy* (1986).

STRANGE BUT TRUE

- Courtney suffers from lawyers' block. "It's really tough to balance your business and creative sides," she says. "I've only written about five songs in a year because of the legal battles I'm going through now. It takes all your time and energy."
- Rage—The Key to Increased Productivity: "In my day job through rock, anger works for me," admits Love.
- In 1999, Love, who's injected enough heroin to empty half the Golden Triangle, came out against drugs. "If you want to be a musician, be a musician, be a poet, be a goddess, be a god."
- A chastened Love told Roger Ebert, "You can't dive into the mosh pit after a certain age." Like when you're so old, you can't see it from the stage.
- One Thing That Wasn't Contested at Probate: Courtney preserved some of Kurt's ejaculate.

RAW DATA

DATE AND PLACE OF BIRTH January 5, 1969, in Canton, OH.

CURRENT RESIDENCE Hades.

DISCOGRAPHY *Holy Wood (In the Shadow of the Valley of Death)* (2000); *The Last Tour on Earth* (1999); *Mechanical Animals* (1998); *Antichrist Superstar* (1996); *Portrait of an American Family* (1994); *Refrigerator* (1993); *The Family Jams* (1992).

VIDEOS "Get Your Gunn," "Lunchbox," "Dope Hat," "Sweet Dreams," "The Beautiful People," "Cryptorchid," "Tourniquet," "Man That You Fear," "Long Hard Road Out of Hell," "Space Lord," "The Dope Show," "I Don't Like the Drugs (But the Drugs Like Me)," "Rock Is Dead," "Coma White," "Astonishing Panorama of the Endtimes," "Disposable Teens."

BOOKS *Holy Wood* (2001); *Long Hard Road Out of Hell* (1998).

STRANGE BUT TRUE

- Manson's official Web site offers merchandise such as T-shirts, beanies, a carry bag with the Manson logo and "a navy blue outer wall equipped with extra slots" (for garters, mascara, and press releases) and a lunch box in which you can carry everything you need to hold a Black Mass anywhere, anytime.
- Taking Laser Vision Surgery Too Far: Some of Manson's fans believe that he somehow removed the pupils from his eyes.
- Most Likely to Butcher a Chicken on Stage: Several Manson fan sites run a banner ad for classmates.com.
- An MTV psychologist diagnosed Marilyn with multiple personality disorder, dissociative disorder, and delusions of Alice Cooper.
- One snowed-in night in Allentown, PA, during a tour in 1995, Manson found themselves trapped in the same hotel bar as the touring company of "Sesame Street Live" and the Orlando Magic basketball team. Rumor has it that Marilyn broke Big Bird's neck and put a curse on Shaquille O'Neal that's prevented him from making free throws.

marilyn

>"Some IDIOT hundreds of years from now may have a Marilyn MANSON T-shirt, and a bunch of people are gonna pray to it, and they're gonna make little Marilyn Manson necklaces that EVERYBODY WEARS."<

THE INSIDE SCOOP

As Scripture prophesized, the Antichrist is finally upon us, and he wears garters and stockings. In the early 1990s, Brian Warner, a scrawny kid from Canton, OH, moved to Tampa and stitched together his ghoulish androgyne from shards of Ozzy Osbourne, David Bowie, Friedrich Nietzsche, and Zacherle. Warner then formed an eponymous five-piece death metal combo, which in 1994 was discovered by Nine Inch Nails leader Trent Reznor. Thanks to a few power chords, deathless marketing, and teenagers' limitless appetite for Satan-for-Dummies histrionics, Marilyn Manson became the darling of rebels-without-causes and the bane of "The 700 Club."

The band's 1996 breakthrough album, *Antichrist Superstar,* sold 1.3 million copies, and their SRO concerts and sensational public appearances comprised an almanac of bad taste: Manson threw a live chicken into a mosh pit, mooned the audience at the MTV Video Awards, and was even declared a reverend by the Church of Satan. Outraged defenders of the faith forced Manson to cancel shows (and even tours, such as Rock Is Dead) and blamed him for everything from the Columbine massacres to the devaluation of the peso. In 1998, Manson released the album, *Mechanical Animals,* which, while moving the band in a glam rock direction, vented his vehemence about the desensitization of contemporary America. As of 2001, an unrepentant Manson is still at it: The cover of his latest, *Holy Wood (In the Shadow of the Valley of Death),* features Manson in a crucifix pose with eyes rolled back and lower jaw missing. The day people stop reacting to his provocations, he'll melt down like the Wicked Witch of the West.

MANSON

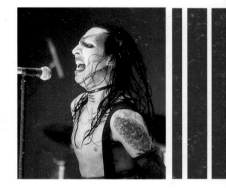

SKIN DEEP

>Manson treats his body like a temple—the temple of Satan. Let's see, we've got a grinning red devil's face, black pentagram, curly black object with a green eyeball in the middle of it, a grinning malevolent-looking ogre missing some of his lower teeth, a spider-web, another black thing with a green eyeball center, a grinning skull...and those are just on his arms.

>Mark WAXED COSMIC when he said, "God took a LUNCH BREAK when he was making my stuff, so I was always SELF-CONSCIOUS."<

THE INSIDE SCOOP

Orange County, 1992: a telemarketer, a paralegal, a truck driver, and a failed security guard turned pizza chef formed a band that has made barely a dent in rock history. The band was named Sugar Ray by their lead singer, Mark Sayers McGrath, a boxing fan who revered Ray Robinson. McGrath, guitarist Rodney Sheppard, bassist Matthew "Murph" Karges, drummer Charles Frazier, and Craig "DJ Homicide" Bullock developed an alt-rock ensemble influenced by the Beastie Boys. They signed with Atlantic Records and released *Lemonade and Brownies* in 1995. Sugar Ray toured almost non-stop during the next two years, opening for the Sex Pistols, Cypress Hill, and Korn (with whose lead singer Mark supposedly made out). Sugar Ray's second album, *Floored,* hit the Top 20 in 1997, led by the No. 1 modern rock single, "Fly." *14:59* followed in 1999, to less avid public consumption. In the celebrity version of Zeno's paradox, public apathy toward Sugar Ray grew in inverse proportion to McGrath's emergence as a sex symbol. (*People* magazine named him the "Sexiest Rocker Alive.")

The band seems to be dropping off the cultural radar screen, and McGrath's last grasp at the brass ring of celebrity seems to be appearing on VH1's "Rock & Roll Jeopardy." ("I'll take 'Has-Been Rockers' for fifty.")

SKIN DEEP

>Mark has seven tattoos—a Cadillac logo, hands praying with rosary beads (for his grandmother, who was always praying), the letter "M," (not a reference to the Fritz Lang film, but to "one of the loves of my life"), a sparrow just under each shoulder (a celebration of "Fly," which he admits is "corny"), shamrocks on his leg, the word "Irish" written on his back (which he admits looks more like "Trish" and may be another revisionist ink job executed the morning after a hasty back-stage affair), and his most telling tattoo—the Rolex logo on the right side of his midsection, which he claims to have had done on a dare. A true rock n' roll rebel, for years he was afraid to tell his family he'd gotten inked.

mark

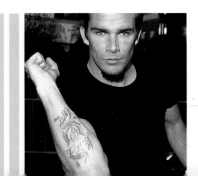

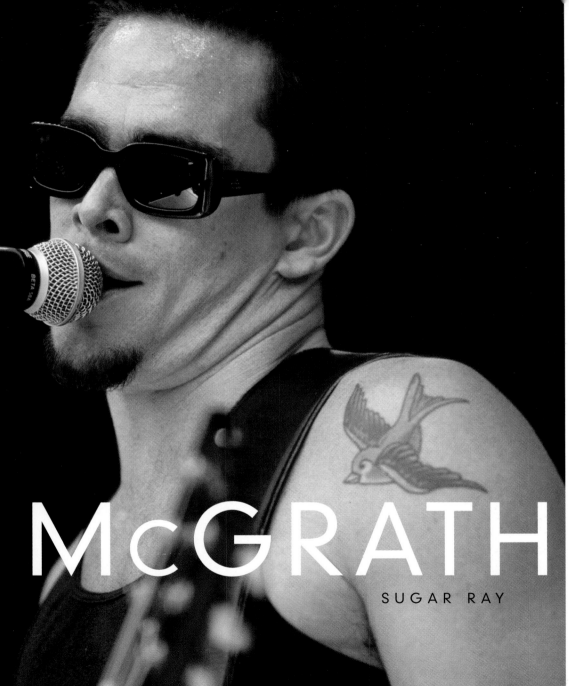

McGRATH

SUGAR RAY

RAW DATA

DATE AND PLACE OF BIRTH March 15, 1970, in Hartford, CT.
DISCOGRAPHY *Star Profile* (2000); *In Conversation* (2000); *14:59* (1999); *Sweet and Swingin'* (1998); *Floored* (1997); *Lemonade and Brownies* (1995).
VIDEOS "Falls Apart," "Someday," "Every Morning," "Fly," "RPM," "10 Seconds Down," "Mean Machine."
FILMS *Father's Day* (1997).

STRANGE BUT TRUE

- 14:59 refers to the amount of time the band has used up of its allotted 15 minutes of fame.
- The band's original name was Shrinky Dinx, but they had to drop it after being threatened by a lawsuit from Milton Bradley, the manufacturer of the shrinking-pieces-o-plastic.
- "10 Seconds Down" refers to Mark's self-admitted sexual performance.
- Rod used to make dentures (and still keeps epoxy on hand just in case).
- The first time Mark got arrested, he was on an old woman's roof calling her an "old coot." (He relishes intimate contact with his fans.)
- According to one fan site, "Mark is NOT Vanilla Ice or Ethan Hawke!!!!"
- Mark gave himself a deadline age where he would give up on trying to be a musician (a deadline he has perpetually extended).
- In his free time, DJ Homicide practices scratching.
- Sugar Ray has vowed to never stage dive after they had an accident with another band. (Both bands were trying to dive into the same pit, and Jimmy Carter was called in to settle the dispute.)

RAW DATA

DATE AND PLACE OF BIRTH January 9, 1978, in West Palm Beach, FL.

CURRENT RESIDENCE It's a secret, A.J. lives in fear of stalkers.

RECORDINGS *In the Spotlight with the Back* (2000); *Black and Blue* (2000); *Millennium* (1999); *Interview* (1999); *Star Profile* (1998); *Backstreet Boys* (1996).

AWARDS Grammys, Album of the Year, *Millennium*, Song of the Year, "I Want It That Way" (2000).

STRANGE BUT TRUE

- A. J.'s first theatrical role was Dopey in a grade school production of Snow White. Now, he does solo performances as his alter ego, Johny No Name.
- When the activist group Students Against Sweatshops staged a six-day sit-in at the president's office at the University of Toronto, local police tortured them by playing the Backstreet Boys around the clock.
- The Boys threatened to leave Jive Records after hearing that the label had signed rival boy band 'N Sync. (There wasn't enough Clearasil to go around.)
- The Backstreeters have been called, "prefabricated, too pretty," "music video marionettes" and "superficial ear candy"— and that's by people who like them.
- The Boys are releasing a series of CDs available exclusively through the Burger King chain. The songs are actually pressed into Whoppers buns, so now customers can get indigestion with back-up vocals.

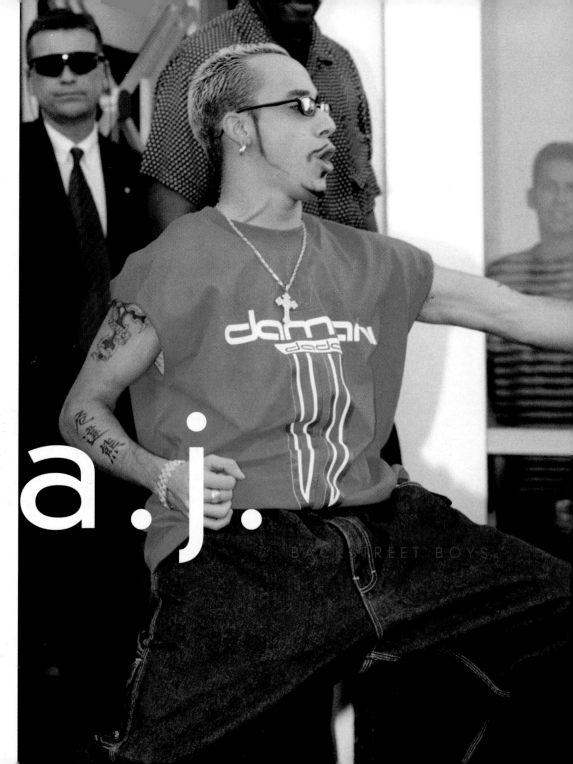

a.j.

BACKSTREET BOYS

>One of the BOYS once told the press, "You know, we do more than sing and dance. We've got A BRAIN, too."<

THE INSIDE SCOOP

A kind of Yanqui Menudo, the Backstreeters were assembled, Frankenstein-like, by their Svengali, Louis Pearlman, in Orlando, FL, in 1994. Originally, the band's core consisted of cousins Kevin Richardson and Brian Littrell, from Lexington, KY. Two other members, Howie Dorough and Alex James McLean, were Orlando natives who met each other—and fifth Backstreeter and teen heartthrob Nick Carter—through local auditions. Through circumstances too banal to recount, the quintet was spawned. Through Pearlman, they signed with Jive Records in 1994. Pearlman then pureed ballads, hip-hop, R&B, dance-club pop, generic pretty-boy looks, and dance moves for white people desperate for

street cred into a prefab pop phenomenon. Their eponymous CD sold 27 million copies worldwide and helped launch, along with 'N Sync, Britney, and Christina, the teen pop onslaught that music lovers say contravenes the Geneva Convention. Although Americans initially resisted them, the Boys finally scaled the U.S. redoubt with 1997's redundantly titled "Backstreet's Back," scoring hits with the singles "Quit Playin' Games (With My Heart)" and "As Long as You Love Me." The follow-up, "Millennium," was released in 1999, as was the group's "Christmas Album." For those resistant to BSB's charms, there is hope that the end of puberty may do what the scorn of rock critics couldn't.

McLEAN

SKIN DEEP

>Welcome to A. J.'s TattooLand: (1) Read his name written in tribal on his left upper arm; (2) "Laugh Now," just above his left elbow; (3) Ponder the origin of laughter while viewing the mask of Thalia, the muse of comedy, on his left lower arm; (4) Look out! There's a serpent on the shoulder blade—it's his Chinese astrological sign; (5) Quick, don your asbestos suit! A dragon awaits on the right shoulder blade; (6) Guess what "Da Bone"—written on a cross on his upper right arm—means. (It's one of his nicknames, along with Mr. Cool.); (7) Symbolism, anybody? Ooh and aaah at the heart splintered by a flame and a cross at the right elbow joint; (8-10) Speak Chinese? Then read A.J.'s lower right arm; (11) The number "69" inscribed on his navel. For A.J., tattoos are "another form of artistic expression for me" (like singing, dancing, and merchandising). He says the tattoos hurt the most when they color in the outlines. "When they colored in the first one I got, on my shoulder, I went pure white." He plans to have one final tattoo done: "Expires..."

>"I'm torn between the ARTIST AND THE WHORE. I have a hard time deciding between the dollar sign and SELF-EXPRESSION."<

SKIN DEEP

>In addition to having both nipples pierced, Navarro sports so many tattoos, he's run out of epidermal real estate and may have to scour Flea for open space. Here's a topographical map: "Los Angeles" sprawls all over his neck. The name of his mother—Constance—can be read on his lower back. On his left shoulder, a snake corners a pig. The pig represents how Dave characterizes himself, the snake is how he views the world. A tribal design half-encircles the snake—a reminder of his Jane's Addiction phase. Nearby, a ring of dolphins symbolizes the time he swam naked in Hawaii among 100–150 bottle-nosed mammals. A Virgin of Guadalupe (with whom he didn't swim naked) stands on his left forearm. Four suits from a deck of cards lay outside his left forearm. Continuing our museum tour, a miniature of a Gustav Klimt painting, "Life and Death," depicting a skeleton wrapped in a blanket of crosses standing on a skull, is brushed on the inside of his left arm. On the back of both hands, you'll see a spider spinning a web. A Roman numeral adorns each finger. The following tats adorn his right arm: (1) A fairy logo from the Chili Peppers' *One Hot Minute* sits on his right shoulder; (2) "Love fades," a line from Woody Allen's *Annie Hall*; (3) the words "DER ZEIT IHRE KVNST, DER KVNST IHRE FREIHEIT"—"To every age its art, to art its freedom," a line Navarro apparently spotted inscribed above the entrance to the building designed by Joseph Maria Olbrich of the Secession of the Association of Viennese Artists, which was created by Gustav Klimt and others in the late 1890s; (4) "Jane's"; (5) "V" for an ex; (6) a pregnant woman lifted from another Klimt painting; (7) a cross; (8) a unicorn; (9) the word "angel" in Theban script; (10) a sperm cell.

> The words "Trust No One" loom from his right hip. There's a licentious nun filched from a Justice Howard photograph on his lower left leg, and a dominatrix complementing her on his right leg.

THE INSIDE SCOOP

Although best known for his flintily melodic guitar licks and a Son of Bowie glam look, David Navarro's most impressive feat is to have played for two of the most influential bands in rock over a 15-year period while maintaining a major heroin habit. Granted, his passion for "the girl you shoot in your arm" (as jazz trumpeter Fats Navarro called it) probably was instigated not just by the pressures of the road and celebrity but also by the murder of his mother and aunt when Dave was just 15. The mainlining started not long afterward.

In 1985, he met fellow junkie Perry Farrell (nee Bernstein), and they formed a quintet called Jane's Addiction (a reference to the woman who introduced them). Their 1988 release, *Nothing Shocking,* gained them a cult following, but their follow-up release, *Ritual de lo Habitual,* propelled the band into MTV Land. Jane gradually picked up steam, forging a sound that blended metal, art, funk, and folk and that would become a genre unto itself.

In 1991, Farrell then brainstormed the idea of a kind of traveling Woodstock megatour, which he named Lollapalooza. However, the band members' drug use and other problems had begun to overwhelm Dave. The night before the Lolla kickoff, he tried to commit suicide in his hotel room. Just as Jane's Addiction was poised on the brink of stardom, they broke up. Navarro then formed Deconstruction, which self-destructed after one album. In 1994, he joined the Red Hot Chili Peppers after the departure of their guitarist John Frasciante. The Chilis won critical and public acclaim, although the pressure of touring and their unorthodox stage uniforms (e.g., lightbulb suits) eventually wore Navarro out, and he left in 1998 to write his memoirs and form a band called Spread with Chili Pepper drummer Chad Smith. After Smith left to rejoin the Peppers, Navarro remained with the project, founding his own Spread Entertainment label. He still claims to be battling demon junk, but will probably die at 90 in a retirement shooting gallery in Boca Raton.

david

NAVARRO

RAW DATA

DATE AND PLACE OF BIRTH June 7, 1967, in Santa Monica, CA.

CURRENT RESIDENCE Hollywood.

DISCOGRAPHY (with Spread) *Unicorns and Rainbows* (1999); (with Red Hot Chili Peppers) *One Hot Minute* (1995); (with Jane's Addiction) *Kettle Whistle* (1997); *Live and Rare* (1991); *Ritual de lo Habitual* (1990); *Jane's Addiction* (1987); (with Deconstruction) *Deconstruction* (1994).

VIDEOS (with Jane's Addiction) "Classic Girl," "Stop," "Mountain Song," "Ocean Size," "Jane Says"; (with Deconstruction) "One Way Song"; (with Red Hot Chili Peppers) "Californication," "Other Side," "Around the World," "Scar Tissue," "Coffee Shop," "Aeroplane," "My Friends," "Warped," "Soul to Squeeze," "Breaking the Girl," "Under the Bridge," "Give It Away," "Taste the Pain."

BOOKS *Trust No One* (1998).

STRANGE BUT TRUE

- * Plasma-Gram!: Navarro once scrawled a message in blood outside Fiona Apple's dressing room, after which a biohazard team was called in to scrub it off. "In my world, that's like saying hello," said Navarro. Apple tried to respond with her own blood, but couldn't find any.
- JunkieWear: He shot a Gap commercial that he said later was "proof positive that I had been on drugs."
- Typecasting: In the 1994 movie *Floundering*, he plays an addict whose mantra is "You got a dose?"

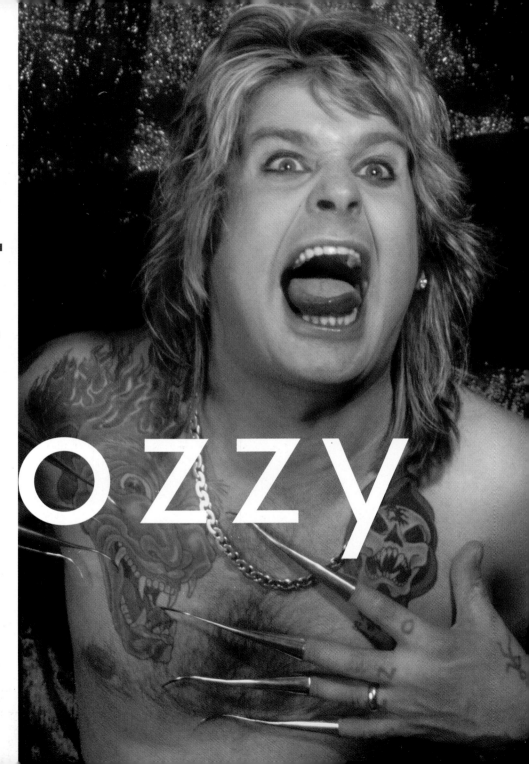

RAW DATA

DATE AND PLACE OF BIRTH December 3, 1948, Birmingham, England.

DISCOGRAPHY *Diary of a Madman* (1998); *Ozzman Cometh* (1997); *Trust Me* (1995); *Ozzmosis* (1995); *Live & Loud* (1993); *No More Tears* (1991); *Just Say Ozzy* (1990); *No Rest for the Wicked* (1989); *Tribute* (1987); *Ultimate Sin* (1986); *Bark at the Moon* (1983); *Speak of the Devil* (1982); *Diary of a Madman, Blizzard of Ozz* (1981).

VIDEOS "Back on Earth," "Changes," "I Just Want You," "See You on the Other Side," "Perry Mason," "Mr. Tinkertrain," "Time After Time," "Crazy Babies," "Shot in the Dark."

AWARDS Grammy, Best Metal Performance with Vocal, "I Don't Want to Change the World" (1993).

STRANGE BUT TRUE

- Ozzheimer's Syndrome: Ozzy recently discovered his 1970 basement tapes—while cleaning out his attic.
- Ozzy once sang "Born to Be Wild" with Miss Piggy for a Muppets album. Then he barbecued her.
- Fantastic Voyage: "I'd love for someone to be in Ozzy's head for a day," he once said. "You'd run down my asshole in, like, four seconds. You'd find the nearest escape route or take a laxative, and scream 'Get me out of here!' 'Cause I'm mad."
- Infanticide: "I distinctly remember one night, somebody threw this frog on stage and it was the biggest frog I ever saw and it landed on its back. And I thought, 'My God, I've taken this too far. Someone's thrown a baby on stage!'"
- Like Father...: "Being a parent is harder than being a rock 'n' roll star, 'cause any second, your kid will run through with a 16-inch-nail sticking through his head going, 'Daddy, I just got hit with a two by four!'"

OZZY

>"I'm not a MUSICIAN, I'm a HAM."<

THE INSIDE SCOOP

The man urinated on the Alamo wearing an evening dress. He bit the head off a live dove in a room full of record execs, then spit its bloody skull back on the table. His fans once trashed the former Meadowlands Arena, leaving him with an $80,000 damages bill. He's been banned from half the cities in America and denounced by clerics from Pat Robertson to Cardinal O'Connor. If heavy metal is the pro wrestling of rock, then its ultimate heavy is the Birmingham Madman, Ozzy Osbourne.

Although critically scorned in their lifetime, Black Sabbath, the 1969 creation of Ozzy and three of his proletarian mates, is now cited as the progenitor of metal, punk, goth, grunge, and what might be called Satanica—everything but rap. After a decade of outrageous success leveraged on sonic booms, Kreskin-level mysticism, and grossout circus tricks—such as gnawing the head off a live bat a fan tossed to the stage, for which he had to have rabies shots—Ozzy felt spinal tapped out. His legions of worshippers (who, through Ozzy, could act out their repressed feelings about geeking small animals) proved loyal; Osbourne's first two solo LPs went double platinum, and in 1981 his single, "You Can't Kill Rock 'n' Roll" (as hard as you might try), reaped heavy FM-airplay.

His succeeding albums racked up more platinum than a line of Vegas showgirls, but in 1986, he checked into the Betty Ford Clinic to battle alcoholism so advanced he was staring at the shadow of Megadeath. Between 1985 and 1990, three different families sued the Lizard of Oz, claiming his song "Suicide Solution" was responsible for their sons' self-inflicted deaths. (In actuality, the song expressed an anti-suicide sentiment, and Osbourne won every suit.) In later years, the former prince of darkness has Ozzified into an almost avuncular figure, writing antinuclear anthems, inaugurating an annual Ozzfest metalthon, and welcoming a third generation of addle-brained devotees.

OSBOURNE

SKIN DEEP

>When Ozzy finally goes to the big Headbangers Ball in the Sky, they could turn his body into a horror theme park, like the Haunted Mansion. That's because he's decorated his grizzled body with the following macabre images: a particularly fiendish looking serpent baring its fangs; a skull in a monk's cowl; a bat holding in its claws the head of an understandably apprehensive, overly made-up woman who resembles Vampira; and the letters "O-Z-Z-Y" imprinted on each of four fingers so that when he makes a fist, they spell his name. One arm is inked shoulder to wrist, leaving no further tattoo vacancies.

THE INSIDE SCOOP

If you think the Goo-Goo Dolls is a moronic name for a rock band (where admittedly the inanity bar is set at ground level), it could've been worse. Like the Sex Maggots (the band's original name). Or The Rzezniks, which could've happened if guitarist and vocalist John Joseph Theodore Rzeznik had been a tad more egocentric 15 years ago in Buffalo, NY, where the garage band was first housed. The Dolls, named for a toy they found advertised in the back of *True Detective* magazine (a detail that's captivated the top minds in French structuralism), spent the greater part of a decade toiling in the suburbs of celebrity. In fact, up until 1995, the members still had part-time jobs. Rzeznik was working as an independent radio promoter when the band broke through. Ironically, it wasn't with the power pop tunes they'd been crafting all along, but with Sominexy ballads such as "Name," a hit that propelled their album, *A Boy Named Goo,* to platinum status. Yet success can be its own mosh pit. On the eve of the album's release, Rzeznik and bassist Robbie Takac fired drummer and original Doll George Tutuska. As the new album climbed the charts, the Goo Goos threw a nine-month legal tantrum over a contract that left them in virtual liege to the Metal Blade label. They eventually signed with Warner Brothers Records, for which they scribed "Iris," the band's first No. 1 hit in 1998. In September of that year, Goo-Goo-ites were ordered to *Dizzy Up the Girl,* and were rewarded with more platinum.

SKIN DEEP

>He purportedly has six tattoos. John borrowed the image tattooed on his right arm from Picasso's painting, "The Dream." He had it done in two grueling, five-hour sessions (which may be longer than it took Pablo to paint it). Imagine his disappointment when only a few days later, he saw the exact same tat on a fan in Indiana. "I couldn't believe she already had that done; I hadn't even had my own tattoo that long," Rzeznik exclaimed. On the inside of that same arm, he has some Japanese characters, which he had done in a soul-searching period after the wild success of *A Boy Named Goo.* "I got the feeling that everyone was waiting to see me fall on my face," he said. Rzeznik suddenly became unable to write songs, and consulted various therapists and others until someone tipped him to the Japanese characters known as kanji. He had an artist inscribe icons for love, dreams, discipline, faith, truth, and greatness. "You know how neurotic I am?" Rzeznik said afterward. "I am the only guy in the world who has a self-help tattoo."

johnny

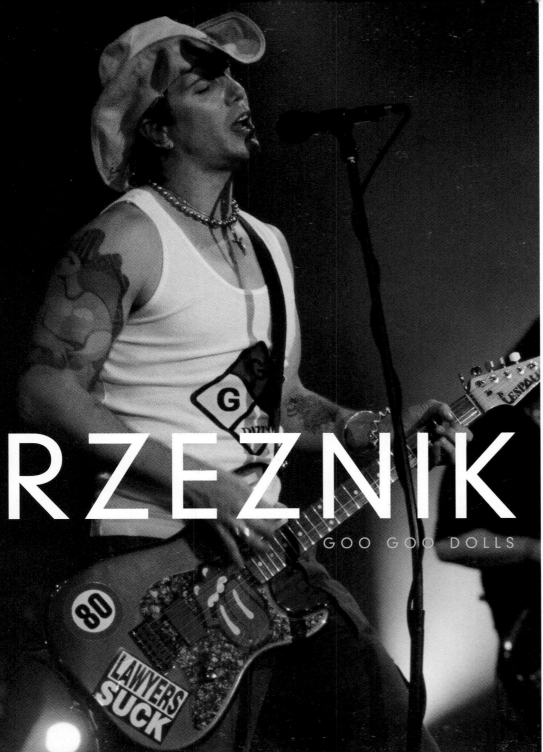

RZEZNIK
GOO GOO DOLLS

STRANGE BUT TRUE

- Johnny studied at Buffalo State College, where, he brags, "I spent three years, all freshman."
- Rzeznik once said, "The nicest part about success is being able to pay people back who did right by you." I guess this excludes members of the band: Drummer Tutuska discovered that Rzeznik had been hoarding songwriting royalties for the song "Fallin' Down," rather than splitting them with the other two band members as they'd agreed. This led to Tutuska leaving the group.
- Rzeznik likes to sleep in a hot dog vendor uniform…to remind him of what he could be doing with his life.
- Rising Star: Johnny keeps vinegar and beer in his fridge.
- His hobby is watching porn.

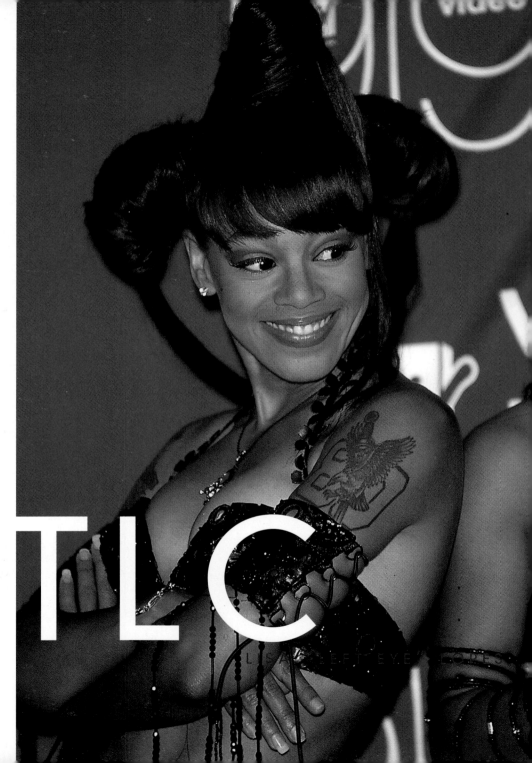

RAW DATA

FULL NAMES Tionne "T-Boz" Watkins, Lisa "Left Eye" Lopes, and Rozonda "Chilli" Thomas.
DATE AND PLACE OF BIRTH T-Boz: April 26, 1970, Des Moines, IA; Left Eye: May 27, 1971, Philadelphia; Chilli: February 27, 1971, Atlanta, GA.
CURRENT RESIDENCE Atlanta, GA.
DISCOGRAPHY *Star Profile* (2000); *Fanmail* (1999); *CrazySexyCool* (1994); *Ooooohhh...On the TLC Tip* (1992).
AWARDS The trio has garnered just about every prize in an industry second to none in self-congratulation: Grammys, MTV Video Music Awards, Soul Train Lady of Soul Awards, and the Aretha Franklin Award for Entertainer of the Year.

STRANGE BUT TRUE

• T-Boz appeared in the film *Belly,* and Left Eye hosted MTV's "The Cut." Chilli was in talks to take over "The Capitol Gang," until she learned that it wasn't a gangsta show.
• Left Eye wears a lens on her right eye and a condom eye patch on the left. (Translation: Even pirates should practice safe sex.)
• Left Eye also wears lamp black under her left eye, as she doesn't want to lose any reporters in the paparazzi's lights.

TLC

>Chilli on PREMATURE INTIMACY: "Many of the problems I've had happened because I didn't give myself the chance to know SOMEONE before doing the CHICKEN WING."<

THE INSIDE SCOOP

TLC, the best-selling female group of all time, was formed in 1992 when Lisa "Left Eye" Lopes, Rozonda "Chilli" Thomas, and Tionne "T-Boz" Watkins hooked up with R&B producer/singer Pebbles and hit-making producer Dallas Austin. The Atlanta-based hip-hop trio released their first album, *Oooooooohhh...On the TLC Tip,* that same year; it went platinum.

Their blend of club/dance, rap, and urban-pop, labeled "New Jill Swing" (species Homo Hilfigerus), was da bomb, and the group had three consecutive Top 10 hits in 1992, including "Ain't 2 Proud 2 Beg," "What About Your Friends," and "Baby-Baby-Baby." Shortly before the release of their second album in 1994, in a bold PR maneuver, Left Eye torched the five-bedroom suburban Atlanta mansion of her boyfriend, Atlanta Falcons receiver Andre Rison. (To be fair, the previous year, Lopes and Rison had a high-profile contretemps involving gunplay and physical abuse; Rison was penalized for illegal use of the hands.) As a character defense, Lopes's lawyers' painted her as a hopeless alcoholic. It worked; the diminutive rapster avoided a possible 20-year sentence. And the imbroglio didn't affect the sales of the album, *CrazySexyCool,* which featured three No. 1 singles and sold a deplorable number of copies.

In July 1995, as their "Waterfalls" single (with accompanying $2 million video) sat atop the *Billboard* charts, and after selling 14 million albums, the band had a royalty dispute with their record company and filed for bankruptcy. Their liabilities were said to total $3 million, including $1.3 million to Lloyd's of London, who insured Rison's house. After a sabbatical, during which Lopes did damage control on her reputation, Watkins announced she was suffering from sickle-cell anemia, and Thomas gave birth to a son, the trio returned in 1999 with the album, *Fanmail,* which included hits such as "Unpretty" and introduced the term "scrub" (meaning: a geeky loser who lives with his mom) into the pop lexicon.

SKIN DEEP

>Left Eye wears a large number "80" with a falcon and cross on her left arm, undoubtedly a reference to Rison. On her right arm, she sports a bleeding blue heart impaled on a cross and encircled by a ring of thorns with the word "Parron" written over it. Lopes views tattooing like Hemingway viewed war, as an existential test of sisterhood. She boasts, "I can take pain pretty good. I can block it out. I can feel it, but I know it will be over. Fear is just not knowing. Get prepared to deal with it. I have accepted it." Talk about grace under pressure.

TO BRAND OR NOT TO BRAND?

> DENNIS HENSLEY chats with Sunset Strip Tattoo's artist in residence, Mike Messina, about going under the needle and joining the ranks of Hollywood's INKED ELITE<

Last week, one of my best friends got a tattoo. I had never thought of him as the tattoo type—he used to play Aladdin at Disneyland for cryin' out loud—and now, suddenly he's subversive, devil-may-care, unpredictable. Since his grand unveiling, I've concluded that the surest way to go from being the type person who'd never dream of getting a tattoo (i.e. uptight like me) to being the kind of person who actually might, is to get a tattoo.

But do I dare?

At least in Hollywood I knew I certainly wouldn't be alone, for stars of every age, shape, and breast size have been going under the needle for ages. At present, there seems to be a particularly vital tattoo frenzy going on among denizens of young Hollywood, like your David Arquettes and Charlize Therons. But before I join their rebel-rousing ranks, I figure a little investigating is in order.

"I've been giving tattoos here for a little over ten years," proclaims Mike Messina, a genial, pony-tailed artist who works at Sunset Strip Tattoos in West Hollywood. "This shop has been here for about thirty years so we've tattooed everybody from Ringo Starr to Cher to Nicholas Cage to Lorenzo Lamas to the blond girl from 'Dawson's Creek.'"

Though I'm tempted to say to Mike, "Just give me what Lamas had!" and be done with it, I opt instead to take my time. "I was thinking of something simple," I tell Mike. "Like Allison Eastwood, who has a purple rose on her left shoulder."

"I don't know Allison Eastwood," Mike admits with a shrug.

"She's Clint Eastwood's daughter," I say.

"Oh, OK," he says. "Well, a flower is something that twenty years down the line, it's not a bad thing. Like Clint can say, 'It could be worse. At least it's not a dripping bloody skull with an ax in it's forehead.'"

Mike admits that he gives pretty good flower himself, adding that he spent six or seven hours penning a whole slew of them across Cher's Oscar-winning derriere.

"I sat there with *an* ass in my face," he clarifies. "I automatically disconnect. I mean, I tattooed my mother's upper thigh and it was a four inch square of flesh I was looking at, and then when I looked up, there was my mother's head on this person's body."

I'm tempted to inquire who's older, Mike's mother or Cher, but instead I ask him if he knows who Fairuza Balk is.

"No," he shrugs. "What has she been in?"

"I can't remember," I say, "but she has a Sanskrit mantra around her arm. Is that sort of thing popular?"

"Yeah, actually Chester's got Sanskrit on his arm there," Mike says indicating his fellow artist, Chester Oswalt. "It's a dead language, like Latin, only it's deader than Latin."

"It was a popular tattoo in the 1930s and it became popular again in Vietnam," Chester explains. "It's a good luck charm more than anything else. I put it on my right wrist so I do good tattoos. A lot of people put them on their ankles so wherever they put their first step is always with a mantra."

"I like the idea of that," I say eagerly, then realize that if it really was a good luck charm, I would have been able to come up with at least one Fairuza Balk movie. Hoping to drop a name or two that Mike and Chester may have heard of, I bring up Pamela and Tommy Lee and their his-and-her ring tattoos.

"We did those," says Mike, "and the barbed wire around her arm as well."

But what about couples that are splitsville? I ask Mike if his clients come in wanting to get rid of a tattoo when the object of their affection is no longer in the picture.

"Oh, that never happens in Hollywood," he deadpans. "No, I'm just kidding. Actually, it depends on what your definition of 'get rid of' is; like I did the 'Winona Forever' on Johnny Depp, and unfortunately, forever came and went. But he's not opposed to having a tattoo; he was just opposed to having *that* tattoo, so I think he had somebody cover it up with a different tattoo. Or you can just have a doctor laser it off, but it would cost infinitely more than covering it up."

None of which has a damn thing to do with my tattoo selection process, given that the last love interest I had was wearing a prom dress. I decide to bring up something I at least have some connection to—cartoon characters.

"Maybe I could get a Dennis the Menace," I suggest. "I mean, Casper Van Dien has a tattoo of Casper the Friendly Ghost on his arm."

"These names don't ring a bell," says Mike needlessly. "Anyway, people identify with certain cartoon characters. I kind of identify with Bugs Bunny because nobody really got the better of him."

"David Spade has Hobbs from Calvin and Hobbs on his arm," I remark.

"Hobbs is the tiger guy who's pretty much a smart ass," says Mike.

"Janet Jackson has a Mickey and Minnie Mouse," I report. "I think Minnie is giving Mickey a blow job."

"As well she should be," chirps Mike. "Even mice need some to get every now and then."

Just then, the phone rings. While Mike fields the call, I think about getting a religious tattoo like Tom Arnold's star of David or Alyssa Milano's cross and rosary beads, but that idea quickly falls by the wayside when I realize that the closest thing I practice to a religion is a curious worship of, well, Alyssa Milano.

"Do a lot of people get Asian images," I ask when Mike returns, "like Angelina Jolie who has a Chinese dragon on her arm and Julia Roberts who has the Japanese symbol for strength next to a little heart?"

"Strength of heart," says Mike with a smile, leading me to wonder if Lyle Lovett has the same type of tattoo but with a *Ghostbusters*-style slash through it. "A lot of people relate tattooing to China and Japan like they created it or something. They just have a lot of neat artwork, basically. The artwork is ancient and mysterious and has folklore behind the imagery, which makes it fun."

When Mike explains that he's got an ass to illustrate in 15 minutes, I decide to fire off more of the celebs who seem to be beckoning me into their multicolored, body painted clique.

"Vivica A. Fox has a fox's head on the top part of her left arm," I announce.

> "Nowadays, every SOCIAL class is getting tattoos…It's not just the BIKER and the SAILOR and the HOOKER anymore." <

"Theres nothing wrong with a little head," says Mike.

"Courtney Love has a flying angel," I say.

"Yeah, we tattooed her," he says coolly. "It's all a matter of people's perceptions of themselves."

"Jon Bon Jovi has a Superman logo," I say. "Does that mean he fancies himself a man of steel, if you know what I mean?"

"Could be," laughs Mike, "but then again he could just like Superman."

"Minnie Driver has a rose on her butt."

"News to me."

"Can Minnie cover that up if she had to do a nude scene in say, *Hard Rain 2*?"

"Yeah. There's stuff called Tattoo Cover. It doesn't fool the eyes, but it fools the camera, and that's all it really needs to do."

"Rose McGowan has a Varga Girl tattoo," I say. "Is it unusual to have sexy girls with pictures of sexy girls on them?"

"We don't do that much, but I don't think it's unusual," Mike says. "Guys get big, hairy Vikings and stuff, so why not?"

"Sheryl Lee has a snake," I say. "I think it's interesting to have an image of something most people are afraid of."

"Well, it's not a snake," says Mike. "It's a tattoo of a snake. See, Chester's got a snake on his arm. But he's married, he's not afraid of anything."

Mike's next client arrives, so I get up to go, but before I do, I make tentative plans with Mike to have my Dennis the Menace done on Saturday.

"People who don't have tattoos look at them, but they don't really see them on other people, and then, all of a sudden when they get a tattoo, they start seeing tattoos everywhere because now they're sort of part of that group." A group that includes Drew Barrymore and Mark Wahlberg, I think to myself. "Nowadays, everybody from every social class is getting tattoos; college students and doctors and lawyers. It's not just the biker and the sailor and the hooker anymore."

"It's the chick from 'Dawson's Creek'!" I say excitedly.

"Whose name escapes me," admits Mike, before bidding me farewell.

Saturday arrives and, hell-bent on going through with it, I hop in the car and head for Sunset Strip Tattoos. I get stuck, however, in Laurel Canyon, when a house fire holds up traffic for hours. I decide it's a sign. I call Mike from the traffic jam and tell him I'm going to hold off, that he can let Tony Danza or the guys from Motley Crüe have my ink.

"If you have to make a decision, don't," Mike says reassuringly over the sound of girls giggling in the background. "You'll know."

The final straw in my decision to hold off came a week later when I read that some of the Spice Girls got tattooed in West Hollywood on the very afternoon that I was going to. In other words, had I not got stuck in traffic, Baby could have held my hand while Ginger rubbed me down with Neosporin and Posh got the gauze ready and Scary flirted with Mike, and Sporty went in the corner and shadow-boxed.

It would have been my own perfect little SpiceWorld, and if I can't have that, I don't want no stinkin' tattoo. All the same, I called and told Mike to page me if Hanson wanders in.

Dennis Hensley is the author of the novel *Misadventures in the (213)* and regularly contributes to such magazines as *Movieline*, *Us Weekly*, *Cosmopolitan*, *TV Guide*, *In Style*, and *The Advocate*. He has also recorded an album, *The Water's Fine*, and is currently working on his second book, a humorous collection of movie-related essays entitled *Screening Party*. To learn more, visit: www.dennishensley.com

FROM THE CREW AT SUNSET STRIP TATTOO

Over the years, we've had the opportunity to meet and tattoo many celebrities. We take great pleasure in our work—communication with our clients is very important to give them the best possible tattoo. When we see our work out there in the movies, on television, up on stage, or on the playing field, it's a good feeling. We can sit back with the knowledge that we produced quality tattoos and our clients are proud to show them off. We thank all our clients for the opportunity to do what we really enjoy. Without them, we'd be sitting around tattooing ourselves—and I've got no more room left!

On the following pages, feast your eyes on the most popular tattoo art for men and women.

Estelle Hallyday
Page 82, photo (main) by Terry O'Neill/Corbis-Sygma; photo (inset) by Darren Keith/Corbis-Outline

Iman
Page 84, photo by Isabel Snyder/Corbis-Outline

James King
Page 86, photo by Steve Azzara/Corbis-Sygma; page 87, photo by Thomas Lau/Corbis-Outline

Stephanie Seymour
Page 89, photo (main) by Mitchell Gerber/Corbis-Sygma; photo (inset) by Stephane Cardinale/Corbis-Sygma

MUSICIANS
Gregg Allman
Page 92, photo by Jay Blakesberg/Retna Ltd.

Phil Anselmo
Page 95, photo by George De Sota/Liaison

Bjork
Page 96, photo by Davies & Davies/Corbis-Sygma

Mary J. Blige
Page 98, photo by Steve Azzara/Corbis-Sygma; page 99, photo by Regan Cameron/Corbis-Sygma

Blink-182
Page 100, photo by Bozi/Corbis; page 101, photo by Tim Mosenfelder/Corbis

Jon Bon Jovi
Page 102, photo by Larry Busacca/Retna Ltd.; page 103, photo by Gavin Evans/Retna Ltd.

Mel C.
Page 104, photo by Stephen Ellison/Corbis-Outline; page 105, photo by Pacha/Corbis

Sean Combs
Page 107, photo by Michael O'Neill/Corbis-Outline

Crazy Town
Page 108-109, photos by E. William Blochinger
E. William Blochinger Photography
"Photography wih an edge"
Los Angeles, CA
323-634-0911
ewilliamphoto.com

D'Angelo
Page 111, photo by Dah Len/Corbis-Outline

Jonathan Davis
Page 112, photo by E. William Blochinger; page 113, photo by John Popplewell/Retna Ltd.

Fred Durst
Page 114, photo by Barry King/Liaison; page 115, photo by Vaughn Youtz/Liaison

Eminem
Page 116, photo by Eric Wile/Shooting Star

Eve
Page 118, photo by Chris Delmas/Zuna Press; Page 119, photo by Steve Azzara/Corbis-Sygma

Flea / Red Hot Chili Peppers
Page 120, photo by Neal Preston/Corbis

Keith Flint
Page 123, photo by S.I.N./Corbis

Janet Jackson
Page 124, photo by Regan Cameron/Corbis-Sygma

Lenny Kravitz
Page 126, photo by Blake Little/Corbis-Sygma; page 127, photo by Kim Andrealli/Corbis-Sygma

Tommy Lee
Page 128, photo by David LaChapelle/Corbis-Outline

Courtney Love
Page 130, photo by Lisa Rose/Globe Photos; page 131, photo by Paul Smith/Feature Flash

Marilyn Manson
Page 132, photo by Rune Hellestad/Corbis; page 133, photo by E. William Blochinger

Mark McGrath
Page 134, photo by Jeff Slocomb/Corbis-Outline; page 135, photo by Tim Mosenfelder/Corbis

A.J. McLean
Page 137, photo (main) by Scott Audette/Corbis; photo (inset) by Barry King/Liaison

David Navarro
Page 139, photo (main) by Mitchell Gerber/Corbis; photo (inset) by S.I.N./Corbis

Ozzy Osbourne
Page 140, photo (main) by LGI/Corbis; photo (inset) by Dave Hogan/Corbis

Johnny Rzeznik
Page 143, photo by Tim Mosenfelder/Corbis

TLC / Lisa "Left-Eye" Lopes
Page 144, photo by Evan Agostini/Liaison; page 145, photo by Steve Granitz/Retna Ltd.

Feature
Pages 146-149, all photos by Dennis Hensley

Tattoos
Pages 151–155, courtesy of Mike Messina/Sunset Strip Tattoos

ACKNOWLEDGMENTS

President	Ken Fund
Publisher	Greg Brandenburgh
Art Director	Susan Raymond
Production Editor	Jay Donahue
Jacket Designer	Howard Grossman
Designer	Leeann Leftwich
Project Editor	Wendy Simard
Photo Researchers	N. Warren Winter and Wendy Simard